TEACHING IS A TATTOO

PRAISE FOR *TEACHING IS A TATTOO*

Everyone has a story. And in *Teaching Is a Tattoo*, Mike Johnston encourages us to wear our stories and our hearts on our sleeves—sometimes literally. In engaging and thoughtful prose, Johnston explores the shapes, colors, and lines of what it means to be in the classroom and what it means to display that meaning on our physical person. Teaching, Johnston tells us, impacts our emotional selves and sculpts our narrative, while the tattoos we wear on our physical bodies do the same. Teaching and tattoos share so many similarities, not the least of which is that they are both the story of our hearts, the poetry of our flesh. Let this book make its mark on you.

—**Dan Tricarico**, author, *The Zen Teacher: Creating Focus, Simplicity, and Tranquility in the Classroom*

Get ready for a conversation with a new friend as you read Mike's *Teaching Is a Tattoo*. If you're a teacher, you know that the profession is indelibly inked onto your soul, just as a tattoo adorns your skin, and both become sources of rich storytelling. Mike takes you on a journey as he reminds educators that our work is something worth wearing and it has value within the fabric of others' experiences. This book will affirm your worth, uplift you with stories inked on others' skin, and remind you of the human behind your title of "teacher." Mike even provides ideas for you to amplify your own storytelling in your classroom and with colleagues, giving you permission to be vulnerable as he leads the way for you to reflect on how deeply personal and wildly public teaching and tattoos can be. His connections and writing will draw you in as he encourages you to embrace the unique aspects you bring to your students. I'd say that's pretty powerful, especially in current times. Teaching is part of who we are and has its own cultural identity, and because Mike lives that, too, he weaves a narrative threaded with empathy and understanding that will make you feel seen. Get ready to reflect on your own stories as a human being with myriad layers. Grab a comfy seat and dig in.

—**Wendi Pillars**, author, *Visual Impact: Quick, Easy Tools for Thinking in Pictures*

Mike Johnston's *Teaching Is a Tattoo* isn't just another education book; it's a personal and impactful exploration of what it means to be a truly committed educator. Mike challenges us to embrace imperfection, highlighting the value of authenticity through personal experiences and teacher testimonials. His story walks the reader through personal anecdotes, insightful reflections, and practical classroom activities, which any educator—tattooed or not—can connect with. Just as tattoos leave a lasting impression on our body, being a teacher leaves a mark on our hearts.

—**Ben Cogswell**, author, *The Eduprotocol Field Guide Primary Edition*

From the moment I opened *Teaching Is a Tattoo*, I was captivated by its heartfelt pages. Mike masterfully intertwines his own teaching experiences with those of others, using metaphor to illuminate the profound impact of our stories and the confidence to wear them proudly. Each section offers a transformative activity, guiding readers through meaningful self-reflection and encouraging them to embrace their unique strengths as educators. By the final page, you'll feel a renewed passion for teaching and an invigorated sense of purpose: to wear your teaching tattoo with pride and boldness.

—**Tisha Richmond**, educator, author, consultant, speaker

MIKE JOHNSTON

TEACHING
* IS A *
TATTOO

Own Who You Are as an Educator
Enough to Wear It Out Loud

Teaching Is a Tattoo: Own Who You Are as an Educator Enough to Wear It Out Loud
© 2025 Mike Johnston

All rights reserved. No part of this publication may be reproduced in any form or by any electronic or mechanical means, including information storage and retrieval systems, without permission in writing by the publisher, except by a reviewer who may quote brief passages in a review. For information regarding permission, contact the publisher at books@daveburgessconsulting.com.

> This book is available at special discounts when purchased in quantity for educational purposes or for use as premiums, promotions, or fundraisers. For inquiries and details, contact the publisher at books@daveburgessconsulting.com.

Published by Dave Burgess Consulting, Inc.
Vancouver, WA
DaveBurgessConsulting.com

Paperback ISBN: 978-1-956306-91-0
Ebook ISBN: 978-1-956306-92-7

Cover and interior design by Liz Schreiter
Edited and produced by Reading List Editorial
ReadingListEditorial.com

This book is dedicated to 1980s supergroup the Care Bears for proudly wearing the unique tattoos proclaiming who they are right on their soft, fluffy bellies—and for showing us that one of the most powerful things we can do is just care.

CONTENTS

Introduction .. 1
 So Dangerous You'll Have to Sign a Waiver

Lucky #1 .. 9
 Teaching is a tattoo because people might never understand
 why we choose either, but we do, and that's powerful

Lucky #2 .. 29
 Teaching is a tattoo because both have permanent impacts,
 so both should be taken into real consideration

Lucky #3 .. 43
 Teaching is a tattoo because both are a point where deep
 traditions meet modern styles and approaches

Lucky #4 .. 59
 Teaching is a tattoo because both create connective tissue
 between things that might not otherwise be connected

Lucky #5 .. 73
 Teaching is a tattoo because both are simultaneously
 deeply personal and wildly public in nature

Lucky #6 .. 85
 Teaching is a tattoo because there's only so many inches
 of a person for you to decide how to cover

Lucky #7 .. 103
 Teaching is a tattoo because the closer you look at it, the easier it
 becomes to see imperfections (but there can be positives in that)

Lucky #8 .. 119
 Teaching is a tattoo because both can be painful, both are worth
 the pain, and healing is an essential part of the process for both

Lucky #9 .. 133
 Teaching is a tattoo because both are things that we do
 to feel a little more seen as a human being

Lucky #10 .. 153
 Teaching is a tattoo because sometimes it's black and gray,
 sometimes it's full color, but it's always meaningful art

Lucky #11 .. 169
 Teaching is a tattoo because people too easily make assumptions
 about the human beings who choose either (or both)

Lucky #12 .. 187
 Teaching is a tattoo because at some point, you have to
 have enough faith to give control to the artists to create

Lucky #13 .. 201
 Teaching is a tattoo because both can be changed,
 but that demands work

Conclusion .. 219
 Sometimes constellations reveal themselves one star at a time

Flash Art Tattoo Activities .. 225

Acknowledgments .. 228

About Mike Johnston ... 229

More from Dave Burgess Consulting, Inc. 230

INTRODUCTION
So Dangerous You'll Have to Sign a Waiver

Everything is a blank canvas until it isn't.

There are days when we wake up with something pulling us toward creating meaningful things. A spark inside kindles and catches, and it invites us to leave our mark. We house this slow-burn inspiration, thinking and rethinking through the risks and logistics, imagining the possibilities. We give these thoughts and ideas form and shape, and we become brave enough to put them out into the world, knowing there is every possibility that our vision won't be realized the way we pictured it. We think about where and how and with which colors to make our aspirations tangible. We accept that making them physical means inviting others into the process and trusting their input, which can be uncomfortable, even painful for some of us. It inevitably creates a relationship between what we imagine and those who we invest in co-creating it with. Regardless of how it all goes, you end up modifying the canvas permanently. You do something that gets under the skin of it all. You take a blank canvas and change it from potential to purposeful.

That's what teaching is. But that's also what tattoos are. Teaching is a tattoo.

Human beings are a blank canvas until we aren't. Until moments and experiences forge us and shape us and make us works of art. Ideas become ink in these moments. Ambitions and hopes become nuts-and-bolts lesson plans, logistics, and tangible outcomes. In both teaching and tattoos, we have the immense privilege of being part of creating something physical from something conceptual. You know what story you want to tell, and you know what you want people to see and experience and learn. Both teaching and tattoos are intangible ideas worked into something you can see.

The process and impact of teaching and tattoos are virtually identical, like Mary-Kate and Ashley Olsen. Well, early career Mary-Kate and Ashley Olsen. We all carry tattoos as teachers. We're wearing them right now. Some are metaphorical. They are the permanently altered pieces of canvas that make up who we are, carrying memories and moments and lyrics from "Wannabe" by the Spice Girls. (So many of us can, at the very least, ask people to tell us what they want, what they really, really want.) They're the scars we earn adventuring. They're scars like the one I have just below my knee from a bike outing with over a hundred students where I was so attentive to their safety that I drove my own bike straight into a tree. They're the wrinkles that we earn worrying about our students. I doubt there is a single educator who read that sentence without picturing the face of a kiddo they've lost sleep over. They're our graying hairs. They're sometimes literal tattoos. Regardless of how we carry them, they are a manifestation of change. Both teaching and tattoos provide an opportunity to consider what and how and why we'll create something permanent. Because of the permanence, both tattoos and teaching become opportunities to help us reflect, celebrate, and grow. We change through these stories that we've had a hand in creating.

I've always felt a deep connection to the stories that we choose to carry in the skin and bones of who we are. I love that about us human beings. I love that just by existing, we become this singular

miraculous moment in the universe where science and story fuse together. Biologically, we're mostly empty space between atoms in constant motion that are drawn close to one another by impossibly strong, unseen attractive forces. The nature of us is to be held together, even on days when we feel like we're falling apart. The way I like to see it, that empty space between our atoms fills up with a lifetime of stories, experiences, moments, memories, heartbreaks, hardships, healing, and hope. It fills up with everything we live that makes us who we are. It fills with nurture in between nature.

That's why every single one of us becomes immeasurably important by just being; each of us is the only junction that will ever exist where our unique science and our unique stories meet. Believing this has fundamentally changed the way that I understand the people around me. With every person being the only time those particular pieces will exist together, I understand that if I miss the chance to really see someone, I won't get another. Ever. Especially as an educator, I believe it is our responsibility to see the unseen in everyone. That's another parallel between teaching and tattoos: Both are a commitment to finding, creating, and amplifying meaning in unexpected places. In teaching, it is our responsibility and privilege to see the stories nestled in the empty spaces between the atoms of our students and colleagues. Tattoos do the same work in a way that is sometimes easier to see. Both teaching and tattoos present us with wonderfully unique and diverse human stories, and we must ask ourselves how we take these and make them into something tangible that can be carried effectively and meaningfully into future experiences. In essence, both tattoos and teaching take stories and evolve them into something palpable. With both, we aspire to take pieces of a person and help them be proud to wear those pieces out loud.

Wearing something out loud is the decision to seek things that live inside of us—stories and experiences and skill sets, passions and preferences and the things that drive us—and to put them out into the world. Tattoos and teaching share that. Both become an opportunity for people to choose pieces of their unique human existence

and concretize them so others can interact with them. Teaching is a tattoo because it recognizes how important each and every person's unseen experiences are, how each and every person is the only one who will ever carry their specific stories. Committing to seeing, embracing, and creating space for those unseen pieces in one another changes pedagogy and practice. It changes teamwork and time use. Both in education and beyond, so much of what can't be seen is the bedrock of our motivations. You can't see things like love or faith or gravity, but you can see what people are capable of through those unseen things. You can't see music, but you can see people dance or . . . try to dance. You can't see the forces and stories in between our atoms, but they are there, and they matter because they're what make you, you.

Tattoos are a next-level commitment to wearing those unseen stories that exist in our empty spaces. So is teaching. With education being the business of human beings, a massive piece of the work we do is simply seeing our students for who they really are, for the stories and circumstances that forge them, and finding ways to make learning effective for each individual's growth. I believe that's what makes education magic: We all bring our own unseen stories to a community, and we spend our time figuring out how we all connect and intersect, how we make sense together, and how we can best create the world we share together moving forward. It helps each of us find our place. Every day each human being that we interact with will form millions of neural connections in their brains and live new stories in between their atoms. Every minute that you work with a human being, you are being woven into their brains, into the fabric of what they're experiencing with you. It's unseen but undeniably true: Everyone you have the privilege of interacting with

carries pieces of you, as you carry pieces of them. These are permanent stories that become part of who we are, but this is especially true for educators: We don't have the option of taking our stories off when we get to work—just as students can't take off the impact that we have on them when they're not in our classrooms. That is why teaching is a tattoo.

What have you fallen in love with when it comes to being an educator? What do you want to wear out loud? What do you most value about who you are as a teacher? I want to see the unseen stories of you and know how they connect who you are to what you do. I want you to own it. What is it that you see in yourself as an educator that you would wear as a tattoo for the world to see? I chose every one of my tattoos because I am proud to show the world specific stories from the unseen space between my atoms. I do the same as an educator. I actively look for and reflect on every inch of what I love about this work that we do. I choose to give myself the chance to see what it is that I bring to the table as an educator. I ask myself why. Then, most importantly, I wear those answers to work every day like tattoos. What about teaching is your tattoo?

Give yourself that permission to reflect and respond with commitment. Be specific about what you see in yourself as an educator and what you love enough about the work to wear it out loud. Avoid things like "The kids are what I love about being a teacher." You're right, the kids are fantastic, but that's like saying your favorite ice cream is "cold." It's all cold. That's what makes it ice cream. Kids are what make schools. Be specific with the stories and experiences you choose to wear. After all, when someone asks which Teenage Mutant Ninja Turtle you relate to most, you don't answer, "I root for all shelled reptiles trying to make a difference in their communities." You give yourself permission to say you're more Michelangelo than Donatello. You owe it to yourself to embrace what you love about teaching and who you are as an educator. Stop comparing yourself to other educators or romanticizing what teaching is. See the hard human work that comes with being an educator and own what that

work is for you. Ask why teaching is your tattoo. Students deserve you. Colleagues and coworkers deserve you. You deserve to be a human being while you're working in the business of human beings.

I have seen the life-changing power of bringing authenticity and humanity to the work, of letting students know that you work at it, for them, because that's who you are. The word *teacher* is becoming less and less monolithic, as is how we live that word. More and more, we're seen as human beings who choose to educate rather than just educators. It's a distinction that I lean into. I am a better teacher because I carry pieces of who I am into the work like tattoos. I have never seen more student engagement, connection, and success than in the years since I made the conscious choice to wear who I am out loud as part of how I teach. I am better as a teacher because of who I am as a person. And so are you. Sometimes the trickiest part is just allowing yourself the perspective and grace to see that who you are is one of the most powerful tools you have when you're building how you teach. It's gospel truth, I promise you: The best part about you as a teacher is that you are you. Period. Full stop. Big facts. Everything else is a matter of how you're going to bring who you are into the work.

And bringing who you are into the work benefits your own mental health and self-image. You don't need to compartmentalize who you are for the sake of your work. The two can become symbiotic, the self and the work growing together in value and expanding how we see both. Your humanity provides the benefit of experience and perspective beyond curriculum and textbooks. Possibly the biggest benefit, though, is connection. I believe that kids can't learn from people they don't really know. If they don't really know you, they'll struggle to connect with and understand you, so they'll struggle to learn from you. They deserve to understand what motivates your perspectives and pedagogy. They deserve to feel safe with you and see themselves in you. They deserve to feel like they are learning beside you rather than bowing to the smoke and mirrors of some great and powerful Oz.

Thirteen is a meaningful number in tattoo culture. It represents choice. Some get the number thirteen tattooed because it's lucky, others because it's unlucky but choosing it defies luck and embraces empowerment. We're going to embrace a lucky thirteen chapters together. Each will echo different tattoo-related metaphors for who you are as a human being and educator. We'll look at a lucky thirteen ways in which teaching can be your tattoo, a lucky thirteen moments where you can walk into work feeling more yourself than ever. You are the canvas, you are the artist, you are the opportunity.

I can't wait to take this journey with you. The more you fall in love with who you are and the stories and experiences you've earned as an educator, the more you allow yourself to fall in love with the incredible things that you bring to the table. This will help you wear the stories that make you who you are out loud like a tattoo, encouraging people around you to do the same. Let's turn some blank canvases into works of art together.

Teaching is a tattoo because people might never understand why we choose either, but we do, and that's powerful

People often ask what motivates both my tattoos and my teaching. Love it. People should care enough to be curious about each other. I don't personally understand why anyone straps on a parachute and throws themselves out of a perfectly good airplane at ten thousand feet, but I'm genuinely curious about what motivates their choice. I don't personally understand why anyone chooses to watch horror movies either. Scared is not a feeling I choose to pay money for. Give me a rom-com where the scariest thing is the acting and plot holes, but tell me why you choose the horror movie experience. Choice makes the world go round (scientifically—the world goes around because of inertia, but my choice is always metaphors).

There are over eight billion humans on our planet, and we're not unanimously on the same page about anything. Not parachuting or movies or even metaphors. We're in this beautiful position where

each life is unique. We get to make choices and live the experiences of those choices. Choice is power. There are many ways to play through the original *Super Mario Brothers*, and they only had eight bits to create experiences with. Imagine the myriad ways humans can play through their lives. We've chosen to spend parts of our playthrough as educators. Bold choice. There are currently ninety-four million humans planetwide registered as teachers. Counting support staff, custodians, bus drivers, and volunteers, that's still less than 2 percent of everyone alive. The other 98 percent of your planetary cohabitants won't really understand your choice to teach because something inside them is telling them to choose to be things like social media influencers, chefs, dental hygienists, theme park mascots, or balloon animal artists. Among almost infinite other possibilities.

As a kid, I wanted to be a marine biologist, caring for wildlife and their environments, which is kind of what I do as an educator, only less waterlogged. I work to learn about creatures, their adaptations and unique needs. Some are colorful and need to be noticed, and others need to blend into their environment. Before the marine biologist idea, I wanted to be a reporter. (I was even a kids' news reporter on local cable TV. Seriously.) Before that, a detective. Now I constantly lose my own phone. I was lucky that every time I shifted gears, I had the privilege of grown-ups telling me I could achieve anything. I had full support when I went to university planning to become a psychologist. It wasn't until I finished that first degree and told my friends and family that I was inspired to become an educator that they raised eyebrows and asked, "Why? Are you sure?" I was sure. I still am. But I understand now why it was the first time that support was conditional—that it depended on me knowing my why.

Being an educator is a unique commitment. Even though there's a bell that rings to end our days,

our days never really end. There is no separation of the wonderfully human pieces from the mechanics of the work. We take who our students are home with us. We take home struggles, stories, triumphs, moments. We wear them like tattoos. When I graduated, some of us newly minted educators toasted the moment. Someone raised a cup and said, "Here's to being done!" I added, "I think it's more like 'Here's to choosing a path where we're never done!'" It felt wonderful starting in a profession where, if we do the work right, it becomes part of us and we become part of something far bigger than ourselves. Something potentially infinite. Later, at a BBQ thrown by family and friends who wanted to celebrate my graduation with sheet cake and dips, I had a conversation with an electrician friend of mine. He started a lot of sentences with "I could never," listing reasons that he felt education couldn't be his path. He felt he could never bring all of that baggage home, that he could never handle a full day of dealing with little humans. I said, "Dude, you have three kids." He answered, "Yeah, and I love them, but I could never deal with my own three all day, let alone a class full of other people's kids. Working with high voltage seems less dangerous. Why do you do it?"

I love that question. I get it often. But my favorite time was when I got it from students. We have a rule in my classes where if someone has an epic question, we pivot like Ross moving the couch on *Friends* to pursue that curiosity together. I was drawing low-quality pictures on my whiteboard to explain behavioral adaptations and asked, "Any questions at all?" As an educator, you'll understand the rookie mistake I made by inviting "any questions at all." But that's part of the fun of teaching: constant surprises. A hand went up.

"How do I say this . . . Why do you do this? You could be so many things, why be a teacher?" Thoughtful. Respectful. Legitimate question. I paused too long and she thought I was upset. "I'm sorry! I didn't mean to sound rude, I just know you said all curiosity is valuable and you ask about our lives because you care, so I wanted to know why you like to teach because it's obvious that you like to teach, anyway, I'm sorry." Pivot.

"Stop. Everything."

And they did. I explained that we needed to shift gears because that was the kind of question worth answering well, a question so good that it would be wasted if I was the only person answering. Instead, we evolved the question together into "What is something you *choose* to be?" We had a spectacular debate about whether being a brother or sister was a choice since you could choose to ignore a sibling or choose who you consider family. We had a brilliant chat about whether being a student was a choice. We figured, yes, legally you had to physically be at school, but engaging in learning by pursuing curiosities, accepting challenges—those are all choices. We knew the difference between choosing your location and choosing your actions within that location. This unintentionally became my answer to the original question.

"This is why I choose to be a teacher. Because I learn with you and about you. I learn about myself. I get to spend time with people who can take a question like 'What is something you choose to be?' and fill the room up with powerful, meaningful, unique answers. I do this because we get to be part of each other's stories." That is why teaching is a tattoo. Teaching and tattoos are both variations on storytelling. A creation of space for voice. They are an invitation to interact with and become part of each other's experiences. Teaching and tattoos are synonymous because some people will never fully understand why we choose to do either, but I do, and so do my students.

We could choose less public (and sometimes less painful) ways to do something memorable and permanent. But teaching is a tattoo because I know when people see my ink or ask about my chosen profession, sometimes it's because they don't understand what they haven't experienced. It is impossible to show someone else all of what fills up the empty spaces in between your atoms. But when you choose teaching or tattoos, you choose to take a personal, powerful, and meaningful step, saying out loud to the world, "This is me. This is why I do what I do. This is what makes my empty spaces whole."

INK-THINK-ASK

To harness that power of owning your unique motivations, each chapter will feature a section I call Ink-Think-Ask. It will challenge you to own the things you're proud of as an educator. I'll ask you to be honest with yourself and then to push a little further because the humans around you deserve *you*, and that takes honesty and self-reflection. You'll get to use this section of each chapter as a reflective safe space, and then you decide how to go further with that reflection. If you want to integrate what you reflect on into your practice and build that quiet confidence, you do you. If you want to take what you've reflected on and shout it from the mountaintop so that people know you as an educator on a deeper level, you do you. All of this, just like tattoos, is about authentically highlighting some of the stories that fill up the spaces in between our atoms. How you choose to own teaching as your tattoo will be as beautifully unique as you are.

★ INK

I'd like you to draw a tattoo. I want you to ask yourself the question "If I had to get a tattoo to show the world why I choose to be an educator, what would that look like?" Now, before you argue that you're a terrible artist, that even your stick people look like sick people, I'm going to tell you what I tell my students: Trying is fun if you let it be. Let yourself have fun trying. Plus, as the great Bob Ross once said (in a quiet and soothing voice), "People say, 'I can't draw a straight line'—that's baloney. 'I don't have talent others have'—that's baloney. Talent is a pursued interest. Anything you're willing to practice, you can do." There is no prerequisite of talent

here, just enough interest to pursue what these tattoos that you draw might show you about yourself.

★ THINK

Now that you've shown how teaching is your tattoo, I want you to reflect on a few questions based on what you've created. Be specific and honest. Dig deep. I'd like you to actually write your reflections down. It is next-level ownership to solidify things in tattoo ink or pen on paper. Own why teaching is your tattoo.

- ★ Looking back on the Ink section, if you had this tattoo and someone asked about it, how would you explain it in terms of your choice to be an educator?
- ★ Do you think you show this choice through your work as an educator? How do you show people that teaching is your tattoo?
- ★ How do you feel about this tattoo as a representation of your teaching? Proud? Inspired? Motivated to change?
- ★ Would you ever actually get this inked? Why/why not? Where would you put it and why?

★ ASK-TIVITY: "TAPE GHOST" TATTOOS

Now for activities you can immediately and easily take into a classroom or staff meeting! My favorite educational books have things that can be used the next day to empower and electrify pedagogy and classroom communities. And I'll be offering you activities like that in every chapter! This activity directly relates to your reflection in this chapter, which will allow you to create space for students and colleagues to have a similar reflective experience. I like to call these ASK-tivities, because they're activities built to take the reflection work that you've done and ask others to do similar reflective work.

This activity is designed for grades 3 to 12 as well as staff (but modifications to make it inclusive of all learners are upcoming!). There will also be next-level options. These tattoo activities are all

designed to be flexible and easy to implement with minimal prep and resources but maximum engagement and impact.

Step 1—Prepare Resources: You'll need a piece of blank white paper for each participant. You'll also need markers, pencils, crayons, pastels, whatever you've got!

Step 2—Instructions: Tell your participants this page is going to be their tattoo. The question we want participants to answer with their design is "What is something you care enough about that you would wear it in public, every day, like a tattoo?"

Here are some discussion questions that will help them figure out their answer:

- What does it mean to care about something?
- What kinds of things do people care about?
- How do we know that we care about things?
- How do we show that we care about those things?
- How do you think other people show care for you?

Then have participants brainstorm a list of things they care about—as many as possible. Set a time limit. After, have them look over that list and use it to inspire their tattoo design.

Step 3—Create! Once participants start drafting, walk around and ask them about the stories behind their work! This will help ease them into the idea of sharing their creations.

Step 4—Sharing Is Caring: Once participants have drawn their tattoos, it is essential to share them. When people take the time to put something they care deeply about out there, they need to feel their thoughts and feelings are valued. Depending on your community, you can try the following:

- Give every participant in the group time to share, which has the added bonus of engaging them in oral storytelling.

- ★ Create a visual display of these tattoos, like a tattoo wall. I've had participants also do brief write-ups so that everyone walking by can learn their story.
- ★ Go next level with a visual art piece. With proper permission, I've had henna tattoo artists from the local community create temporary tattoos on participants. I have done the same with face paint. I've also had participants make what we call *tape ghosts*. We use packing tape to create false arms or legs based on participants' own, then we draw their tattoos onto those physical representations of their bodies, which we then turn into beautiful public displays. Important: Ensure the sticky part of the tape is facing away from the skin for the first layer; the next layer sticks down on that one. Otherwise, ouch!

You can modify these activities by modifying the question. For example, I ask younger students to take their paper and *draw* something they care about (instead of brainstorming a list). In my experience with younger learners, it is important to have a chat about the difference between some*thing* that you care about and some*one* that you care about. It makes for much more diverse work!

These "tape ghost" tattoos were created by grade 7/8 students.

THE CANVAS WE ARE

In this section of each chapter, I'll show you real tattoos worn by teachers, innovators, administrators, authors, and humans who choose education like you do. You'll get the story behind them and, hopefully, this will inspire you to seek out the stories of the incredible human beings around you. That's part of the reason I love tattoos so deeply: they invite you into the stories that a human being carries and values. The more you know about a person, the more you care about that person and the experiences that took them from blank canvas to work of art. So often in my life, I have asked someone the story behind their tattoo and, in listening, I have gained a deeper appreciation and understanding of the human beings in those stories. I believe wholeheartedly that you love a person a little more with each story you learn about them. Exploring these real tattoos worn by real educators will relate directly to your teaching work. You'll see the stories that make your students and colleagues who they are, and you'll be inspired to create space for others to see these stories.

So, let's look at some tattoos. Like mine, for example!

My tattoo is braided sweetgrass. As an Indigenous person, I find deep cultural meaning in this design. Sweetgrass is one of our sacred medicines. An elder once told me that human beings can choose to be mino mashkiki (which is Ojibwe for *good medicine*) for each other too. This tattoo reminds me to always choose to be good medicine for people around me.

We'll also shine the canvas spotlight on . . .

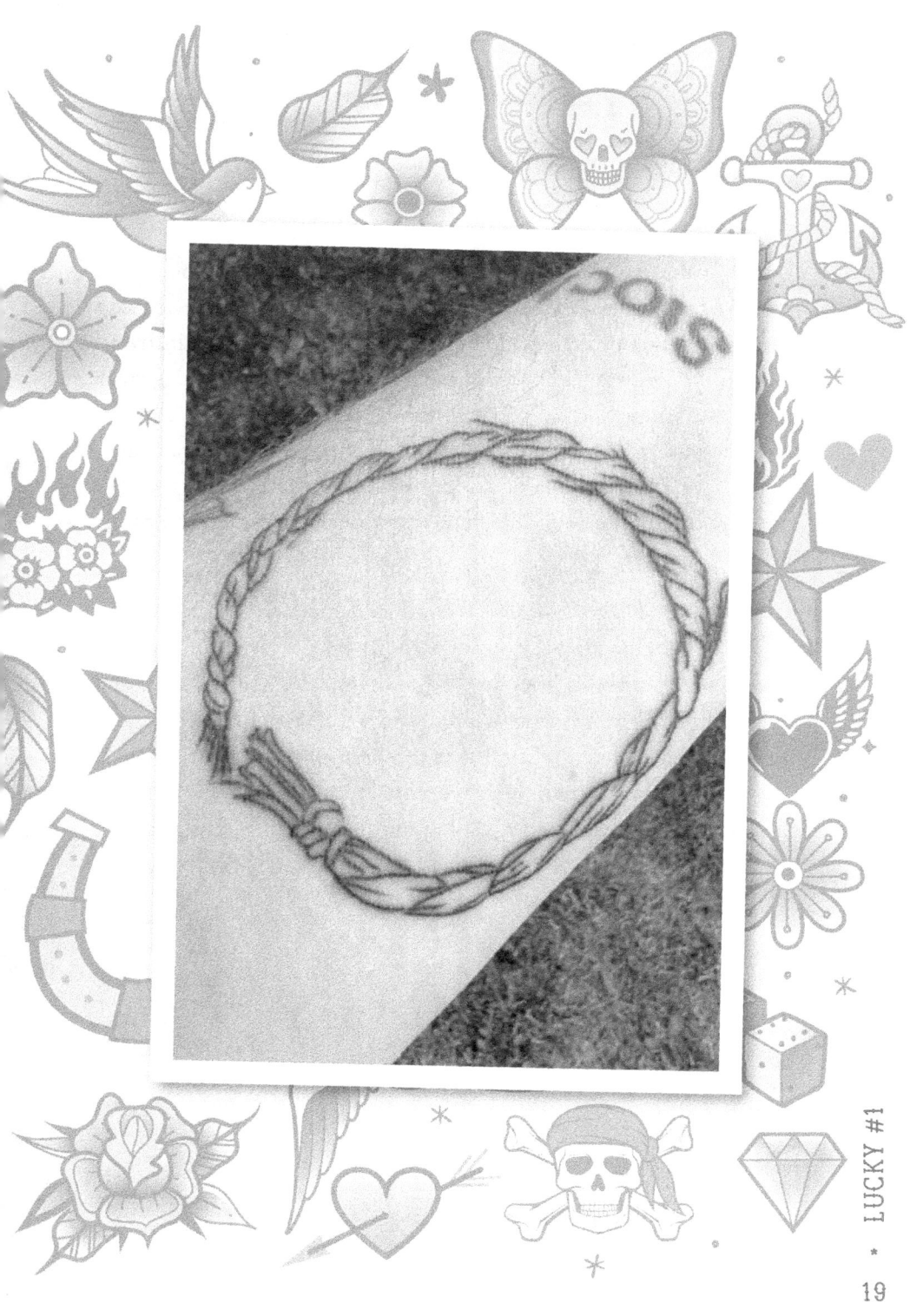

Andrea Trudeau

Middle School Educator and Librarian
Chicago

Andrea Trudeau, MSEd, NBCT, is a human-centered, no-"shh" librarian with twenty-six years of middle school teaching experience. Andrea's boundless curiosity led to her pursuit of a PhD in instructional technology at Northern Illinois University, where she is currently researching the effects of cinematic virtual reality on adolescent students' empathic responses. Additionally, she serves as a board member for Tanzania Development Support, which is dedicated to investing in community-identified educational projects in the rural Mara region.

> This is my tattoo. *Sunshine* was a nickname I earned at the age of two, having brought joy into my parents' lives during a time of immense grief and darkness—after the tragic loss of my baby brother, who was stillborn at seven months. Over four decades later, when I was teaching in rural Tanzania and Kenya as a Fulbright-Hays scholar, I was deeply moved when my students began calling me Jua, which means *sun* in Kiswahili. This tattoo serves as a reminder to be the light.

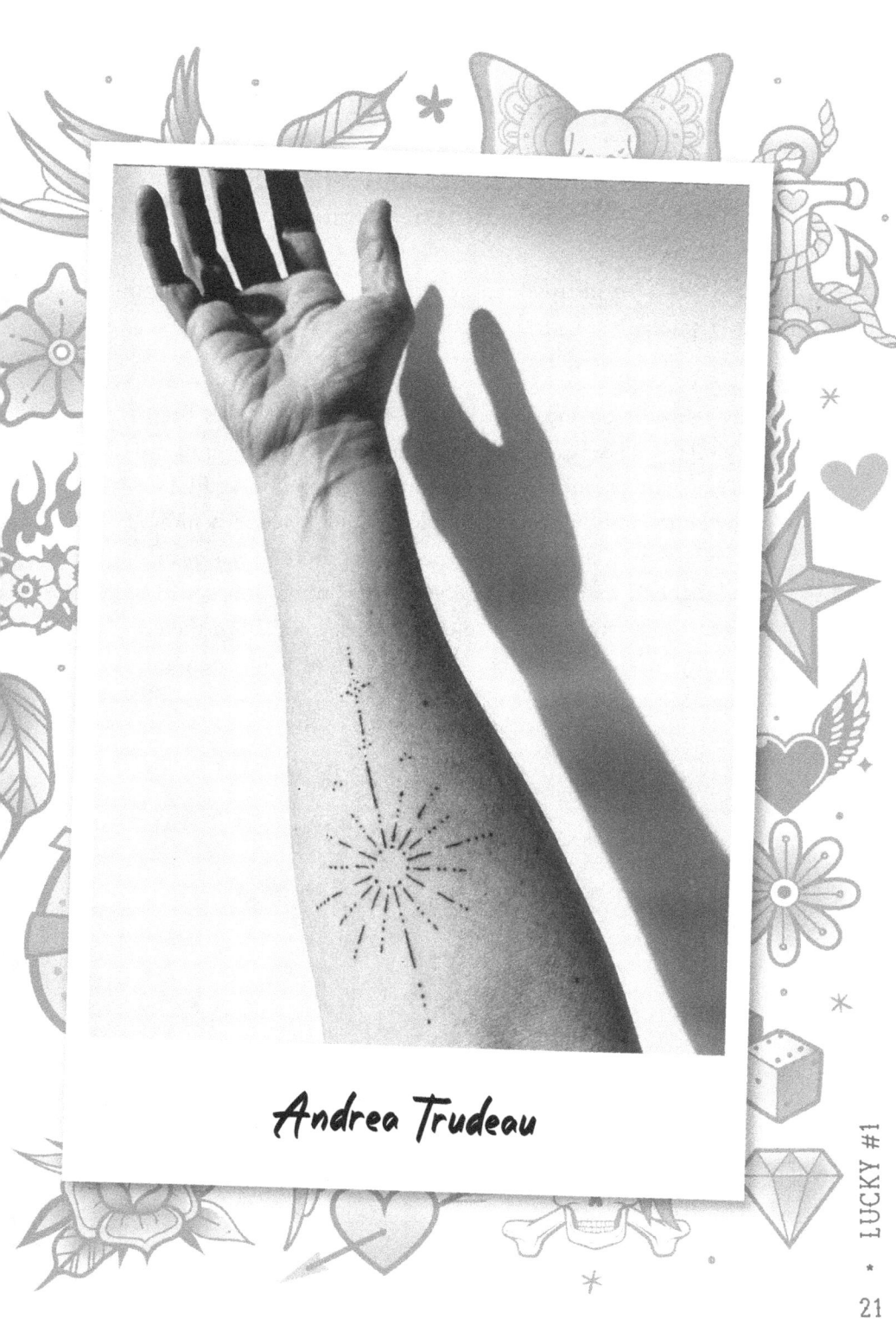
Andrea Trudeau

Jennifer Ives

Instructional Technology Specialist
Virginia Beach, Virginia

Jennifer Ives is an instructional technology specialist from Virginia Beach, Virginia.

My tattoo is on my right ankle. My dad has always been my biggest cheerleader. We lost him to COVID in January 2022, right before my first national presentation at FETC (the Future of Education Technology Conference). My mom threw me on the plane, telling me how proud he was of me and that he'd want me to go. A year later, I was again presenting at FETC, this time in New Orleans. I was born there, and my husband and I both got fox tattoos while we were there. My maiden name is Fox.

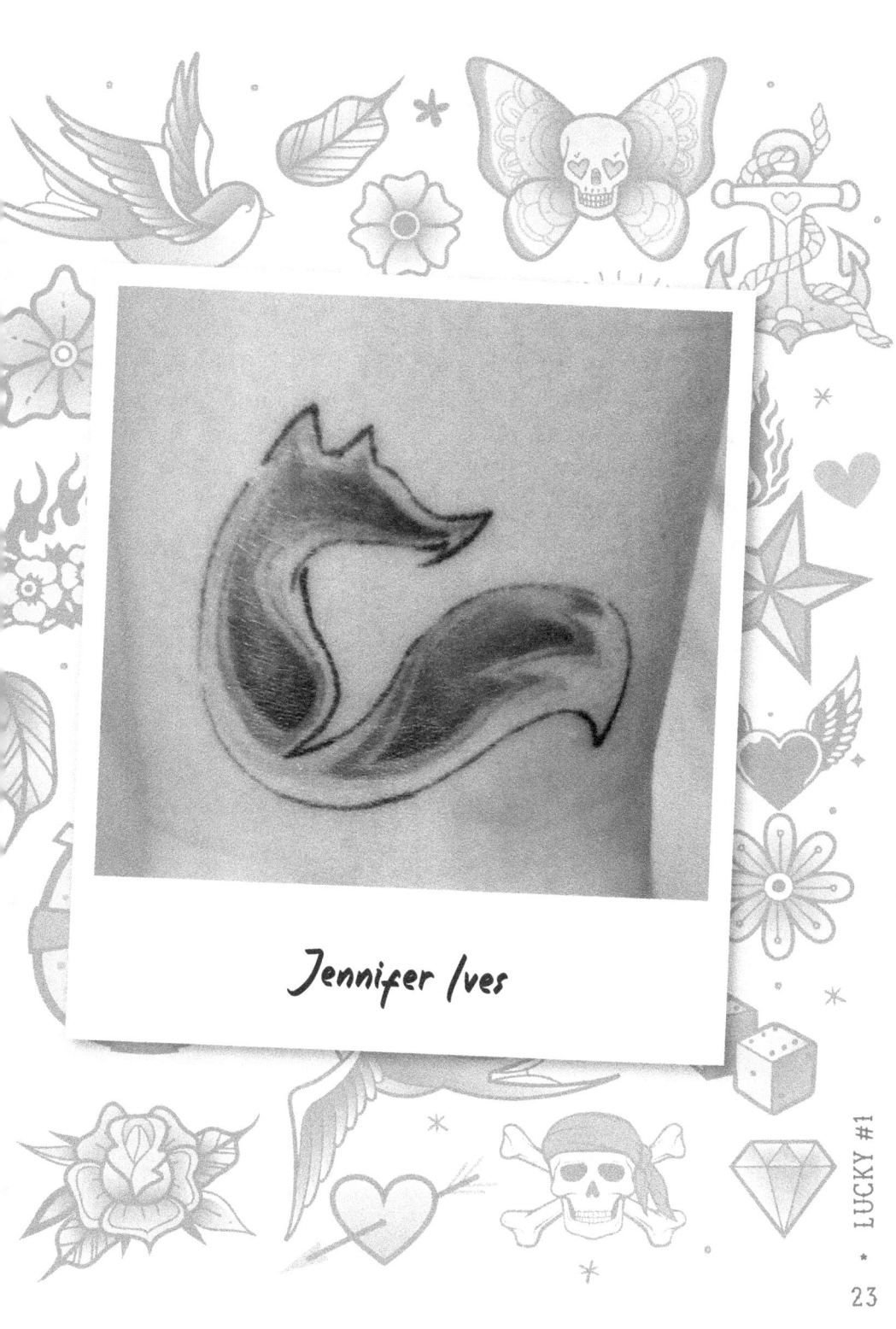

Nelann Bateman

Educator and Educational Consultant
Colorado

Nelann Bateman is a dedicated and innovative educator turned creative consultant with extensive experience in Spanish language teaching, technology integration, and English learner (EL) development. She spent sixteen years in education in Louisiana as a world language teacher, ed-tech trainer, and EL coach. She is a proud alumna of Clark Atlanta University and is currently partnering with nonprofit organizations to train individuals on engaging with multilingual learners through inclusive and assistive technology tools. She's the founder of her own creative consulting business, NBC (Nelann Bateman Consulting). You can find her on Instagram at @NotJustaClassroomBlog and on X at @ladylanguage411 and @MIEE_Louisiana.

For my fortieth birthday, I went to Florida, where I got a tattoo. Why Florida, and why at forty? Honestly, I'd always wanted a tattoo, but I knew they were forever and whatever I decided upon needed meaning. Taking off work for a birthday getaway almost gave me a panic attack—that's something educators don't do. We don't know when to take breaks, but we encourage others to. I left anyway, after my mom told me to get away. The school would be there. Work would be there. But I would only turn forty once.

My friend/family, better known as "Fram," was headed to Florida with her daughters, and I tagged along. I'm so glad I did. We stayed in a fancy hotel, took a yacht ride, and my sister-in-law surprised me and the girls with dinner miles away from home! The weekend was awesome.

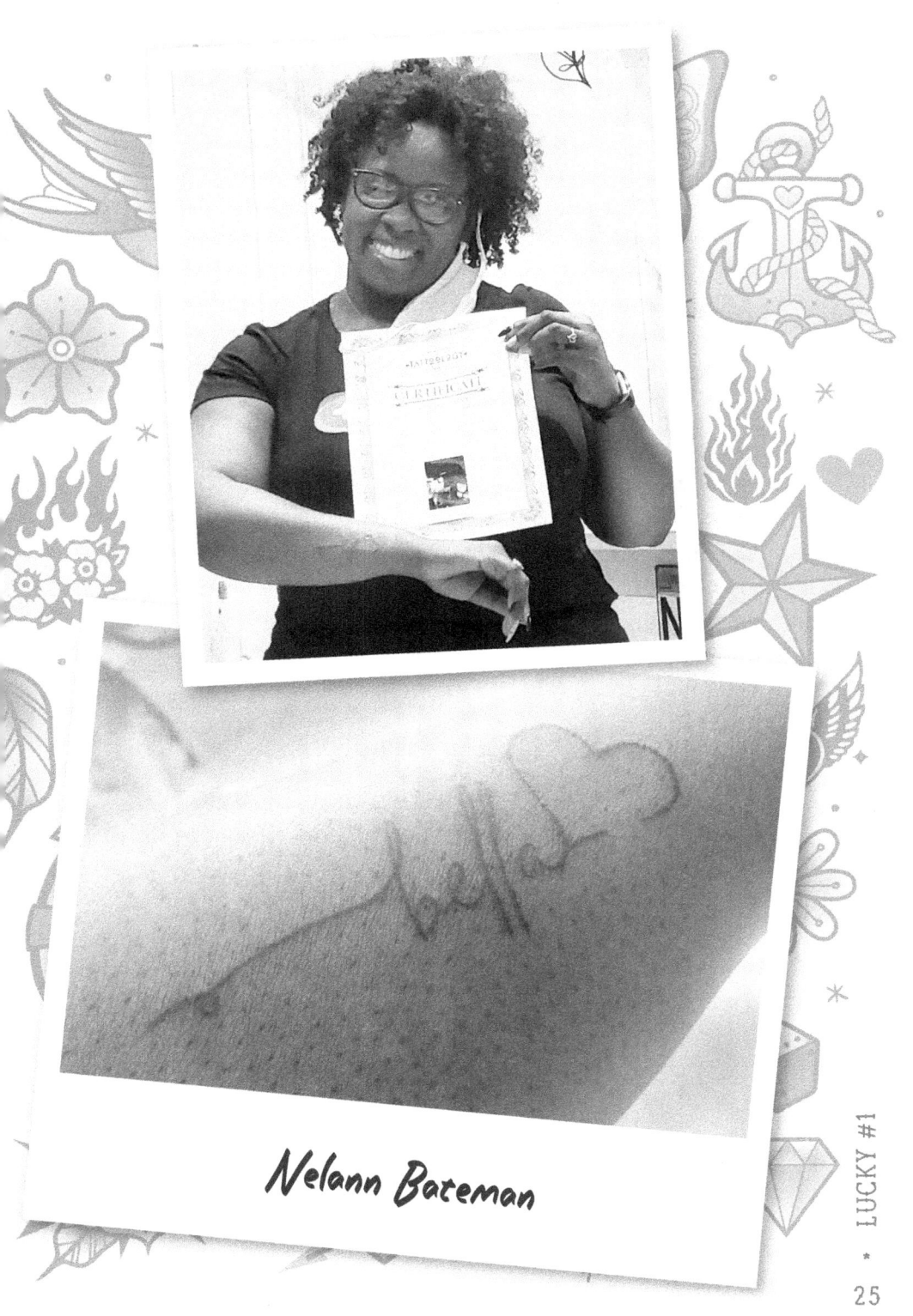

Nelann Bateman

I already had the idea of getting a tattoo in my mind, but I didn't know where to do it. What happened felt like Kismet. I found a place on Instragram. "You're walking around and taking buses like you know where you're going," my friend told me. I was ready. We took two minibuses and walked the rest of the way, and there it was. We walked in, and because I heard Spanish, I began speaking in Spanish. The tattoo artist greeted me, and we talked about my ink. I wanted something outwardly to remind me of who I was inwardly: beautiful. God's creation, made in his image, the apple of his eye. And so, "bella" was it. I love hearts, and when the artist said he could attach one to the end of the word, it was an easy sell. We sat down and looked at fonts and designs that he'd drawn, and I made the decision to go forward. My friend was supposed to get one too that night, but because I had her out on the bus and walking all day, she fell asleep at the tattoo shop!

Micro Motivator

Micro tattoos are a tattoo style. The aim is to create a full tattoo story in less than an inch! As the last word in every chapter, I will leave you with a Micro Motivator—a chapter-specific miniature pep talk that will encourage you to "wear" the chapter's message to work the next day. Here's our first one:

You are the only person who will ever know all the stories tattooed in between your atoms. The same is true for the stories that create every person around you. Be the reason that your stories and others' stories are valued and seen.

Teaching is a tattoo because both have permanent impacts, so both should be taken into real consideration

People often point out things that make them feel old like it's a bad thing. Honestly, I love it. The day I dropped my eldest off at her first day of high school, all the other parents were crying over their babies growing up "too fast." But I had this feeling of excitement and thankfulness. I was thankful that I had lived long enough to be part of this next chapter, and that I had lived well enough as a father for her to want me there. All right, I also cried. But I stand behind the moments of joy in feeling old. Every creak in my bones, every aching muscle is earned through lived experiences. I wouldn't give a single moment back in exchange for fewer gray hairs. Wrinkles are badges of honor. Feeling old can be an important reminder that we are finite, while both teaching and tattoos can be important reminders that, despite our finite nature, our impact is lifelong.

Here's another harbinger of my advancing age: I don't love going to the mall anymore. I practically lived there as a teen. I had my first job there. Now, because I'm old, the mall feels a little loud for me. But I go, mostly to add to my sneaker collection and scratch my head at current fashion trends as I pay for the new clothes my kids choose. There was one mall visit in particular that made me feel wonderfully old. I have gotten used to seeing tiny former students all grown up with facial hair and jobs of their own. It feels like a big win when they slide their employee discounts onto my purchases while we reminisce about our good old days together. There are few things more delicious than discounted donuts and nostalgia. But I will never forget how old I felt the first time a former student introduced me to their own children at the mall.

It was the perfect storm of feeling elderly. I was trying on shoes, considering arch support, when the person beside me noticed who I was. We had that spark of mutual recognition and he dove in for a hug. One of his kids asked, "Daddy, who's that man you're hugging?" Fair question. He answered, "Sweetheart, remember the joke I tell you whenever you have an apple? I say, 'What's worse than finding a worm in your apple?' And then I say . . ."

"Finding half a worm!" She interrupted in a minuscule voice, then proceeded to lose herself in tiny laughter. "Wait, *this* is your teacher that made up the apple worm joke when you were a kid?"

He and I exchanged glances and smiled, knowing full well that I didn't deserve the credit for writing the joke. But it meant something that one of the many, many awful jokes I had told over the years had become not only part of this student's memories of school, but had also found a place in the home life and history of his own family. And that wasn't even the best part. As my former student finished helping his daughter try on shoes and they gathered themselves to leave, the little peanut turned and said to me, "You were right." We all looked confused, but she forged ahead. "You were right about my dad being good at stories. He told me that he used to write lots of stories in your class when he was little because you told him he was good at stories. I

know he's really good because he makes up stories for me at bedtime, so you're right." That led to another, longer hug between my former student and me, some high fives with his exceptional kiddos, and me walking to my car with new shoes and new perspectives. If I hadn't been sneaker shopping that day, I would never have understood the impact my bad jokes and positive reinforcement had. A passing positive word about this student being good at something in my class had tattooed itself into who he was. So yes, I felt old seeing a student with kids of his own, but I also felt like the years I had lived were spent well. My words had impacted a life. And it was a great excuse to keep shopping for new kicks while reflecting.

The permanence of our impact is something we can see every day if we give ourselves the gift of making time for it. We see our impact in student smiles and progress. It can be heard in kids and colleagues alike—in how they trust you and the space you've made for them to share their stories. Just like tattoos, we become parts of the whole of who they are. If we're being honest with ourselves, sometimes our impacts can be less than positive. Moments of frustration and negativity on tough days can echo. We're perfectly imperfect, and that's the human reality of us. Owning the imperfect allows us just as important a perspective as embracing the positive. Each human being is an absolute work of art. Looking closely, we can see each brushstroke that we helped them to paint with, whether it was perfect or imperfect.

All of it becomes a permanent piece of their story, just like a tattoo. We take up residence in those irreplaceable empty spaces between their atoms. Alice (while adventuring in Wonderland) said it best: "It's no use going back to yesterday, because I was a different

person back then." We're always changing, just like the people we interact with. Knowing that, we owe it to others to consider our impact. Remind yourself often that you are a character in the stories they live, your voice offers tone and context to the soundtrack of their memories, your words give perspective when they look at themselves in the mirror. In turn, the humans you interact with as an educator will tattoo themselves on you. Remember this and act on it.

Make your work as an educator into something worth wearing, worth that valuable finite space in the fabric of others' experience. Be mindful of the permanence and power of your choices. Remind yourself that you are not Marty McFly. No eccentric middle-aged scientist is going to appear in a flash of light to take you back in time in a scientifically modified two-door sports car. Doc Brown knew how incalculably powerful little moments can be, how far reaching their ripple effects are. You have so much more than 1.21 gigawatts of power in that mighty teacher's heart of yours. It is enough to carry the weight of those moments. Minutes become hours, which grow into days, which flourish into years and lifetimes made up of those little moments we hardly realized were happening until they were part of us.

Tattoos stay permanent because the ink is injected into the dermis, the layer below the epidermis, which is the outer layer of our skin. What we do as educators goes beyond the surface level, deeper than the outer layer. As educators, we should care more about writing our obituaries than our résumés. I don't mean that morbidly; I mean that when all is said and done, the titles of our work will be less important than what that work helped create. All our years of life will be just a hyphen between the year of our birth and the year of our passing. What happens in that hyphen will be our legacy. If we embrace the permanence of our impact, then tattoos and teaching become synonymous through how we consider them. The sincerest hope of my tattooed life is that I will live long enough for my grandkids ask about my tattoos, and that I will feel the same pride telling them the story of each one that I felt the day that I chose the designs.

The sincerest hope of my educator life is that I will live long enough to run into more kids of my former students in the mall, and that I will feel the same pride telling the story of impacting their lives that I felt the day I chose to make that impact.

Welcome back to another thrilling edition of Ink-Think-Ask! We're back to challenge you to own the things that you're proud of as an educator!

★ INK

Let's draw another tattoo. I want you to ask yourself the question "If I had to get a tattoo that shows what I hope my legacy will be as an educator, what would it look like?" Then I want you to get creative. (Remember, there are no right or wrong answers, only honest ones.) So think deep here: After you finally take your well-earned retirement, what do you hope the tattoo of your legacy looks like?

★ THINK

Now I want you to reflect on a few questions based on what you've created. Again, I'd like you to actually write your reflections down because ink has the power to make thoughts tangible. Own why teaching is your tattoo.

 ★ Tattoos put big ideas into small spaces. What words do you hope your students and colleagues use when they talk about you? (Which they definitely do.)

- ★ If former students saw you at the mall now, would they be excited to come over and say hi? What would they say?
- ★ Is there an educator you remember who made an impact on you? What made them impactful?
- ★ If you did have a time-traveling DeLorean and you went back and had lunch with yourself on your first day as an educator, what would you say?
- ★ Knowing that you won't have a hand in planning it, what are a few things you think you'll see or hear at your retirement party when you walk in and act surprised?

★ ASK-TIVITY: TEAM TATTOO MEMORY BOOK

Back for another scoop of activities that you can immediately take into the classroom or staff meeting! This again leans into the chapter theme, allowing you to create space and opportunity for students and colleagues to reflect on the permanent impact of their own choices.

This is a beauty of an activity that will allow both you and the participants to collectively reflect on the impact of the moments you share. Over the course of a chosen period, you'll be creating a shareable visual memory and reflection together. Just like a team tattoo! (I suggest committing a full school year to completing this activity, but it can also work over the course of a week or a month if you adjust your strategies.)

Step 1—Timing and Strategy: This activity is about cataloging the most impactful moments you share together, and that can look like a whole bunch of different things. If you're strong with photography and editing, that should be your weapon of choice. If you're strong with art or writing, that should be your go-to. You could make a scrapbook, a video, a collage, a billboard in your classroom, whatever fits for your team and target audience. How long you make the project will also impact how and when you collect moments.

Step 2—Collect Your Impactful Moments: Go time! If you've decided to collect moments once a week, then once a week, ask your

students or colleagues what their most memorable moment of the week was. If you've decided to do this once a month, adjust accordingly, and so on! Here are some moment-collection ideas:

- ★ Have participants do little drawings of their memorable moments and collect the drawings.
- ★ Have them re-create moments with tableaux, and photograph the tableaux.
- ★ Show participants pictures you've taken of your team learning and growing together, and then reflect as a group. (Take tons of pictures while you're together! It's the digital age, so go wild!)
- ★ Have them make little video clips of themselves telling the stories of their memorable moments and catalog those little videos!
- ★ Try building a moment totem. You take a stick and have participants add trinkets and rolled papers with stories and pictures on them, creating a decorated tree totem over the course of the year.
- ★ Create memory boards or walls in the classroom or staff area. Have participants add a variety of pictures, drawings, posters, and artifacts, all chosen together as a team to collectively represent your most memorable moments.
- ★ My personal favorite is getting white T-shirts at the beginning of each year and having participants add one little drawing a month. This adds up to a year's worth of visual memories that they can wear!

Step 3—Sharing Is Caring: Once you've made your memory "book" (in whatever form it takes), it is essential to share it with as many folks as possible. This is a phenomenal reflection for you as an educator, but it's also valuable for the community you serve—everyone can see the permanent impact being made. Luckily, your memory project has many possible take-home forms, meaning it can remain visible

long after the project has ended. An item of clothing, a video, copies of a drawing—whatever works for you!

Modifying this activity is as simple as taking the time to make it authentic for you and your crew. There's no wrong way to make this Team Tattoo Memory Book!

THE CANVAS WE ARE

Back in the tattooist's chair! This chapter we're spotlighting . . .

Jed Dearybury

**Educator and Professional Development Leader
Spartanburg, South Carolina**

Jed Dearybury began his education career in 2001. He was featured in *GQ* magazine as a leader of the year, he met President Obama as the South Carolina honoree of the Presidential Award for Excellence in Mathematics and Science Teaching, and he was named a top-five finalist for South Carolina Teacher of the Year. He was also the very first Milken Fellow from South Carolina in 2016. Since leaving second-grade teaching in 2015, he has been leading professional development across the country and training the next generation of educators through teaching in higher ed. He published his first book, *The Playful Classroom*, in June 2020. His second book, *The Courageous Classroom*, was released in July 2021. Book three, *The Playful Life*, was released in October 2022.

Back in 2003, I fell in love with *The Dot* by author/illustrator Peter H. Reynolds. I used the book in every class that I ever taught from first grade to college. In 2016, as the universe

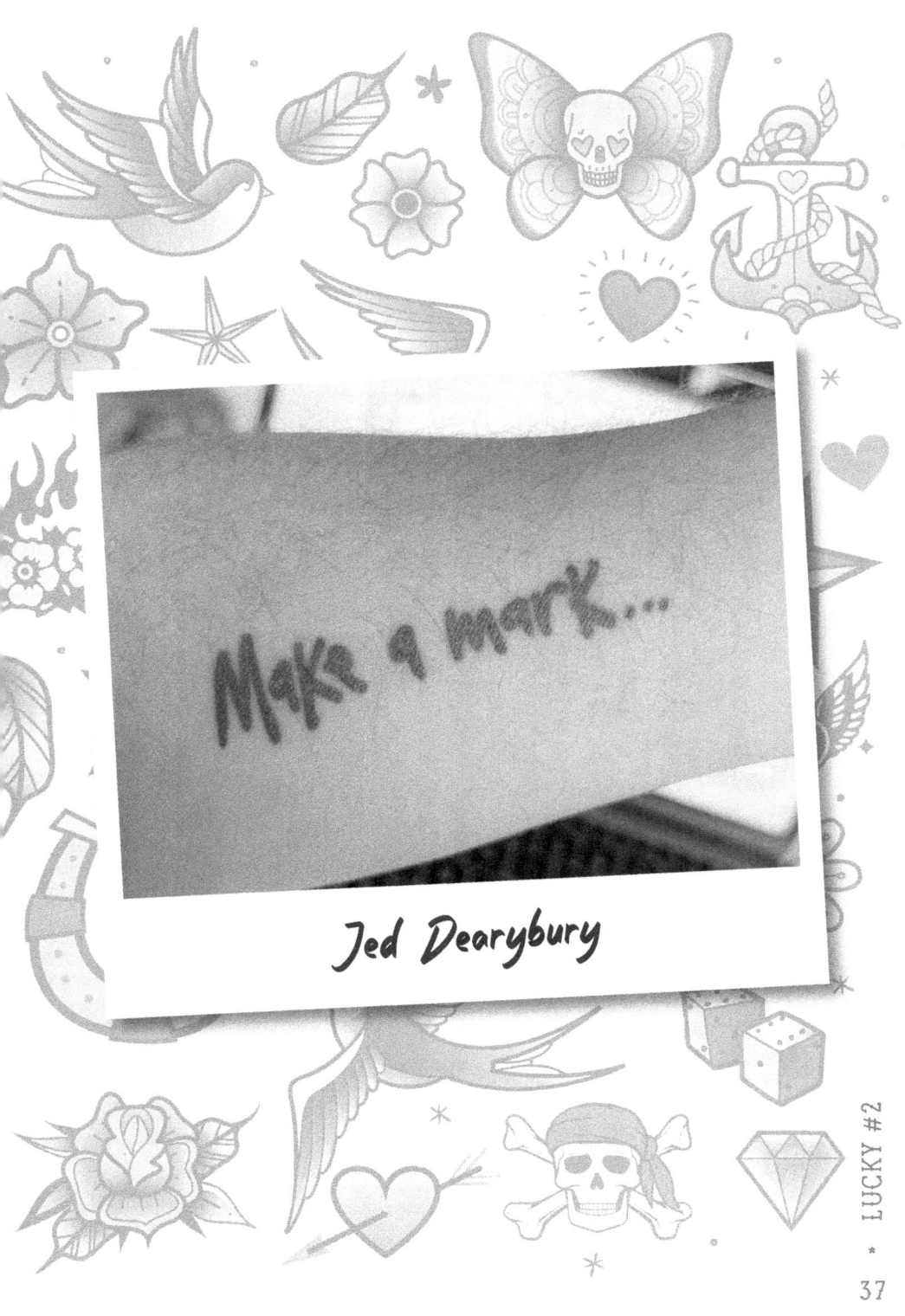

connected dots, Peter and I became friends through a random meeting at the ISTE conference. Our paths continued to connect throughout the next several years as I used his books in my professional work. In 2019, as I was preparing to publish my first book, *The Playful Classroom*, Peter offered to illustrate the cover. In 2021 as I prepared book three, *The Playful Life*, again, he illustrated the cover. So inspired by his work and the famous quote from *The Dot*, "Make a mark and see where it takes you," I asked Peter to write the words "Make a mark" in my journal. I took that to my tattoo artist, and within minutes I had a permanent reminder to make my own mark each day.

Chris Pirkl

ELA Teacher
Portland, Maine (Abenaki Land)

Chris Pirkl has been teaching English language arts for over seventeen years in Maine, mostly in middle school. He loves sharing his passion for reading and books with his students.

> We dealt with infertility and eventually became parents through fostering and adopting our daughter via that process. When we were trying to conceive, we made a deal that if we weren't parents by a certain deadline, we would get tattoos. The deadline passed and I began looking at designs. While I was agonizing over what I wanted permanently inked on my body, we began fostering our daughter. That helped me figure out what I wanted my tattoo to represent and I

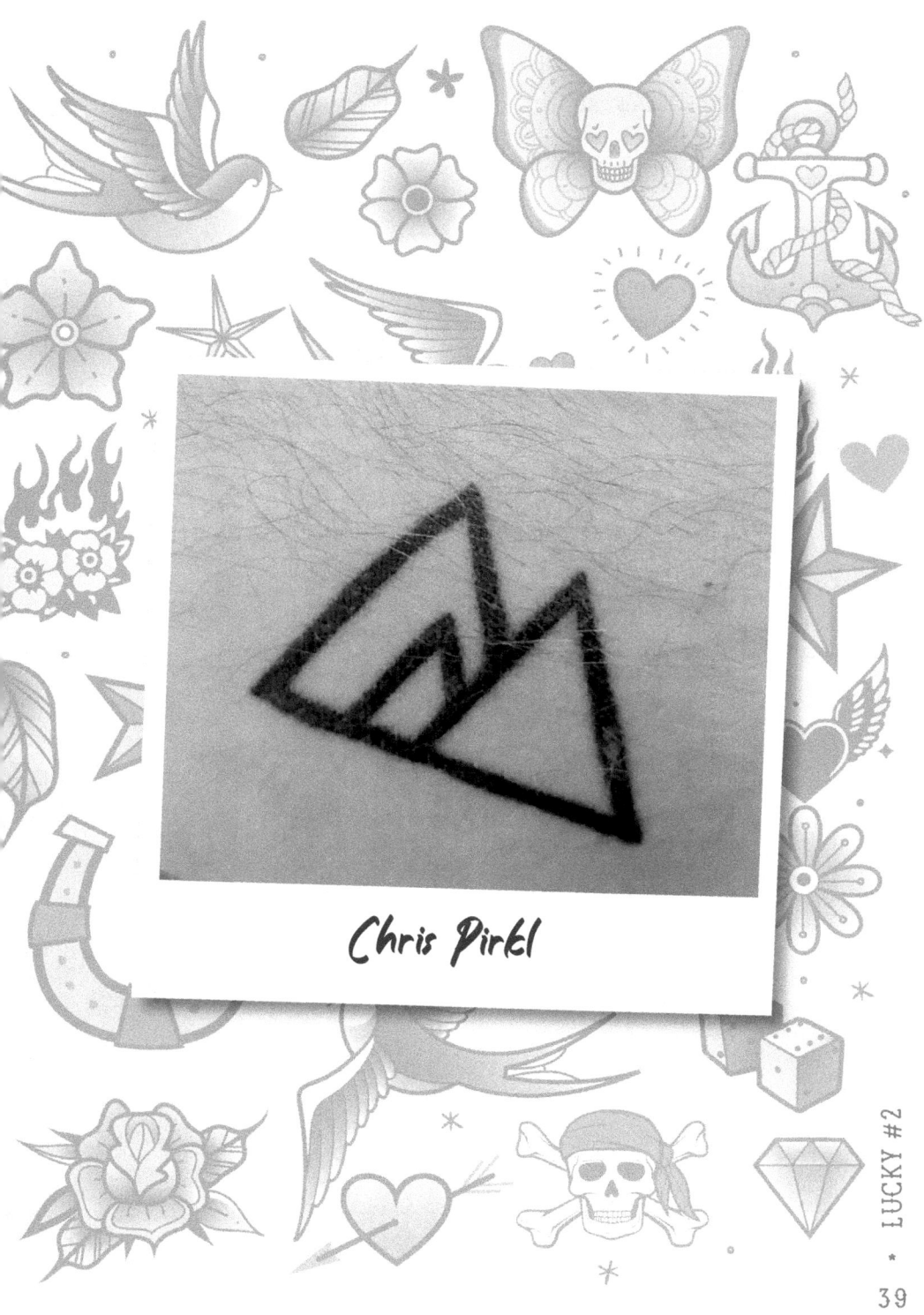

landed on the triangle design. The three triangles represent the three of us: myself, my wife, and my daughter. When she was little, she would point to the smallest one and say, "That's me!"

The triangle is a symbol of change, it is one of the strongest shapes, and the mountains the three triangles form represent challenges overcome. This additional symbolism is why I chose the design. Placing it on my forearm puts it in my field of vision constantly, reminding me of the work that went into becoming a dad and allowing me to maintain perspective of my priorities.

Micro Motivator

Your existence will change someone else's existence daily. That's science. Own that, and make sure that big or little, you're proud of the permanent impact you have.

Teaching is a tattoo because both are a point where deep traditions meet modern styles and approaches

I don't have that much in common with Ötzi the Iceman—the mummified corpse of a man who was killed by an arrow to the back on the Austrian/Italian border of the Alps in 3230 BC, only to be discovered frozen facedown in ice in 1992 by German tourists. In fact, one of the only things that we have in common is tattoos. Even so, I only have seventeen tattoos, while he had a whopping sixty-one. Plus, one of his tattoos is a tribal butterfly lower back piece that says "Sassy Lil' Caveman," which is not a choice I would have made for my own collection. OK, that was clearly a joke, but the tattoos that people commit to are anything but. Fun fact: The cinema classic *Encino Man*, in which two high schoolers find a frozen caveman in the backyard while attempting to dig their own pool (so that they can host the most "killer party after prom") came out in 1992. That makes 1992 arguably the most significant year in frozen caveman discovery in our collective history. It was also the

discovery of Oscar-winner Brendan Fraser and a guy who everyone thought was dead but actually wasn't: Pauly Shore. If you have not seen *Encino Man*, that's now your homework, and you're welcome.

By all accounts, tattoos predate formal education systems. Ötzi's tattoos are the oldest on record at around 5,300 years. Yes, 5,300 years ago, he committed to something permanent for reasons we'll never get to know. Maybe we're more like Ötzi than we think. Tattoos and teaching are both choices that we carry with us. They're an essential moment in the story of who we are, but they are not the whole story of who we will become. Like Ötzi, we take on new permanent pieces, then we're off on an adventure through the metaphorical mountains, the ups and downs of life, wearing them too. We are the embodiment of the lived moments that make us who we are, that parallel the potential and growth of who we are becoming. We are agents of a system built on meaningful traditions and experiences but powered by evolution, growth, and exploration. Really, we are all Ötzi.

Teaching is a tattoo because we're doing work that is both nostalgic and innovative. We honor the past while continuing to evolve new methods, technologies, and social relevance. Both teaching and tattoos help us remember where we came from and to respect history while we change. And how we as a society view tattoos has changed so much. For a time, in some parts of the world, tattoos started out as a way to mark criminals, and the practice itself had tremendous stigma associated with it. And in some parts of the world, education was a system reserved for those with wealth and privilege. While these histories still echo, tattoos and education have transformed, so they represent social evolution. Perhaps the world once viewed both education and tattoos as being only for certain people, but these days, they are for all kinds of people—who have all kinds of reasons for wanting them. Honestly, both look great on a whole bunch of very different human beings. That's the beauty of teaching and tattoos. They remind us that without traditions and history, we have no structure to build on, but without innovation and mindfulness

of our ability to impact each other and the world, we stagnate—and what we do within our structures loses relevance.

Both teaching and tattoos combine old and new when it comes to the tools of the trade and the methodology of their application. My first days of teaching revolved around an overhead projector that glowed warmly as I wrote on its surface with dry erase markers, only to smear-wipe my notes half effectively with a Kleenex. Now, I have a slim, silent little high-definition LED projector mounted to my ceiling. And I used to have to take my students to a computer classroom full of boxy white plastic monsters so they could learn how to make dots on screens move slightly. Now many of my students have devices in their pockets that give them immediate access to all the collective information of human history—though most use it to take selfies. When I started teaching, I had to use textbooks that described Indigenous people like me with words we wouldn't say out loud anymore. Or we shouldn't, at least.

Stories need structure, or it's just rambling. Stories need voices to tell them, but those voices have to speak to an ever-changing audience. As an educator, you are carrying torches lit long ago while shining the light of that torch down new paths. Teaching is a tattoo because neither would exist without history and neither would be relevant without evolution.

Think about how much of your own life is a balance between the warm hug of remembering and the electricity of dreaming about what the future might be. You're a quilt of all the cartoons, toys, songs, movies, and commercials you've ever seen. But you've also chosen to be an educator, which means you have a responsibility to prepare students for a world evolving so quickly that you can't even imagine what they'll need to be ready for. You are a maestro balancing memory and the flint sparking the future. You're Disneyland. You're the embodiment of the nostalgia of Main Street and the fact that Walt Disney himself said that "Disneyland will never be completed. It will continue to grow as long as there is imagination left in the world." Take a look at your own practice and pedagogy. How much of what

you do with your learners reminds you of things you experienced in school yourself? How much of what you do is something new you're challenging yourself to try? How lucky are we that we get to be both the library of things worth carrying forward from the past and the drive to imagine something better?

Even the words *tattoo* and *teaching* show both history and growth. *Tattoo* comes from the Samoan word *tatau*, which came from the sound of teeth and turtle shells used to tap dark pigments painfully beneath the skin. Now, very few tattoo artists practice the old ways of tap, tap, tapping with teeth and turtle shells; instead, it's evolved into the buzz, buzz, buzzing of tattoo machines. The dictionary definition of *teaching* is "the act, practice or profession of a teacher" and, just like the practice of tattooing, teaching has changed with time. When you say the word *teacher* now, it conjures different ideas than it used to. And you can define yourself as a teacher loudly, in your own way.

Welcome to another electric edition of Ink-Think-Ask! We're once again challenging you to own the things that you would proudly wear about who you are as an educator!

⭐ INK

I want you to draw a tattoo that shows off your "then and now." If you're a seasoned teacher, ask yourself, "If I had to get a tattoo that shows who I was when I first started as an educator versus who I am now, what would it look like?" If you're new to the education game (welcome to the team!) ask yourself, "If I had to get a tattoo that shows who I am now versus who I hope to become, what would it

look like?" Be as creative as possible! Lean into metaphor and representation and remember this is about *you*, so bring the real you to this reflection.

★ THINK

Now that you've shown how your teaching tattoo encapsulates both your past and potential, I want you to reflect on a few questions based on what you've created. Again, I'd like you to write your answers out because ink has the power to make things that much more real. Own why teaching is your tattoo.

- ★ When you tell people "I'm a teacher," what does that word mean to you?
- ★ When was the last time you did something as an educator that you've never done before, and what was that thing?
- ★ What is something that you've carried with you as long as you've been an educator? Why do you choose to keep this as part of who you are?
- ★ What is more important to you in your work as an educator: tradition or innovation? And you're not allowed to say both! (I know the best answer is a combo of both, but asking yourself to choose one will be a great chance to reflect on what drives you.)

★ ASK-TIVITY: PAST MEETS PRESENT MEETS FUTURE

Just like the Backstreet Boys, we're back again, but instead of pop jams, we're here to offer more activities to immediately bring into your educational practice. They follow the chapter theme so that you can create space and opportunity for others to reflect in the same way that you've been given the chance to in the section above. Tattoos are, by their nature, a storytelling medium. Teaching is arguably a storytelling medium, too, and that's why I focus on making these activities easy to engage with using storytelling.

This is where art meets reflection, where representation meets expression, and luckily our activities are curriculum based, too!

Step 1—Accumulate! All you'll need for this one is something to draw on, something to draw with, and something to make it all colorful. Whatever that looks like to your team is perfect. From posters and paper to paint to markers to pencil crayons to pastels, whatever fits for you is the right call.

Step 2—Brainstorm: Have participants take a piece of scrap paper and let them know that this is the time to spill any and every thought. Have them divide this paper into three parts: one for past, one for present, one for future. Then, have them put as many things as possible that represent each category. These can be physical items, popular things, sayings, moments, anything! As long as these things fit their understanding of who they were in the past, who they are now, and who they hope to become in the future.

Step 3—Let's Get Visual: Now that participants have a bank of words to draw from, it's time to get visual! Have them choose aspects from each column and draw them on the same page, creating a mosaic visual representation of who they are as complex and wonderful human beings. Have them draw the past column items only in black and white. Have them draw the present column items in full color. Have them draw the future column in one singular color. (They can choose whichever color they would like and use a variety of shades of that same color!) It's a fun little art challenge, but it's also a way to visually explore and reflect on who they have been, who they are, and who they are evolving into.

Step 4—Sharing Is Caring: The more space you can make for students and colleagues to share the personal reflective work—the more you show that it matters—the more they will feel seen. Whatever works best for your community, do that thing. If it is a sharing circle, if it is some kind of morning meeting, if you want to display the work on the wall and have students do gallery walks, dive in. I like to chat with the artists involved about how they feel comfortable

sharing and build from there. Again, this is about their experience and their voice, so try to listen for it everywhere you can.

Modifying here is about making sure that students can access those past, present, and future pieces easily. In working with younger students, I ask them to draw themselves in the past (when they were little), right now (today), and in the future (when they're a grown-up). That way they can take all three images and talk to the group about their inspirations. You can modify it further by asking them to just draw themselves in the past and talk about how they are different today.

THE CANVAS WE ARE

Back in the tattooist's chair! This chapter we're spotlighting . . .

Ellen J. Foster

Professor of Teacher Education
Abbeville, Mississippi

Ellen J. Foster joined the University of Mississippi School of Education in 2007 and currently serves as professor of teacher education and secondary program coordinator. Ellen was the National Council for Geographic Education-GeoCamp Iceland program co-leader for the 2017, 2019, and 2021 professional field courses and works in the leadership of the Mississippi Geographic Alliance (MGA). Ellen received her PhD in geography with a geographic education concentration from Texas State University-San Marcos in 2006. Before her transition to higher education, Ellen taught high school social studies for nine years in the Greater San Antonio area upon completion of her MA in teaching from Trinity University. Ellen also served as an adjunct geography instructor in the Alamo Community College District.

> This is my tattoo. One of many in my collection that began over twenty-five years ago. I asked the tattoo artist to incorporate my late husband's thumbprint into the bark of my tree. It is fitting in many ways. He was steadfast like a tree and his high school nickname was "Tree" (which he hated). There are deep-rooted stories in my tattoo.

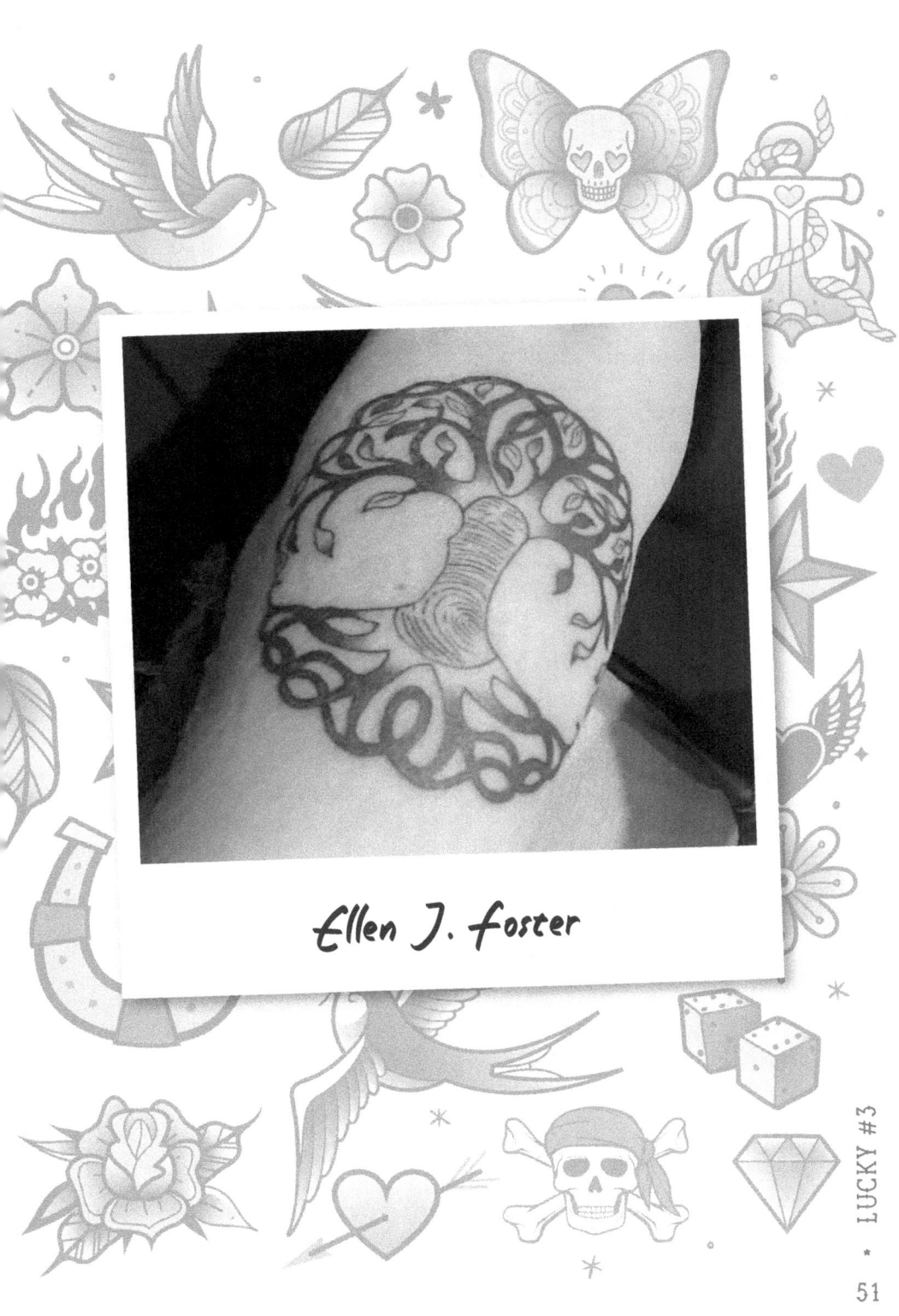

Ellen J. Foster

Amy Rogers

PE Lead and Governor, Year 5/6
East Sussex, England

Amy Rogers has been a teacher for nine years in Year 5/6. She is the PE lead for her school and also supports it by being a governor. She adores the work that she does.

> My tattoo is a geometric butterfly on the back of my neck. It was done at a time in my life where I was going through a big shift. It signified change and a big transformation for me. A true representation of the growth that I did and will keep doing!

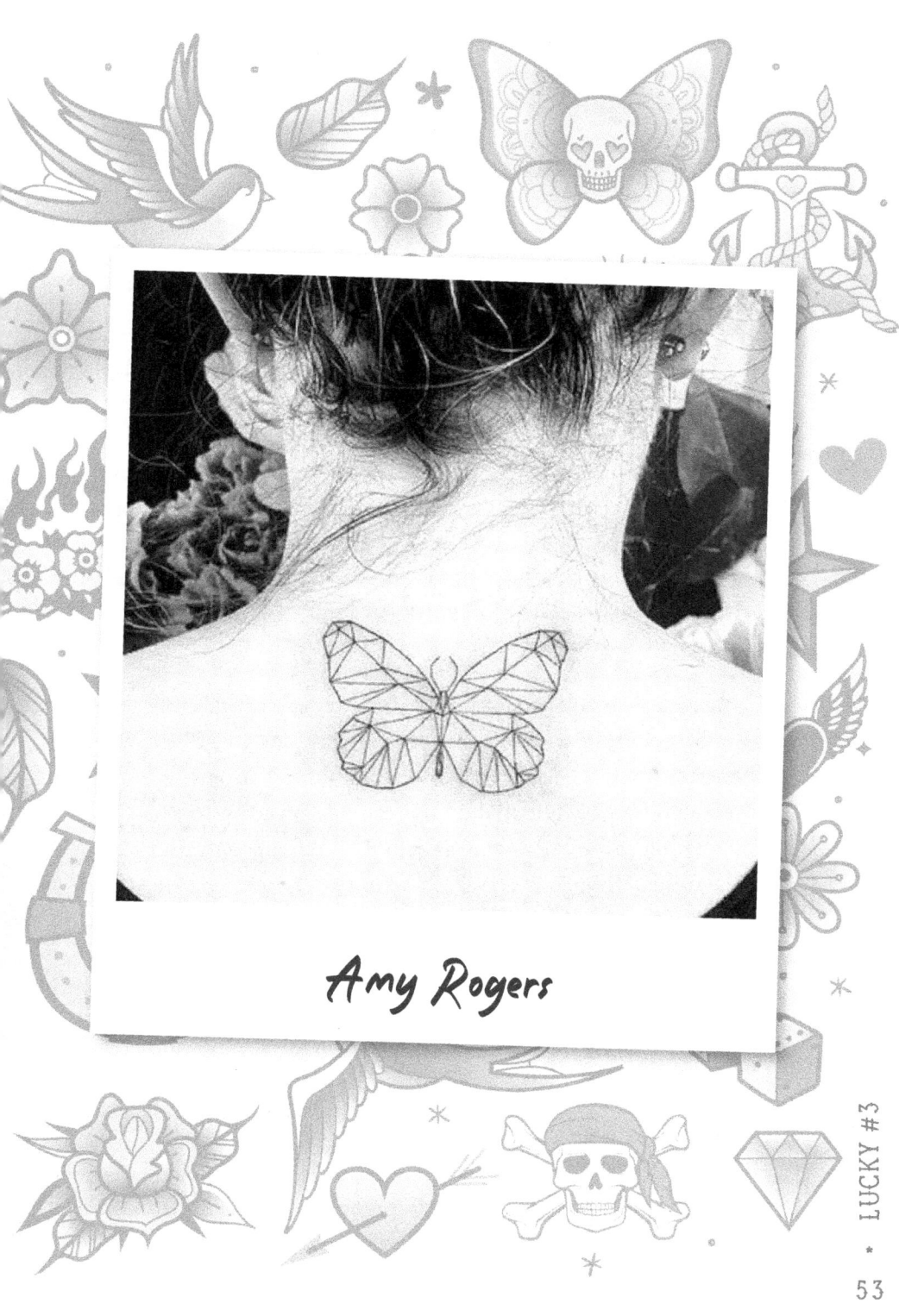

We're also shining the spotlight on…

Holly Painter

**English Teacher
London, Ontario, Canada**

After graduating in 2009, Holly Painter "detoured" from teaching into the world of spoken word and poetry slams; eight years as an artist educator and hundreds of stages later, she undoubtedly learned the power of story and the complex narratives we all hold within us. Returning to the classroom after helping thousands of young people find their voice through poetry, Holly now teaches English in the Thames Valley District School Board in Ontario and can be found most days with her wife and sons, reading and laughing as much as possible.

> My first tattoo was at sixteen; it was a generic off-the-wall sun design from a semi-seedy shop (since covered over). Needless to say, I'm not one who overthinks my tattoos and their significance, but it did take careful consideration to fully tattoo my lower right arm before solidifying my career as a teacher. Though it doesn't stand out in the artwork, the word *poetry* exists in the design and reflects an indescribably significant chapter in my life as a performing poet and public speaker. I decided honoring that part of my life mattered more to me than anyone's assumptions about a "tattooed teacher." Although the upper half of the tattoo sleeve has just recently been completed (eight years later and now including reference to another life-defining chapter with the discreet initials of my two sons), I am grateful to share the story of this tattoo whenever asked and relive memories of the poetry communities who helped make me into who I am today.

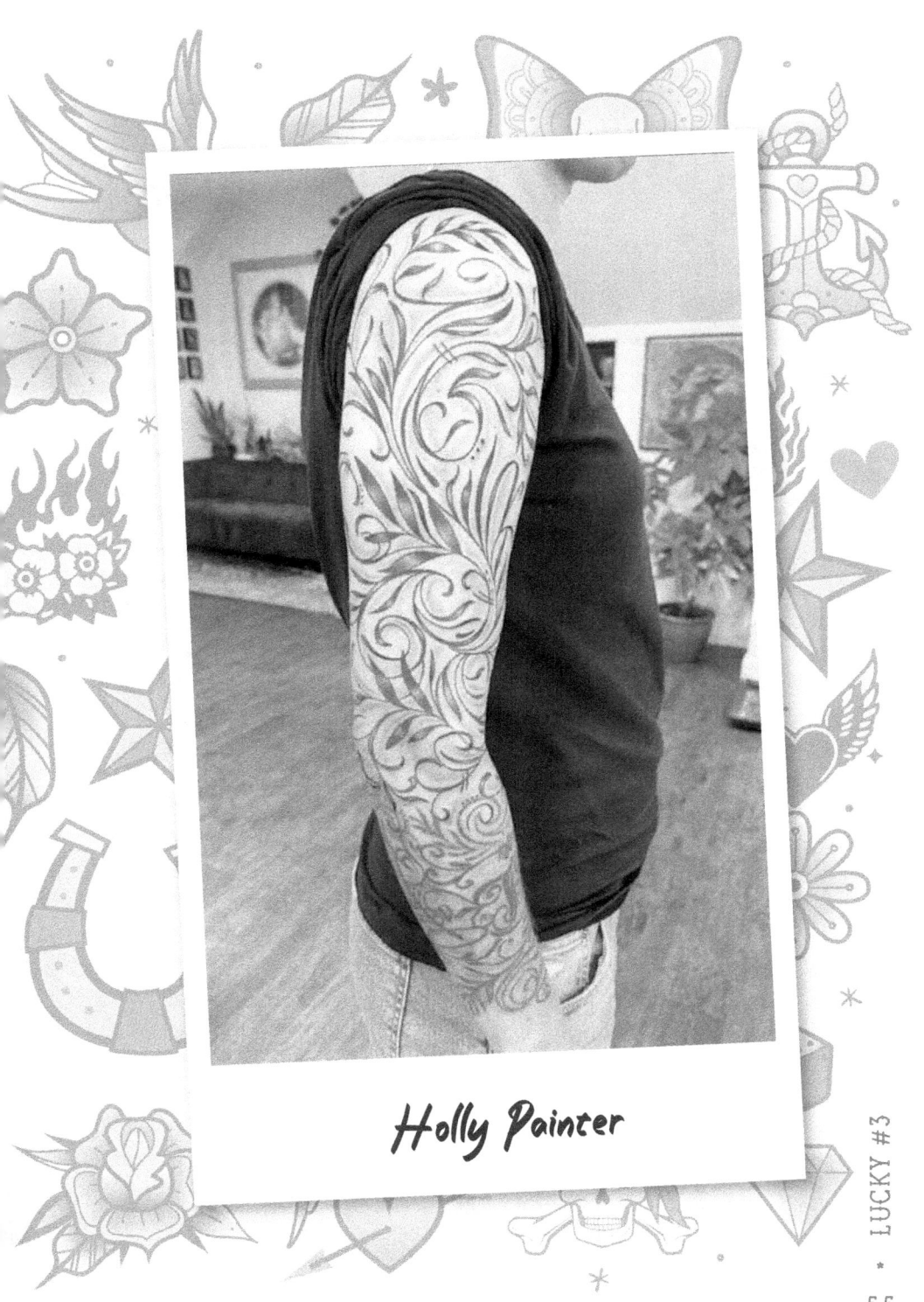

Holly Painter

Micro Motivator

You are made of parts of the past, but you're made for building the future. You are both sides of that same coin. Spend it wisely.

Teaching is a tattoo because both create connective tissue between things that might not otherwise be connected

Like many people my age, I was half raised by Saturday-morning cartoons like *Transformers*, *Captain Planet*, *DuckTales*, and *He-Man*. He-Man was just an average, run-of-the-mill fictional cartoon space prince from the planet Eternia. But when he held the Power Sword above his head and yelled out, "I have the power!" he transformed into He-Man, a superhero built of limitless muscle and very limited clothing (just a Speedo made of fur—and matching boots!). But in revisiting He-Man as an adult and an educator, I had a realization. See, Spider-Man is a spider-themed hero. Batgirl is a bat-themed hero. They carry it in their name. But He-Man is just a pronoun. He isn't a spider. He isn't a bat. He is grammar. He-Man's name might as well have been Guy-Dude, Gentleman-Fellow, Y-Chromosome-Boy, or Male-Man. He-Man's name could have been Captain Grammar.

As heroic as I know grammar can be to educators like us, I don't blame cartoon and toy developers for oversimplifying things for the sake of viewership. Their job is to find ways to connect their material to as many people as possible in the twenty-two minutes of animated action in between cereal commercials. No easy task. They have to convince kids to tune in, to give their time and attention to become part of those moments. The people behind shows want to bring human beings into what they're offering, mostly so that they can sell toys. And He-Man had some exceptional toys, including a skunk person action figure named Stinkor that actually smelled awful because they mixed patchouli oil into his plastic. I still have mine. It still stinks. But what doesn't stink is getting to be an educator. (Nailed that smooth and eloquent transition. #ProfessionalWriter.) I mean it, though. So much time, effort, and resources go into finding ways to make people want to be part of things. We are bombarded by advertisements and sales pitches and all forms of media that are all geared toward convincing us to be part of groups or teams or experiences, to be part of the audience watching shows or movies, to be part of earning and spending money in certain ways. We're social animals by our nature, so that work matters big-time. It helps to shape trends and the social fabric of our collective existence. It also helps forge each of us into these unique patchwork-quilt human beings that are made up of all our big and little individual choices. Teaching is a tattoo because it flips so much of that upside down. Where most of the world is trying to convince unique individual humans to be part of something collective, we have the privilege of being part of a system and structure where individuals show up as unique and create something together. We're not trying to convince them to buy action figures; we're creating opportunities for them to figure out their actions.

If you were in advertising or marketing, your job would depend on how many people you could get to show up for and engage with your product. In education, our audience is ready-made. I don't think people take enough time to appreciate the power of that. But

that's the beauty of both teaching and tattoos. You don't need to build it and hope that they will come. They're there. There are so many of them. But they're not all there for the same reasons or with the same motivations. Teaching is a tattoo because while most other things involve hoping that enough like-minded people show up, teaching and tattoos welcome individuality. Both teaching and tattoos thrive on the reality that each individual has their own story to tell, has motivations and needs and things that made them unique. Both teaching and tattoos are a space where individual stories make the collective experience what it is, rather than the experience trying to find individuals to be part of it. That kind of magic just doesn't happen that often.

I didn't realize that in my first years of teaching. I felt like the title of "teacher" mattered more than the fact that I was a human being behind that title. I was even taught to actively avoid bringing who I was into my teaching—that humanity was the enemy of classroom management. In those early years of educating, I loved my work, but the fact that I am an Indigenous person was never part of what that work looked like. I was only ever a "teacher." Then two things happened at the same time that changed that perspective for me. First, the education system shifted toward deeper incorporation of Indigenous perspectives in learning. Second, my grandfather understood that he was in the last chapter of his life.

My grandfather's mind remained sharp even as his body was failing. With his trademark mischievous twinkle in his eye, he told me that one of his only regrets was that he had hidden his Indigenous background, and that his wife, my beautiful grandmother, who was also Indigenous, had done the same. Afraid of it limiting their options for employment, my grandfather had taken outdoor construction work only in the summer, when he could tell people that

his darker skin was a tan earned in the sunshine rather than gifted from his ancestors. When he passed, I felt like the way that I could best honor him was to live authentically out loud all the time, rather than quieting who I was during work hours in favor of my "teacher" title. Since I decided to embody that lesson, I have evolved the actual day-to-day of my work. I now spend a good chunk of my time doing Indigenous education for a whole bunch of students who get to learn as I learn about myself. I get to spend time using my land-based learning know-how, listening to elders and knowledge keepers, taking students into the wild and seeing them light up with a better understanding of the world and their importance in it. In short, I am showing them wâhkôhtowin.

Wâhkôhtowin is a Cree word that, to oversimplify, speaks to a kinship between all things. So many things have a spirit, an energy to their existence, and wâhkôhtowin is a responsibility to act in a way that acknowledges kinship between those spirited things. In essence, we're all connected to one another through who each of us is. That right there is why teaching is a tattoo. While products and promotion presuppose that we are all singular beings seeking things to participate in, seeking things to belong to, both teaching and tattoos become what they are in the opposite way. Both embrace all individual humans and ask for their stories. Both create their culture and collective experience through seeing and valuing the stories individuals wear. We have what so many work and struggle and fight for; we have people interacting with us. We have people who show up. We have people who listen and, more importantly, we have people who have something to say. We have people who bring themselves and the stories they wear. We have this responsibility to act in kinship with those stories, that spirit in others. It is our responsibility to make them feel safe and valued enough to share. It is our privilege to weave that into something they can wear collectively like tattoos—a community.

INK-THINK-ASK

Back for another tasty scoop of challenging you to own the things that you would proudly wear about who you are as an educator.

★ INK

This time around, I want you to draw yourself a tattoo that shows what the word *connection* means to you. I want you to ask yourself how you work to create and value connection. Being that we are in the business of people, what tattoo would show the world what connection looks like to you as an educator?

★ THINK

Now that you've shown how your teaching tattoo is something that lives and breathes connection, I want you to reflect for a few minutes on these guiding questions. Remember, write your reflections down. Physically putting things down in ink is powerful practice. Own why teaching is your tattoo.

- ★ Reflecting on the big word of the chapter, what does *connection* actually mean to you?
- ★ How do you make space, time, and opportunity for real human connection in the work that you do as an educator?
- ★ What specifically makes you feel connected to the work you do as an educator?
- ★ What do you believe helps students and colleagues feel like they're part of a community rather than just showing up to a building?
- ★ Do you feel like an important part of the community of your school? What makes you feel that way?

★ ASK-TIVITY: WÂHKÔHTOWIN OBJECTS

What time is it? It's time for easy-to-implement and universally accessible activities! We're on the chapter theme again so that you can create space and opportunity for others to reflect in the same way that you've done above.

This one can be done as a visual, written, or even oral activity. It's a real beauty that allows for whatever your community needs or however you want to use it! (It can be a morning meeting activity all the way up to a full-on writing activity!)

Step 1—Accumulate! All you'll need for this one is a series of physical items. They can be literally any item, though I would suggest that simpler is better for this one. (Legit, they can be any items from bananas to bandannas to pajamas to piranhas.)

Step 2—Decide Your Path: You need to have a clear vision of what you expect before you put the items out there to be interacted with. Depending on that expectation, you'll need to prepare things like paper or art supplies or a morning meeting circle.

Step 3—Connect! Now comes the fun part! One at a time, give participants a good chance to interact with each item, to see it and think about it. Ask them one important question: "How do you connect with this item?" Ask them if they can think of stories or moments in their lives that relate to this item. Ask them if they have thoughts or feelings or experiences with this item. Some will have specifics to talk about, while others will have just generalities, and that's OK. There are no wrong answers because big or little, all connections are worthwhile and that's what weaves everyone together. You'll have to allow time and space for them to build their thoughts or, if you're making this a writing or visual activity, to write and create!

Step 4—Sharing Is Caring: Again, I'm on Team Sharing forever, especially with this activity. The students and staff who participate need to be able to see and hear and experience how others are

connected to the item. That's what creates the connection as a collective. It is essential that everyone gets a voice and a moment to share it.

Modifying here is easy peasy. If you have younger students, then just make this a meaningful oral storytelling experience or even an opportunity to draw some picture stories and then talk through those!

THE CANVAS WE ARE

Back in the tattooist's chair! This chapter we're spotlighting...

Amanda Hunt

Middle School Librarian and Secondary Lead Librarian
New Braunfels, Texas

Amanda Hunt, aka TheNextGenLibrarian (@TheNextGenLibrarian), is a librarian for sixth- through eighth-grade middle schoolers in New Braunfels Independent School District and is also its secondary lead librarian. She's been a librarian for twelve years and was the chair for the Maverick Graphic Novel Reading List Committee for the Texas Library Association (TLA) from 2021 to 2023. She was the chair for the TxASL Talks Editorial Board and presently is the TxASL councilor. She also serves on the Conference Planning Committee for the TLA's 2024 conference, the TLA Bylaws Committee, and the TxASL Operating Procedures Committee. Amanda has been selected for the Cybils Awards YA Speculative Reading List Committee and the Margaret A. Edwards Award Committee. She was a TLA TxASL Media Virtual Presence (MVP) Award honoree for 2021 and 2023 and the Branding Iron Award 2022 winner for Digital Only Communications in a School Library.

> Both my parents have tattoos. They got theirs at a time when it was still considered taboo to have them. They are now retired educators, but it was always something I wanted to do myself. I've been getting tattoos since I was eighteen years old and have no plans to stop. This is probably one of my favorites. It's the constellation from the cover of *The Invisible Life of Addie Larue* by V. E. Schwab, my most-loved book of all time.

Charles Williams

Educator and Consultant
Chicago

Charles Williams, a dedicated educator with nearly two decades of experience, has made impactful contributions within K–12 education in capacities including teacher, assistant principal, and principal. His unwavering commitment to fostering equity is highlighted through his advocacy work with the Office of Equity of both the City of Chicago and Chicago Public Schools. Charles extends his passion for promoting inclusive narratives as the host of *The Counter Narrative* podcast and as a former co-host of the educational show *Inside the Principal's Office*. In addition Charles is the founder of a consulting firm, where he thrives as a best-selling author and is celebrated for his compelling workshops and motivational keynote speeches.

Charles contributes his expertise and insights as a board member for the College of Humanities, Education and Social Sciences at Purdue University Northwest. His commitment to educational excellence and leadership development is further exemplified through his roles on the boards of Lead by Learning and the Leadership EDIT Summit. Through these positions, Charles continues to advocate for transformative educational practices and leadership strategies that resonate across diverse platforms and communities.

> As a single father, two names etched in ink—Annelise and Sierra—carry the weight of love, commitment, and an unbreakable bond. These tattoos are more than mere decoration; they are a declaration, a testament to my unwavering dedication to my daughters. Amid all the challenges and the triumphs, these names stand as a constant reminder of what truly matters. Annelise claims the right, a symbol of strength and guidance, mirroring her role as the elder. Sierra, on the left, represents the heart, the emotional anchor of this small,

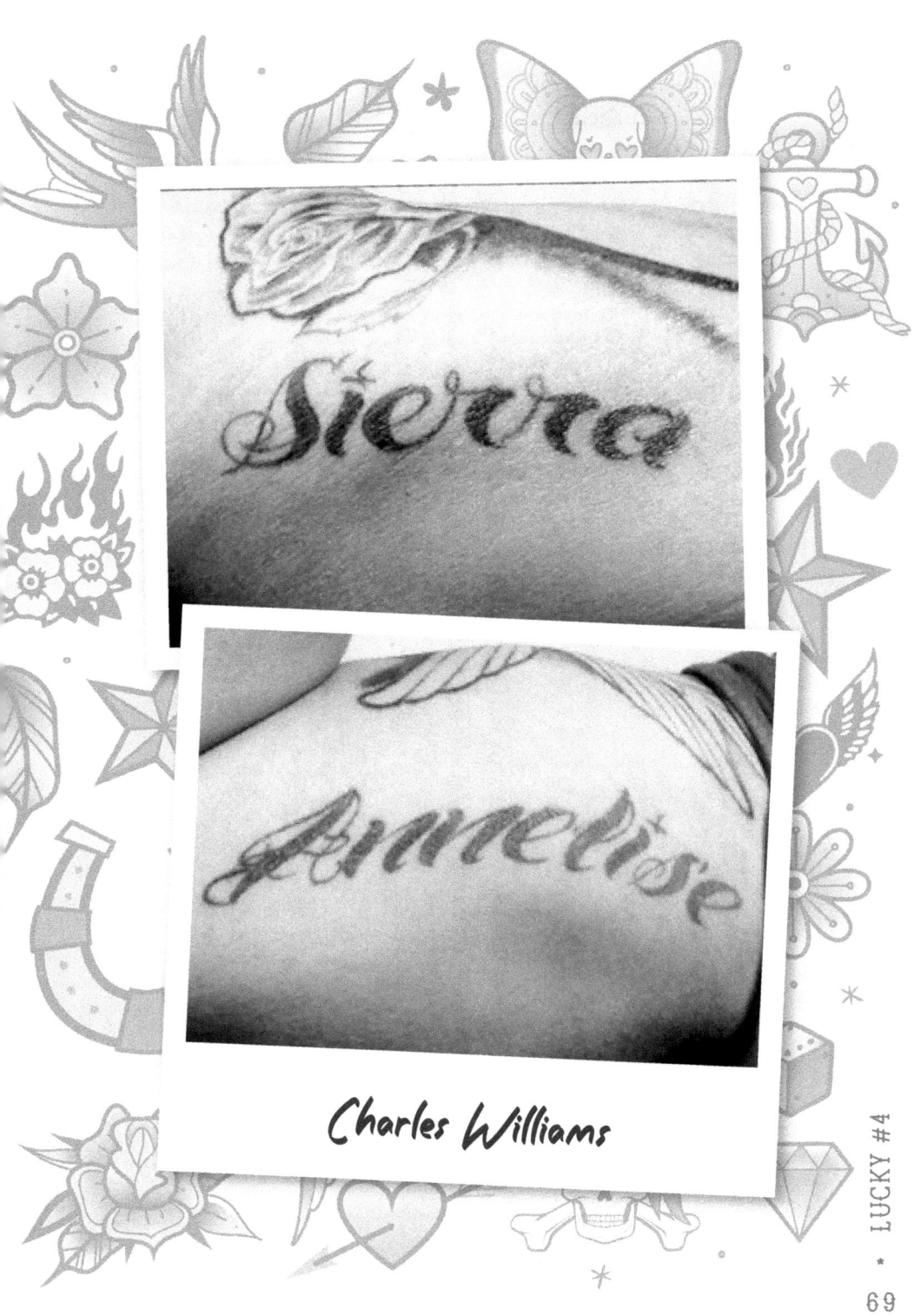

Charles Williams

resilient family. This ink, embedded in skin, narrates a tale of love's permanence, my promise to be the bedrock for my daughters, no matter the twists and turns of our journey.

Micro Motivator

You have the privilege of being in a profession where real human beings carry their real stories within every inch of them. Choose to see them. Choose to hear them. And never forget the great power and responsibility that *you* have to help those human beings see how they're an essential part of something collective.

Teaching is a tattoo because both are simultaneously deeply personal and wildly public in nature

I still remember vividly the first "in the wild" moments I had with students. Running into students outside of school walls is often a reality check for both you and the kids. These moments have the power to humanize educators, widen communities, show people in new lights. They also have the potential to make you question what you're wearing, what you're doing, where you are, and what people think about any of those pieces. The first two times that I ran into students in the wild happened while grocery shopping. At the same grocery store. On the same day. Making a sharp left at the tomatoes, I literally bumped into one of the high school students who had been in my classroom only a few hours before. I had no idea how to play this. I had no prior experience running into students, literally, with a cart or otherwise. Should I try to impart some kind of wisdom? Did they expect that I would seamlessly segue into a teachable moment, using the world around us to engage them in something novel and interesting? "Student! Did you know the potatoes in my cart were the

very same as the first vegetables ever grown in space?" Was it expected that I would always be teaching? Was I supposed to casually interact with the student's mom and little sister, talk about our lives out here in the wild, or was that too familiar? Was the proper professional interaction more akin to some kind of impromptu conference where I earned my paycheck by providing insight into their learning even here among the legumes? Thankfully, as always, students came up with the best answer.

With unbridled positive surprise, my student threw his right hand up into the air, eyes wide with excitement. Luckily, as a new, hip, young teacher, I understood the gesture to be a social invitation to what the kids call a "high five." I was thankful that not only had he taken the lead on what could have bloomed into an awkward moment, but also he was genuinely happy to see me in the wild. I never forget how much it matters and what it says about who we are in our classrooms when a student lights up and smiles seeing us outside of that familiar shared space. My hand couldn't have gone up any faster for a thunderously enthusiastic high five that shook the very leaves of lettuce around us. It was impressive. Well, impressive to everyone but his little sister, who looked way up at me like I was the Jolly Green Giant (understandable considering that I was a much larger person than she was).

"*This* is my teacher," my student said, introducing me.

His sister looked me up and down, perplexed, then fired a volley of questions. "What's your name?" "Why are you bald?" "Is my brother nice at school?" "Why do you have tattoos?" "If you're a teacher, why are you here and not at the school?" Of course, I happily fielded all the questions, including explaining the mind-blowing reality that teachers leave at the end of the day. In my experience, the younger a student is, the more astonished they are when they learn that teachers don't actually live at the school overnight. But that right there was one of the first moments when I understood why teaching is a tattoo. Teaching is a tattoo because who I am is on display for questioning from other people of all ages and heights. The story of

how I teach and how I live as a human being are out there to be read. The nature of the work that we choose to do often blurs the lines between teacher and human being. I would argue that is one of the things that gives our work its meaning.

The last thing that I got out of that "in the wild" interaction was this student's mom adding that she was glad to have met the teacher her son "talks so much about around the dinner table." That statement sent me deep into a spiral of thought about what he might be talking about. Was he talking about things I do or say in my class? Was he talking about what kind of person I am?

I was so deep in the whirlpool of possibilities that I barely registered the other groceries I was mindlessly shoveling into my cart. I definitely wasn't consciously aware of my second student, who was food shopping with her family and had been saying hello and waving enthusiastically with a slowly melting smile as I completely, albeit unintentionally, ignored her. I was overthinking so much about what the first family was saying about me around their dinner table that I didn't notice this second family staring at me, smiling in anticipation and confusion. This time I came off far less positive and socially capable. I gave a strange "Yes! Hello!" and looked down at the family-sized box of Lucky Charms cereal I was holding. Panicking, in a very low-quality impression of cereal mascot Lucky the Leprechaun I said, "They're magically delicious!" Awkward, deafening silence. I filled that silence by saying, "Yeah, they're for my kids. Well, nice to see you!" And then I walked away.

The cereal wasn't for my kids. It was all for me. And so was the free toy in the box. Because I love Lucky Charms and because I'm a kid at heart. That is part of who I am. And that's why teaching is a tattoo: How we show our teaching and our tattoos is deeply personal, but both by their nature are things that people will inevitably get to see. It is magically delicious to wear both proudly.

When I made it back to my car to sit and stress eat Lucky Charms straight out of the box, I had a chance to really think about the privilege of both of those interactions. It made me uncomfortable at first

to know that I was being talked about and I didn't get to know what was being said. But then it hit me: Students talking to their families about their time in our schools is a huge win. It means they're in there, engaged in co-creating this collective experience. There are a lot of jobs and professions people can choose that render them invisible at times. We choose to go in every day and put our hearts into the business of human beings, knowing that the nature of the work makes who we are visible, even when the workday is over. Both in teaching and in tattoos, the motivation that drives each is fiercely unique, the methodology and choices are made by individuals. But when that all manifests into action, it becomes something that the world physically gets to see.

When you teach and when you wear tattoos, you are in a metaphorical fishbowl. Don't get me wrong—it's a beautiful fishbowl with colorful rocks and plants and bubbles coming from one of those treasure chests that open and close, but both teaching and tattoos are an act of display, with glass all around us. With tattoos, we think about location, sizing, content, context, color. We know that inevitably people will see them, and invariably that puts part of the story of who we are out there for people to interpret and judge through their own lenses. With teaching, we do the same. We know that our pedagogy, our plan, how we use minutes and words and tones, even the music we play in class, the clothes we wear, our bad jokes and misused slang, our interactions with colleagues, our communication frequency with parents—that all comes from who we are. No two teachers are the same. No two tattoos are the same either. We may have shared inspirations and motivations, but our experiences and stories always end up being unique.

There is no way to separate the human aspect of our work from the expectation of our instruction. There is no avoiding the fact that teaching will always be public in nature. People will see how you choose to educate. But if you own who you are as a teacher and allow yourself to love the aspects of who you are that you uniquely bring to your students, then those eyes on you end up being both an

opportunity and an invitation. We know people are going to look anyway, so show them what you love about yourself as a teacher. Wear those pieces. The choices that you make as an educator speak to the human being you are as loudly as a tattoo. Both teaching and tattoos get talked about around dinner tables. But the most formidable and meaningful thing about people asking "Why did they do that?" is that your answer can be "Because that's who I am."

Once more with feeling! Back for another opportunity to own the things that you would proudly wear about who you are as an educator.

★ INK

The challenge this time is to draw a tattoo that shows you as a fish in a fishbowl. Make it represent your life as an educator. What does your bowl look like inside? What do you look like as a fish? Most importantly, who is outside the glass watching how you swim? Who really sees you doing your thing as an educator?

★ THINK

Now that you've drawn your fishbowl teaching tattoo, I want you to reflect for a few minutes on these guiding questions. Remember, write your reflections down. Physically putting things down in ink is powerful practice. Own why teaching is your tattoo.

- ★ Have you had an "in the wild" experience with a student? If so, how did you feel in that moment and why?

★ What do you think people say about you as a teacher when they're sitting around their dinner table? Do you agree with them?

★ Of all the eyes on you as an educator, which eyes do you care about the most? (In other words, which one opinion outside of your own do you think has the most impact on you?)

★ What do you think students or colleagues would be surprised to see in your grocery cart at the store? Why would they be surprised?

★ What is the most personal thing that you see in your teaching? In other words, what do you do as a teacher that reflects who you are as a human being?

★ ASK-TIVITY: MY FISHBOWL

Now let's make room for an easy-to-implement activity! Work to create space and opportunity for others to reflect in the same way that you have above.

This is a visual activity, but you can add a writing element if that's where your team is at. The idea here is that they'll design a visual piece similar to the tattoo you sketched, but with their own reality as the lens.

Step 1—The Fish: Photocopy a blank fishbowl (or use one that you make yourself) and ask participants to draw themselves as a fish. While this isn't the focus of the activity, it's a nice peek into how they see themselves.

Step 2—Who Sees You Swimming? Once the participants have drawn themselves as a fish, have them draw, write, or even just talk through a list of people in their lives who see them swimming. Ask questions like "Who sees you do all the work you do in your life, like swimming?" and "How does it make you feel when they see you doing all the work you do in your life?"

The biggest part of this activity is asking this question: "How does knowing people see what you do influence how you do those things?"

Step 3—Sharing Is Caring: However you structure the creation part of this activity for your team, it is always essential to make space for them to share what they have created and reflected on. Make that space for them to be seen and heard, whether in writing or in speech. I also recommend displaying the fish art as a way to help participants understand each other better and also remind them that people see the choices they make.

Here modification is just as simple as the structure you choose for your little fish. If participants are ready for writing, you can incorporate a writing element. If not, you can choose oral sharing in a morning meeting or group circle. It's all about what fits best for your team!

THE CANVAS WE ARE

Back in the tattooist's chair! This chapter we're spotlighting . . .

Meg Gydé-Johnston

Early-Years Educator
Winnipeg, Manitoba, Canada

Meg Gydé-Johnston is an early-years educator with nineteen years of varied experience. She is a Microsoft Innovative Education Expert who represented Canada in the Microsoft Global Educator Exchange in Budapest in 2016 and again in Toronto in 2017. She was a recipient of the Prime Minister's Award in Teaching Excellence. As a multilingual teacher-librarian, she used her expertise to build an entire school library collection from scratch and has now transitioned to grade 1 French immersion education.

> This is my fireweed tattoo. I had this tattoo done after adventuring through the Yukon at the perfect time of year to see the landscape absolutely explode with the brilliant pink of the fireweed along highways and the mountainside. I also love the story of fireweed; it is the first thing to grow back after a fire. Growth that's beautiful and bright after a difficult moment—that's a life metaphor worth wearing.

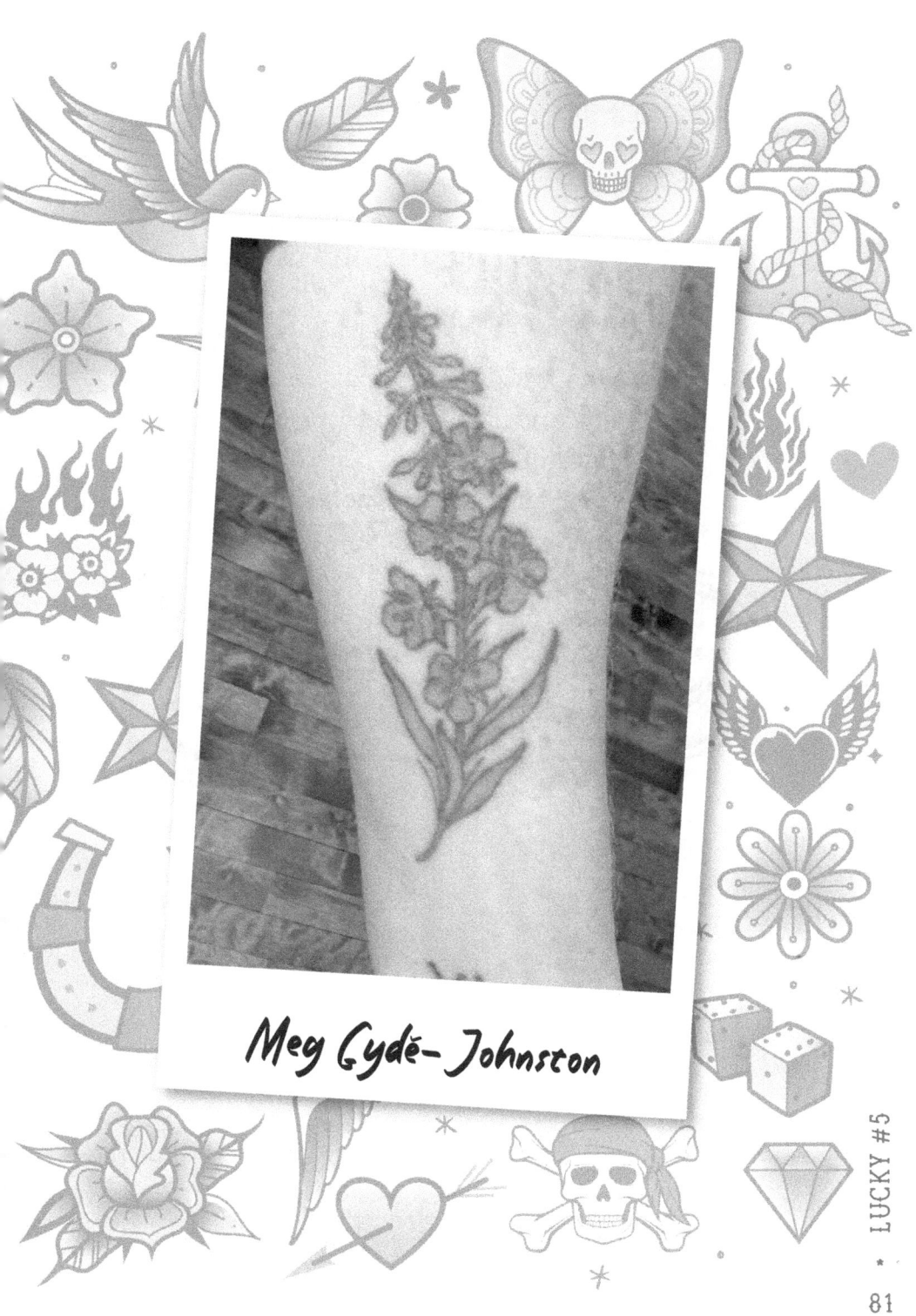

Meg Gydé-Johnston

Micro Motivator

Who you are informs and fuels how you do what you do as an educator. Know that people will see you, and embrace the chance to wear your story through your work.

Teaching is a tattoo because there's only so many inches of a person for you to decide how to cover

The official most tattooed person on the planet boasts coverage of almost every inch of his body. He's spent over a thousand hours being inked, layer over layer, tattoo over tattoo, commitment over commitment, and is now over 200 percent covered (including his ear canals, gums, and even eyelids). He can't close his eyes without the reminder of his choices. I will likely never choose to tattoo my own eyelids, but there are moments every day where I can't even blink without being reminded of how deeply teaching is tattooed into who I am. Don't get me wrong, I'm about that. I have been all kinds of vocal about my belief that our teaching is made immeasurably more meaningful by weaving ourselves into the work. It makes your pedagogy unique and transforms the school you work at into a true community.

Telling people I'm a teacher just feels different from when I'd tell them I worked at the video store. On that note, it breaks my heart a little that my own kids will never experience going down to the

video store, debating which movie to rent together, rolling the dice on it potentially being terrible, and attempting to choose snacks that will satisfy everyone. If video killed the radio star, then streaming killed the video store. As a movie-loving former video store clerk, I do mourn the loss and the fact that my kids will never learn to "be kind, rewind." I stopped being a video store clerk when my shift ended and I locked the door behind me. I wasn't a video store clerk at home. I haven't stopped being a teacher since I stepped into my first classroom. Teaching is a tattoo because it becomes part of who I am, and in turn, I weave who I am into how I work far more tightly than I did when I was just offering my opinions on which movies to rent.

I love the magnitude and stakes of that. I love how regardless of the myriad choices we make in a day—the little things we do that make our practice unique and varied—every single one of us is actively rewiring brains and weaving our choices into the developing neural pathways of real human beings. It is understandable that something like that would become part of how we see ourselves. I want to be clear: I believe that every job has value. If you make the choice to get up, put in work, and get compensated, then you're doing something valuable in our collective existence. That takes many forms. Had I decided to continue along the path of a video store clerk because it made me happy and allowed me to build a life I was proud of, then that would have been a good existence. What I'm saying is that teaching is a job that has taken on a cultural identity all its own, and teachers make their own decisions about how much of that cultural identity they wear. Teachers belong to a pretty exclusive club. Not many careers provide such access to mugs, shirts, keychains, mugs, socks, books, mugs, wine glasses, ornaments, and, when you're looking for an extra-special teacher gift,

there's always mugs. All of which can be found at your local mall. Or local pharmacies in that weirdly small gift section that somehow always features a teacher-related gift. Honestly, I once saw a mug that said, "If you can read this, thank a teacher." It was at a gas station on a shelf beside a very questionable sandwich.

I know teachers who completely embrace that culture, and I'm here for it. I feel like we all know a teacher or two who owns every item ever produced that declares their teacherhood. I also know teachers who couldn't care less for that. Some smile politely when they receive such as gifts, then immediately banish them to the landfill. I don't believe an overabundance of video store clerk gifts is contributing as heavily to landfill mass. But we know it's the thought that counts, that mugs just mean we're seen. The teacher in us, the teacher culture that we espouse, is seen and valued to the point of wonderfully kitschy products that people use to tell us we matter, or at least that they assume we sometimes drink from a mug. What we do has its own cultural identity.

Beyond the merchandise, there have been a boatload of characters on stage and film and in cartoons who tell the stories of how we as teachers are seen. Caricatures and stereotypes of who people think we are. We're John Keating from *Dead Poets Society*. We're Ms. Norbury from *Mean Girls*. We're Michelle Pfeiffer as Ms. Johnson in *Dangerous Minds*. We're Mr. Kotter and Mr. Feeny. We're Edna Krabappel and Principal Skinner. We're Professor McGonagall and Mr. Belding. We can be Mark Thackeray or Ms. Frizzle. We've got it in us to be all of Mr. Schuester and Sue Sylvester and Emma Pillsbury. Sometimes we're Mr. Miyagi or Miss Finster or Mr. Ratburn or Miss Othmar or Miss Grundy or Mr. Weatherbee. Hopefully we're never Walter White. But we're always "teacher."

The title is part of who we are. It's one of our only consistencies. In a job where our uniqueness and individuality inform and inspire our pedagogy, where there are all kinds of different job descriptions and responsibilities, the seed of each of us is that we're teachers. But teaching is a tattoo because when it comes to both, we get to decide

how much of ourselves we give to either. How much of us do we physically tattoo? How much of who we are becomes "teacher"? Each of our little choices changes the answer. Tattoo by tattoo. Decision by decision. I believe there is power and happiness in owning what that authentically looks like for you.

You want a little tattoo? Show it off and tell the story. You want no tattoos and to keep your stories to yourself? That's fair too. You want to try to compete with the world record holder and tattoo 200 percent of your body? You get to choose what balance looks like to you. You get to self-define. Are you symbiotic with the word *teacher*? Is your relationship to the word *teacher* mutually beneficial? Whatever it is, it's your relationship and you decide how it manifests. It's pretty darn difficult to physically force someone to get tattooed—there's a lot of squirming at the best of times. Teaching is even harder to coerce someone into doing. It's a real "lead a horse to water" situation. You can put a grown-up in front of a group of kids, but until they make the conscious choice to teach, they're just a babysitter or children's entertainer. You can tell people you're a magician, but making magic is a choice.

The power we have to choose how much of ourselves to tattoo and how much we embody the word *teacher* is only one side of the coin. On the flip side is you can remove the weight of comparison from your shoulders. Too often we look at other teachers and mire ourselves in the worry that doing things differently means we're not doing things as well. We accept that tattoos are deeply personal visual commitments to pieces of who we are. We can look at someone else's tattoos and acknowledge the beauty and magnitude of the story being worn while also being positive that we'd never make the same choices for ourselves. We're at peace with that, which makes sense because we're different. Our stories are different.

Teaching becomes a tattoo every time I apply the same grace and understanding to my own relationship with the word *teacher* and offer the same respect and appreciation to my colleagues who wear the word differently. If you choose to be the first teacher in

the school every morning and you stay until you get thrown out after dark each night, I love that for you. If you slide in at the bell with the students and slide right out with them when the day ends, I love that for you too. If you run clubs at lunch or if you need to get out of the building in the middle of the day, if you respond to emails on the weekend or if you commit to work being closed until Monday morning rolls around, if you send home weekly newsletters, daily stickers, or monthly phone calls—I love that for you. Pull on the teacher socks, sip from the teacher mugs, gear up in the teacher clothes. Or don't. Embrace the culture of teaching and tattoos in the ways that fit for you. Your choices are the right ones for you. Own them. Wear them. Seek to understand and support how your colleagues wear theirs. Yes, we are all tattooed with the word *teacher*, but just how much is entirely up to us.

You know the drill. Back for another opportunity to challenge you to own the things that you would proudly wear about who you are as an educator.

⭐ INK

The challenge this time around is simple: I'd like you to draw yourself (even if it looks like an oversimplified gingerbread person). Once you draw yourself, I want you to ask yourself, honestly, how much of who you are wears the word *teacher*. How much of who you are do you feel is defined by you being an educator? What does that look like?

Reflect, and cover your little sketch self in the amount of tattoos that makes you say, "Yep, that's me!"

★ THINK

Now that you've shown how much of yourself is tattooed by your teaching, I want you to reflect for a few minutes on these guiding questions. Remember, write your reflections down. Physically putting things down in ink is powerful practice. Own why teaching is your tattoo.

- ★ What percentage of who you are, of your time use and personal choices, is defined by wearing the word *teacher*? Give it a number.
- ★ How do you feel about how covered you are? Would you give more of who you are to being a teacher? Would you want to give less? Why?
- ★ Are there parts of who you are that you keep for yourself, or is everything about who you are displayed like a teacher tattoo?
- ★ Do you have a fictional teacher (cartoon, movie, or whatever) that you identify with? What connects who you are as a teacher to who they are?

★ ASK-TIVITY: PIECES OF ME

Activities, activate! Let's work together to create space and opportunity for others to reflect in the same way that you just have, but with another easy-to-implement activity!

This is a visual activity that can have an added writing element if that's where your team is at. The idea here is that they'll design a visual piece similar to the tattoo you sketched, but focusing on how they see themselves.

Step 1—The Outline: Give participants a chance to sketch an outline of themselves or photocopy the one provided below.

Step 2—Brainstorm! Once the participants have drawn themselves or have a copy of the outline, ask them to think about all the things that make up who they are as human beings. This is a really fantastic moment to have a group discussion that both creates connections and highlights uniqueness. For example, there might be multiple people who play hockey. Connection. There may be only one person in the room who does something completely unique. (Maybe there's a kindergarten kiddo who's into restoring classic cars. You don't know until you ask!)

Step 3—Piece Yourself Together: Now ask participants to fill up their person with colors or images that cover them based on how much each thing makes them up as a person. For example, if they see themselves as a gamer, how much of who they are does that cover? What does that look like? If they've used words like *sibling*, *student*, or *dog caregiver*, what does that look like and how much does that cover? It's a really great opportunity to think about how the pieces of who they are create the full picture of their worn story.

Step 4—Sharing Is Caring: However you structure the creation part of this activity for your team, it is always essential to make space for them to share what they have created and reflected on. Make that space for them to be seen and heard, in written or oral form, and to then connect.

Modification here can look like simplifying. Give them the photocopy of the person, then have them color in or draw on things that make them who they are. Worry less about "how much" and focus on figuring out "what" they see themselves as.

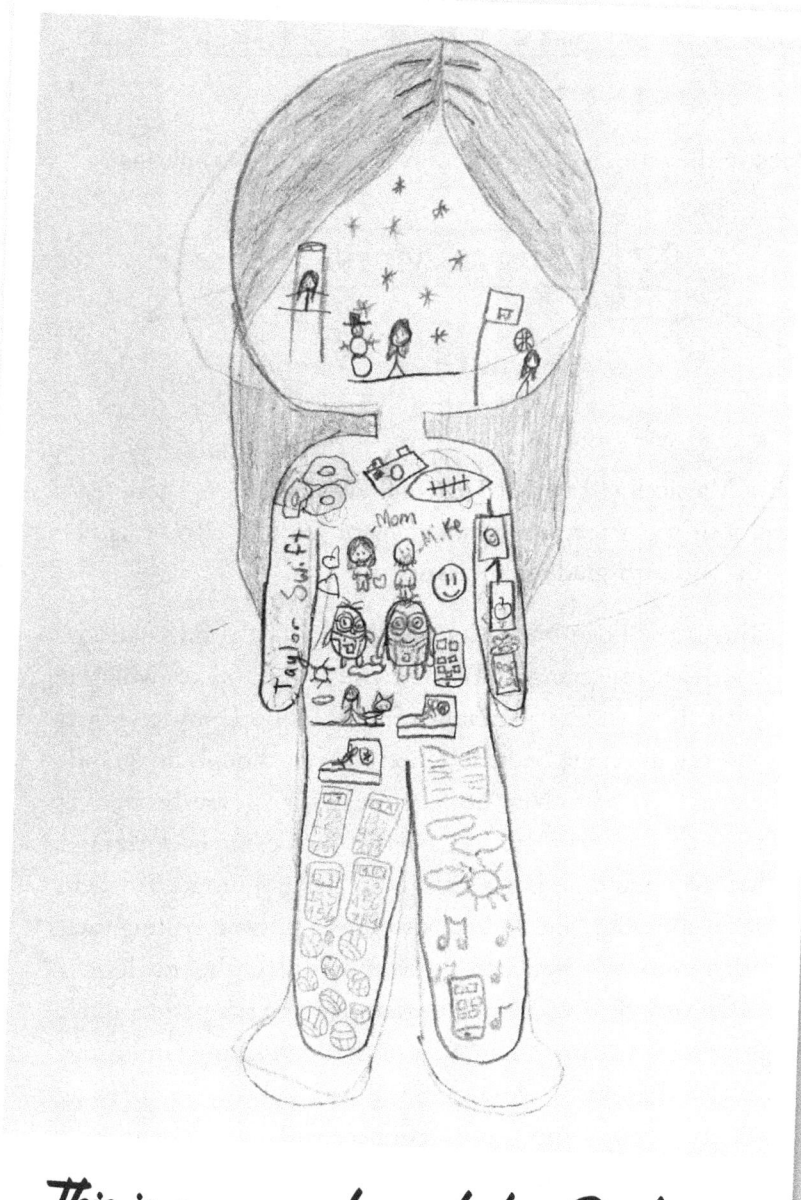

This is an example made by Daphne, a grade 6 student.

THE CANVAS WE ARE

Back in the tattooist's chair! This chapter we're spotlighting . . .

**Fourth-Grade Teacher
Arlington, Virginia**

Sierra Marsicek is a ten-year veteran educator. All of those ten years have been spent teaching grade 4, with her first two years being a fourth- and fifth-grade split classroom.

> This is my Loch Ness Monster tattoo. It's the only tattoo I have that my grandmother currently approves of, which is great, because she partially inspired it. Both my grandma and my mom are Scottish citizens. Even though my grandparents moved to New York before my mom was born, they went back to Scotland to have her, then came back to raise her. My grandma has always been fiercely proud of where she came from. She and her sister used to swap visiting each other every other year, so my sister and I had the privilege of being very close with my great-aunt. When she passed, it felt important to carry a reminder of that part of my family and culture that was so close to me while also being so far away. It's also a really fun way to connect with my students and some of the interesting parts of their own cultures.

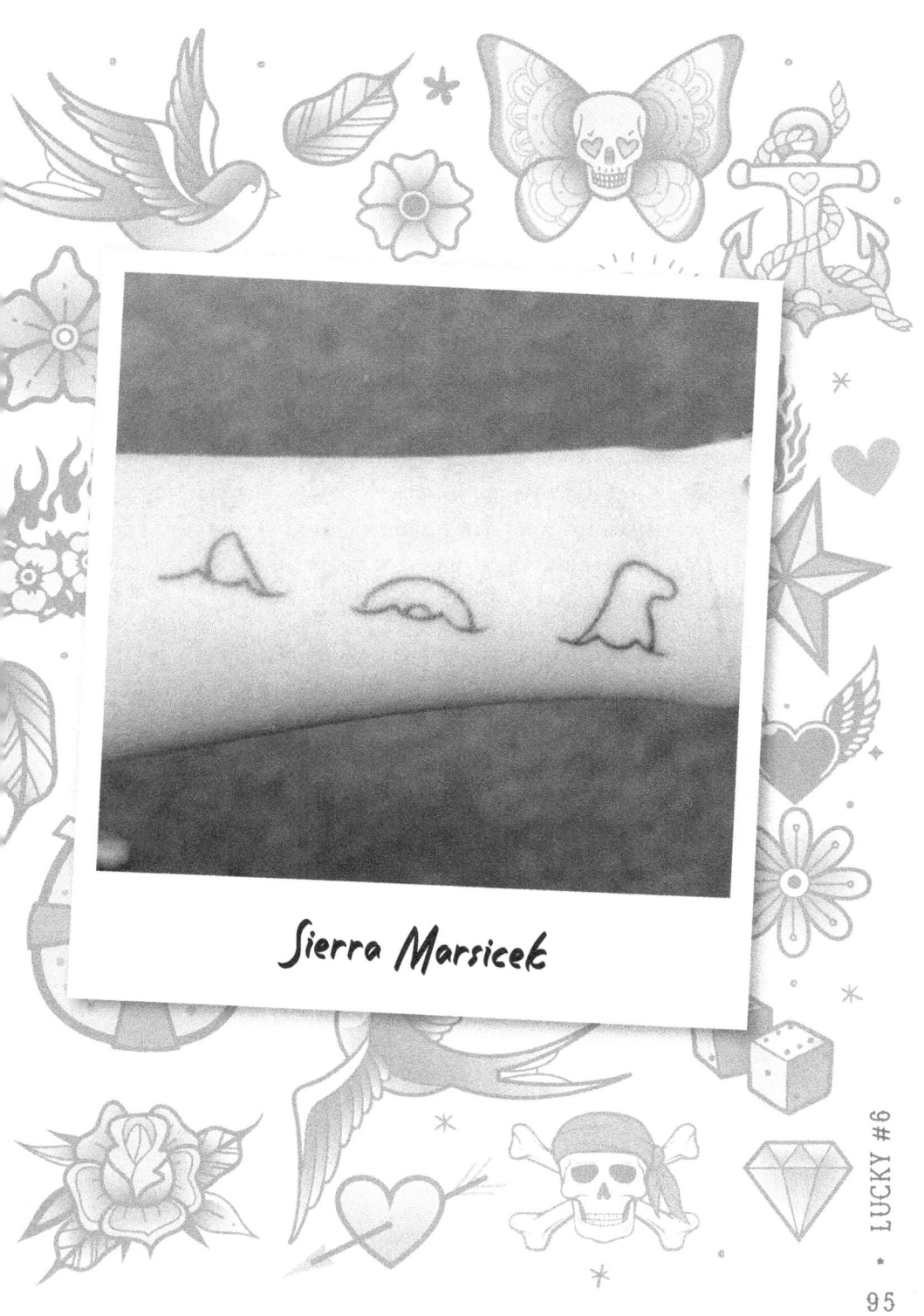

Katie Hinde

Associate Professor
Tempe, Arizona

Katie Hinde is an associate professor in the School of Human Evolution and Social Change and the Center for Evolution and Medicine, both at Arizona State University. She began her faculty career as an assistant professor in human evolutionary biology at Harvard University from 2011 to 2015. Hinde created March Mammal Madness, a month-long tournament extravaganza that celebrates animals, ecosystems, and science. In 2024, March Mammal Madness was played by over seven hundred thousand educators and learners. In 2023, Hinde was inducted as a lifetime Fellow by the American Association for the Advancement of Science.

> The annual six-thousand-mile migration of cliff swallows between Goya, Argentina, and San Juan Capistrano, California, is a powerful symbol of travelers that return home. As a scientist and educator, I have been able to travel all across the world, but from the beginning I wanted a tattoo about always returning to the home of my heart with my family. A few months after I got this swallow tattoo, while at an international conference, I learned my brother had experienced a catastrophic skull and brain injury and was in the ICU. I packed my bag and caught the next plane that could bring me home to Seattle. In the hospital, as my mom thanked me for coming home, I pointed to my swallow tattoo and said, "I don't just have this because it's pretty!" As my brother recovered, we laughed about that interaction, and a few months later he surprised me with his swallow tattoo on his forearm to match mine.

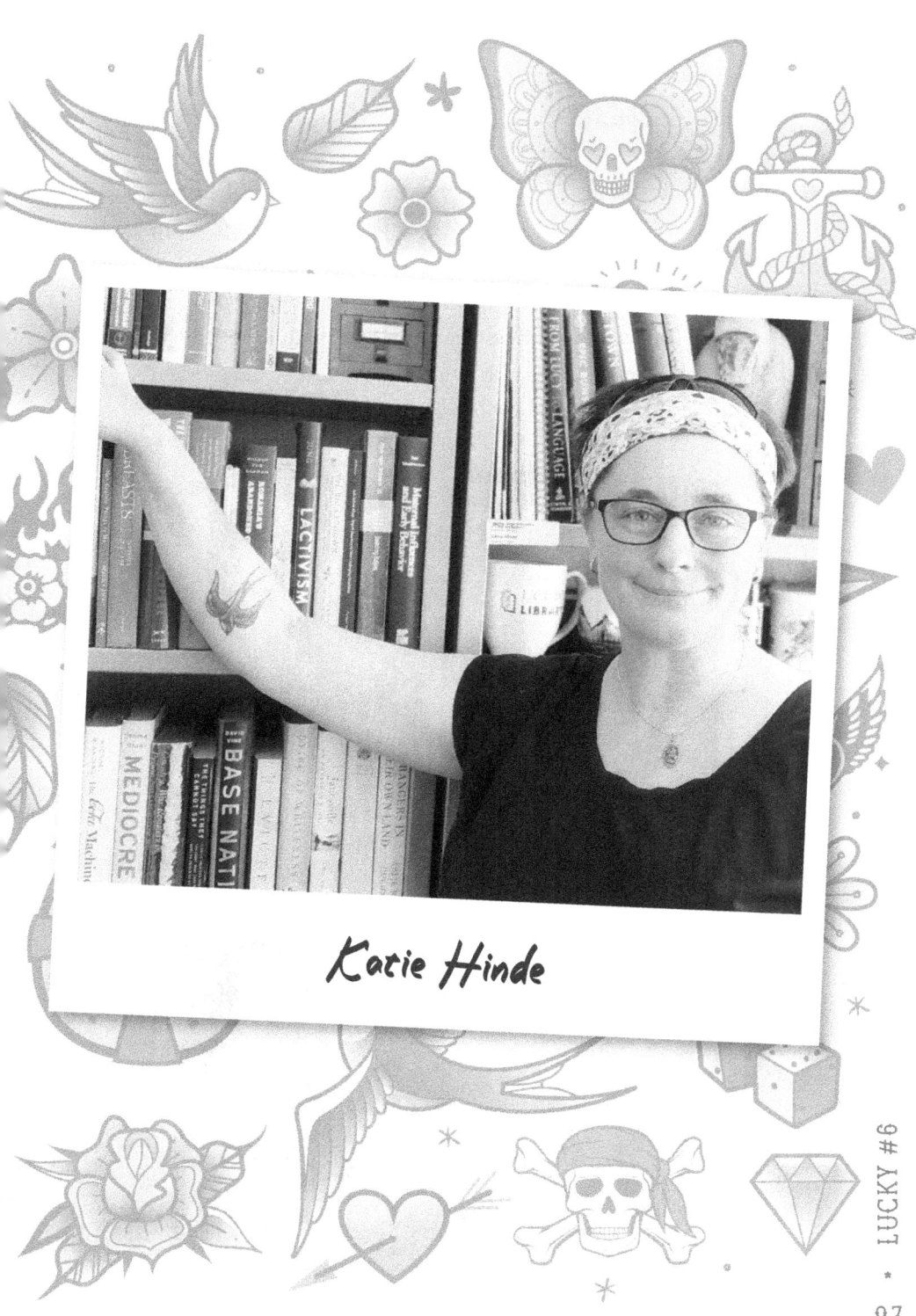

Katie Hinde

LUCKY #6

And this is my splendid beetle tattoo. I was searching for a scientific illustration of a beetle to use for my first tattoo in honor of J. B. S. Haldane's quote about "an inordinate fondness for beetles." Out of all the species identified scientifically, 350,000 to 400,000 are species of beetles, about one out of every four species. They represent adaptation, diversity, evolution, and resilience—a perfect symbol for a tattoo! I found a scientific illustration of a splendid beetle by Lizzie Harper, and my tattoo artist, Jerad Shealey, worked from that for the tattoo on my back.

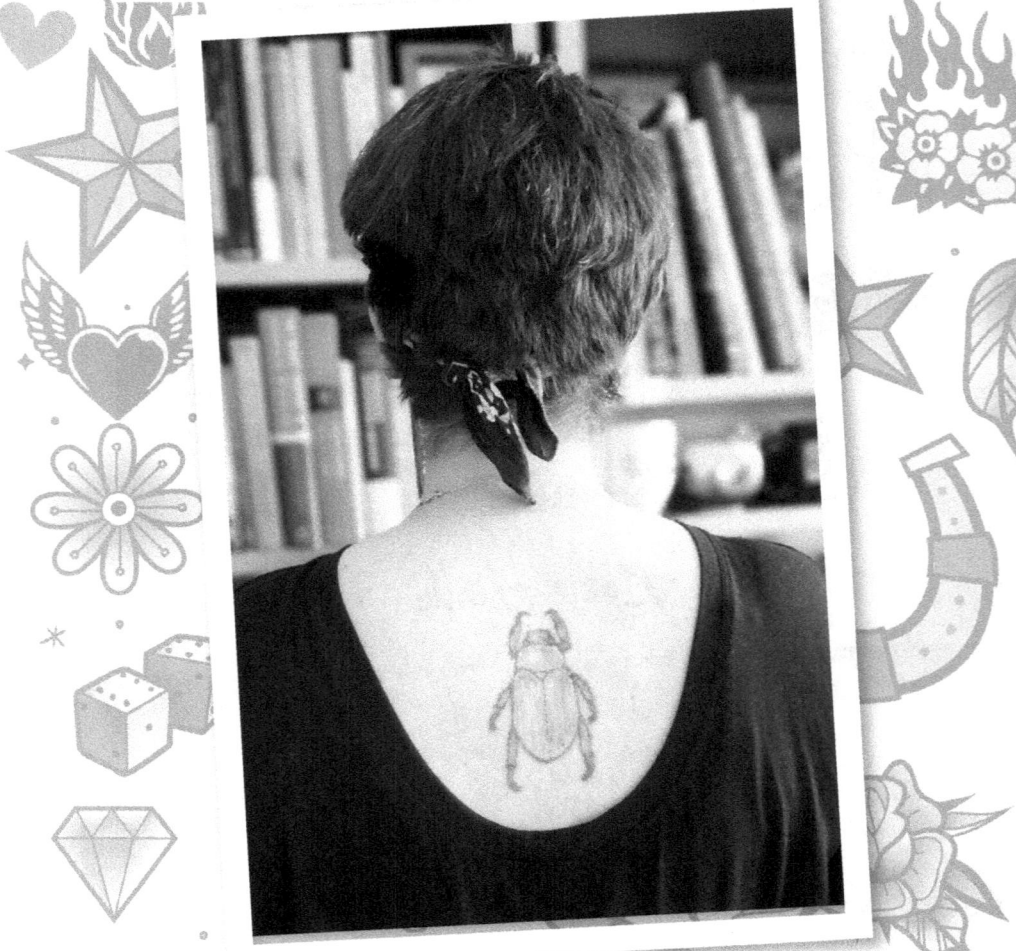

We're also shining the spotlight on...

Computer Science Teacher
Phoenix, Arizona

Leon A. Tynes Jr. is an award-winning educator and leader in STEM education, with over fifteen years of experience specializing in integrating technology into the classroom. He has developed innovative curricula that promote diversity and inclusion, particularly in computer science. His dedication to equity in education has earned him numerous accolades, including the 2023 and 2024 NCWIT state educator awards. Beyond his local impact, Tynes has contributed globally through fellowships with the Fulbright program in Morocco and the Grosvenor Teacher Fellowship in the Galapagos. Currently pursuing an EdD in STEM education at UMASS Lowell, Tynes continues to shape the future of STEM learning through research, student mentorship, and leadership in computer science and technology education.

> This tattoo was twenty years in the making. I found strength from it as I navigated the Eurocentric nature of the corporate world and graduate school. After some significant research, I found that the Egyptian civilization, a Black civilization, was the catalyst for nearly all European civilizations. Therefore, when I felt isolated and stressed being the only one in so many working environments and then classes, the tattoo reminded me of global achievements that came from Africa. The outline was a seven-hour experiment in scarification tattooing with the largest needle possible, and the keloid effect was by design. Ten years later, I finished the project with Patrick Conlon to highlight the prosperity and extinction of the civilization, paying homage to early imagery and glyphs.

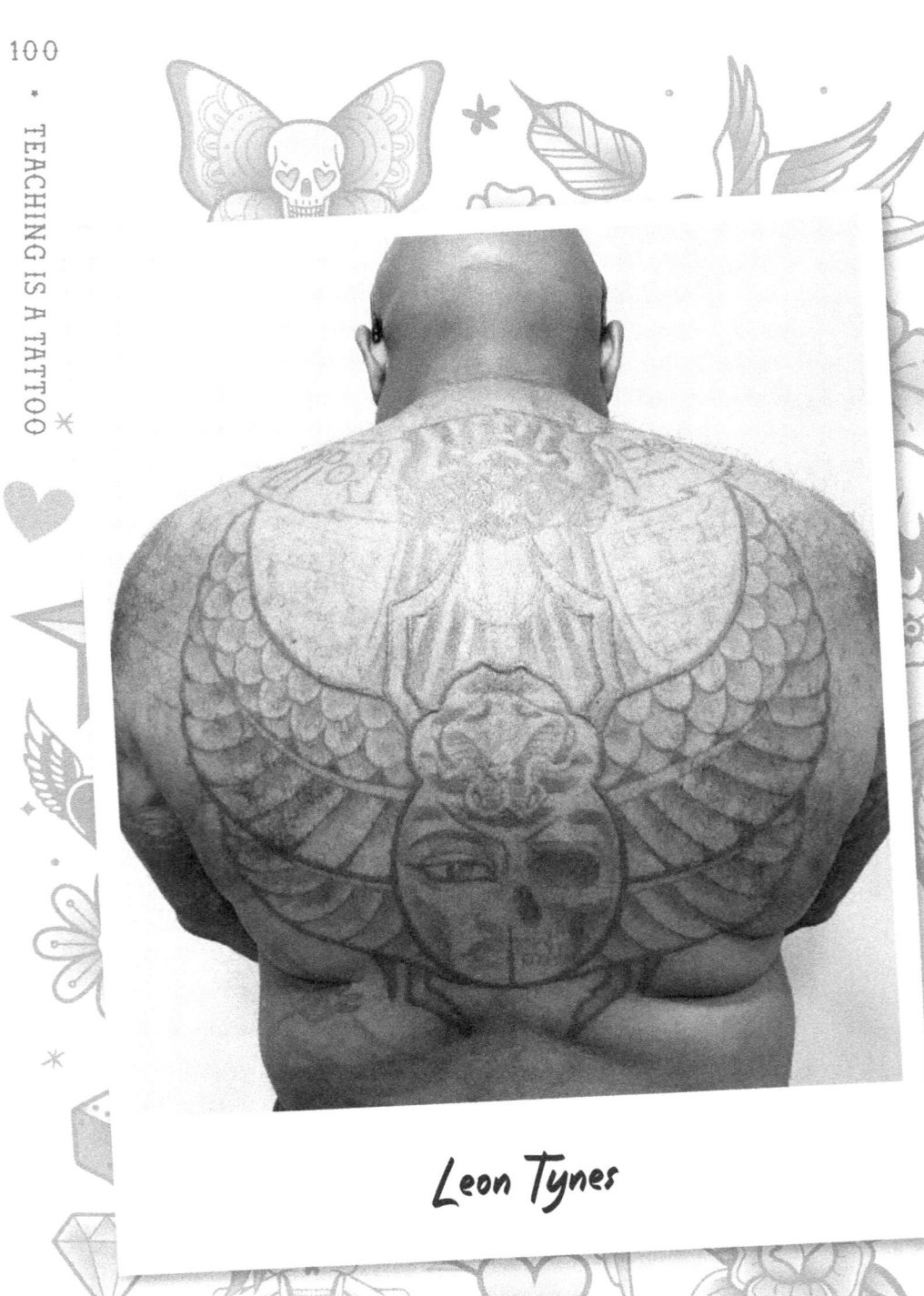

Leon Tynes

Micro Motivator

You own every inch of who you are. You also own what you wear on those inches. Choose wisely, own proudly, and share passionately.

Teaching is a tattoo because the closer you look at it, the easier it becomes to see imperfections (but there can be positives in that)

I get asked a lot about my favorites. I've been asked what my favorite food is, my favorite color, my favorite movie. I've been asked what my favorite video game is and what my favorite dinosaur is. My own kids even ask me if I have a favorite kid. My answers are simple. Fish tacos, green, *Jurassic Park*, *Tetris*, Ankylosaurus, and whichever one has the cleanest room at that moment. I also get asked if I have a favorite tattoo, being that I have so many of them. The real answer sounds cheesy, but the truth is that I don't have a favorite because each carries such a uniquely important story or moment or teaching for me. It's like comparing apples to oranges to fish tacos to Ankylosauruses. While I don't have favorites, I definitely have some that I see more than others just by virtue of their placement.

The tattoos on my forearms and wrists and hands are in plain sight as I write this, reminding me of the reasons that I chose to wear them. Both forearms are mostly covered. On the right side, I wear the words *Everything was Beautiful and Nothing Hurt*. I get asked about it the most often, I would say. I'm glad that I do. It is a beautiful piece that reminds me daily to keep perspective on things that are either beautiful or hurtful. Every time I look down, I am reminded that the beautiful and hurtful things I have experienced in my life sharpen the edge of one another. I wouldn't know something hurts were it not for all the beautiful things I can compare the pain to. On the flip side, I wouldn't be able to deeply appreciate just how lucky I am to have beautiful experiences if I hadn't also been hurt in my life. Everything is more beautiful when you understand how far away it is from hurt.

I decided to have this quote permanently tattooed on me because that is how I want to live. I want to appreciate the blessing of beauty through the unavoidability of hurt. Life is more meaningful in the balance between them. That's why teaching is a tattoo. Both are this incredible opportunity, every single day, to look closely at the flawed moments to help us appreciate and inform the beautiful. The closer we look, the easier it is to see the flaws and the negative, but there is perspective and balance that we can unlock through that.

Looking closely at something and embracing the beauty in imperfections can be game changing. You can go home at the end of a teaching day and tell yourself that everything was beautiful and nothing hurt that day, you can choose to embrace the wins exclusively and build on strength. That works for some people. Or you can embrace the idea that acknowledging imperfections just makes the story all the more real, which makes the next chapters you write that much richer. It's like I tell my students: Perfection is the worst possible goal to set for yourself. Aiming for perfection leaves no space for growth. Which means, mathematically, flaws and mistakes should be a goal. Mistakes and flaws have more value for learning and growth than perfection does. One of my favorite human beings of all time,

Maya Angelou, once said, "We delight in the beauty of the butterfly, but rarely admit the changes it has gone through to achieve that beauty." As much as we hope to be butterflies, I believe we should also delight in the change we go through as caterpillars to become something more beautiful. If a caterpillar already saw itself as flawless, it would miss out on an opportunity to grow, change, and fly.

It did take me some time to gain this perspective. When I first started out as a teacher, I kept a journal. It was a series of notes about things that were big hits and things that were absolute misses in my early teaching months. But it started to trend in a direction I didn't like. It ended up evolving into a negative list of things I had done wrong. Imperfections and mistakes. So I quit that journal and decided to be the guy singing in the car on the way home, exclusively embracing the victories of the day. That didn't work either. It took far more mental and emotional hustle to actively avoid any thoughts of imperfection. It was exhausting to force myself to be someone who only saw the forest when what I really needed was to take a good look at each tree. To balance my day and my experience as a teacher, I simply started to live by the feedback that I always gave my own students. We work hard in my classes talking about why perfection is a foolish goal. It is the goal that does the opposite when you achieve it. Being motivated to be better and better comes to a dead stop when you perceive flawlessness. You have nothing else to work on.

In my classes, we talk in terms of scar tissue and frames. Scar tissue isn't the prettiest skin, but it is the strongest, and it only comes after hurt. When we embrace the learning and imperfections, we own how we deal with those imperfections. They're ours when we discover them. They're ours when we see them. So what we do with them gets to be ours too. We have this superpower to build our own frames, to construct our own individual perspectives. If we build the right frame for how we see things, we can see imperfections as opportunities. That's fossil fuel—things that go extinct can move us forward. Giving myself the gift of this perspective made reflecting on imperfections the most real and satisfying part of my drive home.

And it made me sing louder in the car. Sometimes with the windows down.

If there's one thing I love more than car singing, it's the Japanese concept of wabi-sabi. It's this idea that things with imperfections have more value to us because those mistakes and accidents make them one of a kind and bind their value to stories. *Wabi-sabi* means "flawed beauty." I preface this by reminding you that I myself am not Japanese and that my knowledge of Japanese culture is limited, though I do have a very deep love for Godzilla and have seen all of his movies multiple times. I honestly love Godzilla. But I do embrace my understanding of wabi-sabi in so many aspects of life. I have a very large sneaker collection. An ever-growing sneaker collection. My favorite sneakers aren't the new ones straight out of the box (though there is a special kind of joy that comes from the first time you wear a pair that's all squeaky fresh). The sneakers that mean the most to me are the ones made imperfect through experience, through wear. I can tell you where I earned every scratch and scrape in their leather. I can still smell ocean or lake water on some of them. I like knowing that

the soles of some have been worn black by hiking mountain trails or walking infinite loops at Disneyland. All the painful rocks in our shoes can be reminders of places we adventured to. I can't walk by the window of a shoe store without rubbernecking at a new pair of kicks, but I don't love those shoes. Not yet. I just love the idea of them. I love what they could be if I had the chance to wear them into new adventures. Teaching and tattoos are both beautiful in the same way. Every new year and every blank inch of skin is a fresh pair of sneaks. Each scrape and smell and imperfection, each bruise and tattoo, each moment is this wabi-sabi wonderful imperfection, another brushstroke of flawed beauty, making that pair of shoes into your pair. No other pair will have ever been on the same journey. This is your pair of shoes. Nobody else's. This is your teaching. Nobody else's. These are your tattoos. Nobody else's. These are your imperfections. Nobody else's. In essence, this is all your story. Nobody else's. Wear it out loud.

Listen, I'll give you three guesses as to what comes next, and the first two don't count. That's right! Back for another opportunity to challenge you to own the things that you would proudly wear about who you are as an educator.

⭐ INK

This time around is simple: I'd like you to draw yourself a tattoo of an item—a physical item in your teaching life—that means a little more (or a lot more) to you because of the story behind it. How does the

story make you feel? Do you surround yourself with items like that at work? Desk toys and trinkets? Feel free to draw more than one!

★ THINK

Now that you've shown how stories tattoo themselves into your teaching, I want you to reflect for a few minutes on these guiding questions. Remember, always write your reflections down in ink. It's a powerful practice. Own why teaching is your tattoo.

- ★ How would you say you are imperfect as an educator? How do you think that imperfection might make you stronger in your teaching?
- ★ We often ask students for artifacts that demonstrate their learning. Would you say you're someone who values artifacts in your own life? What do they teach you about who you are?
- ★ In the metaphor of caterpillars and butterflies, do you feel like you're closer to being a caterpillar or a butterfly as a teacher? What makes you feel like that?
- ★ How do you approach failures as an educator—both your own and your students'? Are you happy with your relationship to imperfection? Why or why not?

★ ASK-TIVITY: WABI-SABI WONDERFUL

We're imperfect as educators, but activities are always perfection. Let's work together to create space and opportunity for others to reflect in the same way that you have above, but with an easy-to-implement activity!

This is a visual activity that will help participants learn the value of things that are perfectly imperfect and the stories that give both human beings and objects that wabi-sabi flawed beauty.

Step 1—Images: Either accumulate some simple blank images (vase, books, clothing items, whatever!) or select one item that all the participants will work with. I often use a blank pair of shoes for this

activity because it's really easy for anyone to picture their own shoes going for a walk that takes them from brand-new to full of worn stories. (Here, I'll even give you a blank sneaker!)

Step 2—Create! Once the participants have an item, have them draw a story into it. For example, have them mess up their shoe outlines to show the story of where they've been. Maybe they have seaweed and starfish on them if they're traveling into the ocean. Maybe they're full of sprinkles and icing because they spent the day walking through the bakery. Light the creative spark and let participants show that the more imperfect an item is, the better its stories are! This is how we learn the most about history too—by finding items from the past, well worn through time, and rediscovering the stories in them.

Step 3—Sharing Is Caring: Whatever the item is, whatever the story is, it is essential to make space to share it. You can create a display with each picture and add a writing element by including a story explanation below each drawing (like a wabi-sabi sneaker wall!). Allow for a gallery walk or a storytelling circle where each participant shares the story of their item. It all works as long as every voice and story has an opportunity to be heard. It is important that there is value placed on the stories that turn imperfections into meaning.

Again, this activity is already built to be very accessible, but it can be simplified. You can brainstorm ideas together, you can use the same object for everyone, you can even simplify the language by asking younger students, "Where did these shoes go walking and how do you show where they went?" Whatever works to help spur on that creativity and reflection!

This is an example made by Nathaniel, a grade 8 student.

THE CANVAS WE ARE

Back in the tattooist's chair! This chapter we're spotlighting . . .

Sean Arnold

**Public Schools Educator
New York City**

For twenty years, Sean has been an educator and administrator in NYC public schools (mostly District 75, citywide special education). He remains committed to accessibly and equitably reaching *all* students through innovative technology and practices. He was a featured voice at the International Society for Technology in Education 2023 conference and was named a top-thirty K–12 IT influencer. This is in addition to many other awards and certifications he has received. The areas in education where his expertise is most highly regarded include accessibility, gaming, challenge-based learning, computer science, and STEM. He shares his expertise at BraveInTheAttempt.com.

> I endured various hardships as a child and was diagnosed very early as being neurodivergent at a time when that was rarer than now. Maurice Sendak's *Where the Wild Things Are* spoke to me as a child because I often seethed with emotions and thoughts that few people around me seemed to understand but I couldn't find a way to verbalize. Sometimes that caused me to lash out in anger, a language that had become very familiar to me in my home. I found ways to hide my wolfish self behind a different human mask the world preferred. And I eventually learned to connect with the beasts inside of me and channel them into creative outlets that benefited the world.

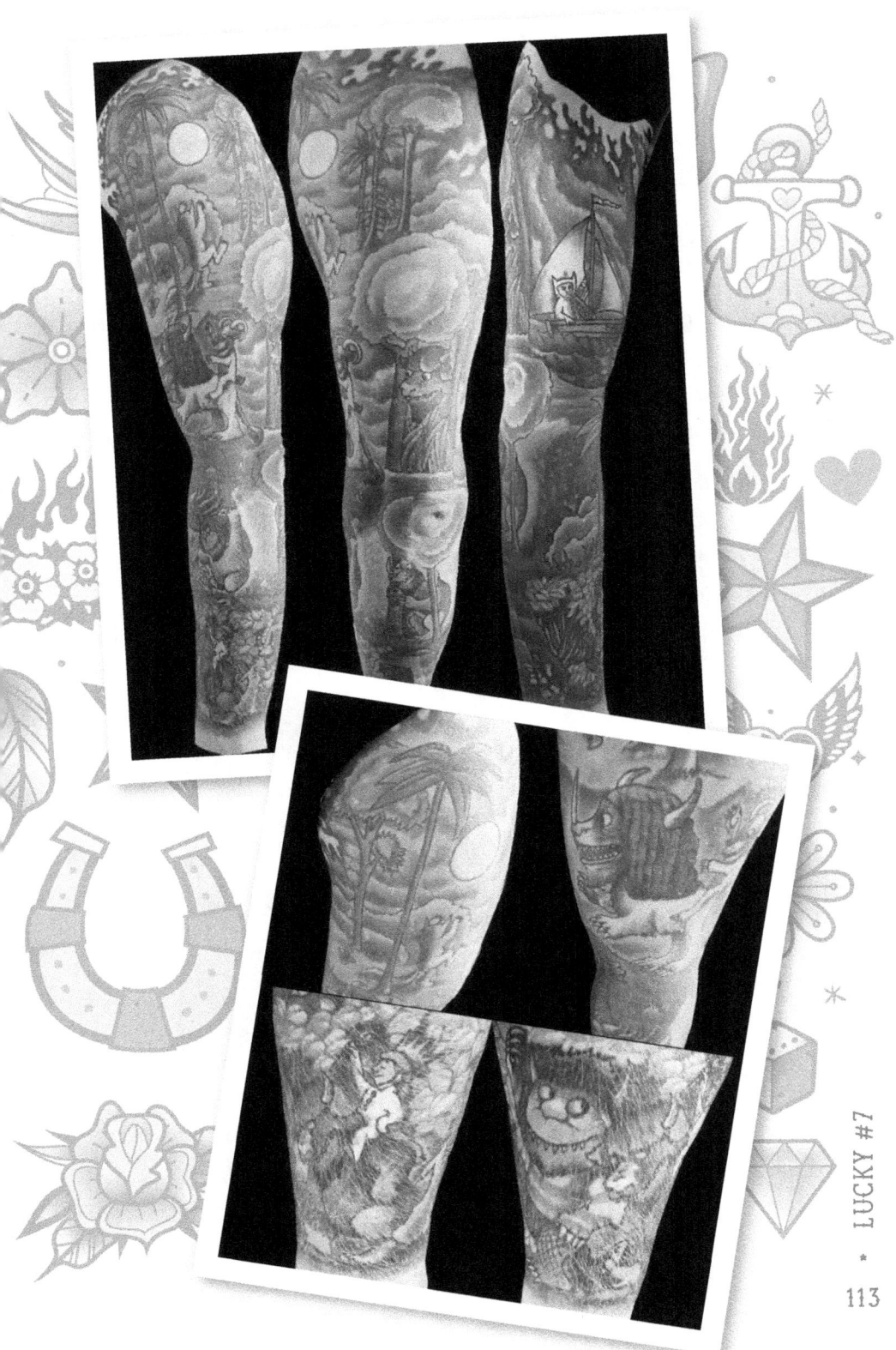

Marc Hodgkinson

Teacher
London, Ontario, Canada

Marc Hodgkinson has been an educator for twenty-eight years with the Thames Valley District School Board in London, Ontario, Canada. He's taught grades 4 to 8, but most of his time has been in a grade 7 or 8 classroom. He's currently teaching grade 7 at Sir Arthur Currie Public School in London.

> My tattoo is my wife's name and the date of our first date. It's significant because I don't wear jewelry (other than a watch, occasionally), so I chose to wear a tattoo representation. I got the tattoo in New York instead of a wedding ring.

We're also shining the spotlight on…

Holly Stuart

Scientific Educational Specialist
South Carolina

Holly Stuart is a wife, mother, scientist, and educator. She began her career working as a scientist in a research lab after graduate school before taking a hiatus to stay at home and raise three amazing children. When she returned to work, she entered the world of education because she wanted to share her love of science with others. Currently, she is the education specialist for a scientific company dedicated to frugal science. Her focus is on creating equitable and accessible tools and resources that are high quality and low cost, enabling her passion for science to extend globally. She has connected with educational communities across the United States, India, Ghana, Peru, and many other places where people have traditionally been marginalized and underrepresented in the sciences. Each interaction is proof that both science and scientists are everywhere.

> The tattoo I'm sharing is not just a design; it's a narrative of who I am. At the heart of the tattoo is an open book, symbolizing my deep love for knowledge and the joy of learning. From its pages, a tree emerges, representing my appreciation for the outdoors and the wonder of nature. This connection beautifully illustrates my belief that as we learn, we grow. The final elements are the words: "aprender," "crecer," and "inspirar." Translated, they mean "learn," "grow," and "inspire." I chose to write these words in Spanish, my second language, to honor my love for languages and cultures. This single image serves as a permanent reminder of my commitment to cultivating curiosity, both in myself and in those I teach.

116 · TEACHING IS A TATTOO

Holly Stuart

Micro Motivator

Every inch of you is wabi-sabi wonderful. You are a collection of perfectly imperfect moments and stories. Embrace that flawed beauty, little caterpillar. Use it to teach yourself to fly.

Teaching is a tattoo because both can be painful, both are worth the pain, and healing is an essential part of the process for both

Some kinds of pain are a choice. But other kinds of pain are absolutely not a choice. Nobody chooses dog bites or bee stings. That's why Maria from *The Sound of Music* sing-lists her favorite things; by remembering them, she is making the choice to acknowledge the impact of pain and how it has built effective strategies for healing—once the dog has bitten and the bee has stung. Of course, Maria was once described by her peers as a "flibbertigibbet," and she includes doorbells as one of her favorite things, but I still think that there is value in her perspective. Pain comes with the territory of being a teacher—this work is too human not to be painful at times. But like getting a tattoo, it's undeniably worth that pain, and it also requires healing.

That's the funny thing about pain; it is a sensation that our bodies are hardwired to try to avoid, but there are still pains we choose, knowing full well they will hurt. We hope that when we get out on the other side, that hurt will have been worth it. People who work out choose pain. That's where the expression "no pain, no gain" comes from. You actually have to break down muscle tissue to build new muscle tissue. The gain makes the healing a worthy cost. People who push their bodies beyond limits in sports choose pain. The victories, the personal bests, the achievements make the healing a worthy cost. People who have children choose pain, primarily in childbirth, but also in stepping on Lego pieces, dealing with wailing meltdowns, and raising teenagers. All painful. But watching who they become makes the quiet healing moments after they've gone to bed a worthy cost. Teaching is a tattoo because people who choose both teaching and tattoos are people who choose moments of pain, of genuine hurt. Getting to have all the stories, learning, victories in understanding, personal-best pedagogies, and views of who each student becomes in their time with you—all of it makes the healing a worthy cost in innumerable ways.

There is power in knowing that you'll have to heal before you even step into the work. When you know that things will be painful, when you know that there will be damage, you can plan accordingly for the care you need to take. That's why, both in teaching and tattoos, you need to leave space and strategies for yourself to deal with the ouch. A lack of proper aftercare will mess up the look of a tattoo the same way that a lack of proper self-care will turn painful experiences bitter. Don't risk the infection. Don't risk the added discomfort of carrying around pain too long after its moment has passed. Plan for pain management. Know how to keep your skin at the right thickness through it all. You always run the risk of letting your skin get too thick, scarred in healing. You don't want to be that person. There is a reason that you chose to work in the business of human beings, and the thicker you let your skin get, the further away you are from the heart of what made you care about this work in the

first place. Literally. Your heart's ability to care about and connect with other hearts is what, in part, called you to this work. But there's also the risk of not letting yourself heal properly. In both teaching and tattoos, the healing process is as individual and valuable as the human being.

I personally heal from tattoos within a matter of days, while I have friends who stay puffy and red for weeks. The same is true for teachers. We pour ourselves into the business of human beings. While many folks get the metaphorical protection of a sternum and rib cage, educators inherently wear our hearts on our sleeves. This makes it so much easier to connect, but we lack the safety of dissociation. Because teaching is so human, because who we are as people is inseparable from how we work as teachers, the way we care and hurt and heal in the work are as unique as who we are in the work. With both teaching and tattoos, there is an understanding that if we're doing it right, we'll have painful moments. If we want to keep doing it right, we have to respect that our healing is part of that process.

Pain is too often villainized. Pain isn't the bad guy it's made out to be. Pain is just a response to a stimulus. Pain is information processed internally about external happenings. I believe that pain can also signal opportunity to prioritize healing and growth through learning. We don't need to avoid it or pretend it isn't part of the experience. It is inaccurate to look at your work as an educator through rose-colored glasses. It's also unfair to set yourself up like that. Pain is part of so

many great processes, but we too often see it as the only part, or at least the part that we sometimes work hard to avoid. But let's do a little math so I can show you how valuable pain can be in any chosen process. If you accept something as personally valuable, you accept the risk of experiencing pain. We do that working in the field of education. No personal value means no personal risk. If you accept the risk, you're accepting the reality of potential pain.

Accepting that reality means that, consciously or not, you are accepting the potential need for healing. The human body and the human heart are preprogrammed to at least try to heal. So, mathematically, every time we accept anything that has potential for pain, you are also accepting the potential need to heal from that pain. Pain is not a villain. Pain is an opportunity. An opportunity for perspective, for giving yourself equal space to heal. An opportunity to come out better than when you went into the hurt. That shows you value not only yourself, but you also value the thing you're pursuing. Pain is temporary; what you earn through that pain can be limitless. It can change you physically. That's why teaching is a tattoo: Both can be a painful choice to make, but both require time and care to heal.

If you've ever gotten your own tattoo, you know that the process of getting inked isn't exactly comfortable. You know that it directly affects how you need to heal in the days after. Some tattoos change how we sit for a few days, the clothes we can wear, the positions that we sleep in. Some moments in teaching are the same. There is pain that comes with the job. Students come to school feeling every type of broken and hurt, carrying the heaviest baggage of what goes on outside of school. When they hurt, we hurt with them. There are days where they bring social, emotional, or physical pain. There are days burdened with trauma, days when their home lives make learning impossible. There is too often the pain of hungry bellies, and we share that pain in knowing we can't feed them all enough. We carry the pain of missing them and worrying about them in the hours that they aren't with us. That sting is part of wearing meaningful things. There is no healing from temporary tattoos because they

don't require the same commitment and care. They don't become physically part of us in the same way.

Meaningful connections and moments and stories weave themselves into the skin of us. That changing of our skin and stories can be painful, and I definitely believe that we should all live by the idea that some pain is worth it. I believe that we should absolutely embrace the value of what some pain can teach us, how it can change us. But I also think that it is essential we never forget the end of that equation: Pain can be positive, but only if we give ourselves what we need to heal from it. We don't just reset after the hard days and painful moments. We must take the opportunity to learn and grow and then give ourselves grace. We must give ourselves new kindness after each pain. Learn from each pain. Grow from each pain. Embrace that earned scar tissue. Remind yourself that more pain will come, but that's how we know what we're doing is worth something. But remind yourself, too, that you're wonderfully human in this work, and you're worth something: You're worth healing.

We're back for another opportunity to challenge you to own the things that you would proudly wear about who you are as an educator!

★ INK

The challenge this time: I'd like you to draw yourself a tattoo that represents a thing (or several things!) that you choose for self-care and healing. Be selfish in this one and make sure that you're drawing

a tattoo that represents something you do exclusively to take care of you.

★ THINK

Now that you've owned what you do to heal and care for yourself, I want you to reflect for a few minutes on these guiding questions. Remember, always write your reflections down. Physically putting things down in ink is powerful practice. Own why teaching is your tattoo.

- ★ What parts of teaching do you personally find painful? How do you reset and give yourself the grace to move forward from it?
- ★ What is something you do exclusively for yourself? What does it do for you as a person?
- ★ Outside of teaching, are there types of pain that you choose? What do you gain from these pains?
- ★ Think about a specific painful moment as a teacher. What did you learn from it? Why was it worth it?

★ ASK-TIVITY: THE HELPING HEART

One thing that isn't painful? Easy and ready-to-use activities! Let's work together to create space and opportunity for others to reflect in the same way that you've been given the chance to in the section above!

This is a visual activity that will help participants learn to give substance to the things that hurt and heal them. It is important to be able to identify these things in order to own them.

Step 1—Get Hearts: Each participant will need two copies of a blank heart. The idea is that they will be filling the heart with images, so it should take up as much of the page as possible, leaving space for creation!

Step 2—Fill Your Heart: Once the participants have two hearts, ask them to fill one with images of things that are hard on their hearts. I know, this seems like focusing on the negative, but when they share these, it will actually be a really powerful moment to get to know each other better. This is also a really fabulous community builder and reference point. When there are future incidents in your classroom or community where people hurt each other (which does happen), they can reference this activity to learn how to help heal one another.

Once they are done filling in the heart with things that hurt, have them fill in the second heart with things that make them feel better. What do they do to heal after being saddened or hurt? This creates an aftercare database of ways to help each other.

Step 3—Sharing Is Caring: I would argue that sharing is the most important part of this activity. However you make space to share each heart (in a classroom circle talk, by posting them on the walls), you create an opportunity for students to see each other more authentically and gain strategies to be heart helpers when needed.

Again, this activity is already built to be very accessible, but it can be adjusted. You can brainstorm ideas together, have chats before participants begin, or read a great picture book together before starting!

THE CANVAS WE ARE

Back in the tattooist's chair! This chapter we're spotlighting . . .

Karen Caswell

**Primary Teacher
Logan, Queensland, Australia**

Karen is an early-childhood-trained teacher who has also been privileged to work in a variety of roles and settings during her twenty-eight-year career, and she is currently a teacher at a primary school in Logan, Queensland, Australia. She is a writer and the creator of the *Authenticity in Edu* blog as well as the host of the *Inspiration, Influence and Impact* podcast for educators. Karen's purpose is to support people by helping them be reflective and feel connected so that they know and understand who they are and how they can make a difference to themselves and others.

> This is my tattoo. I never thought I'd ever get a tattoo but decided on this one after a period of significant depression. It's a reminder to believe in myself, believe in my journey, and believe it's meant to be, with the butterfly symbolizing hope and transformation.

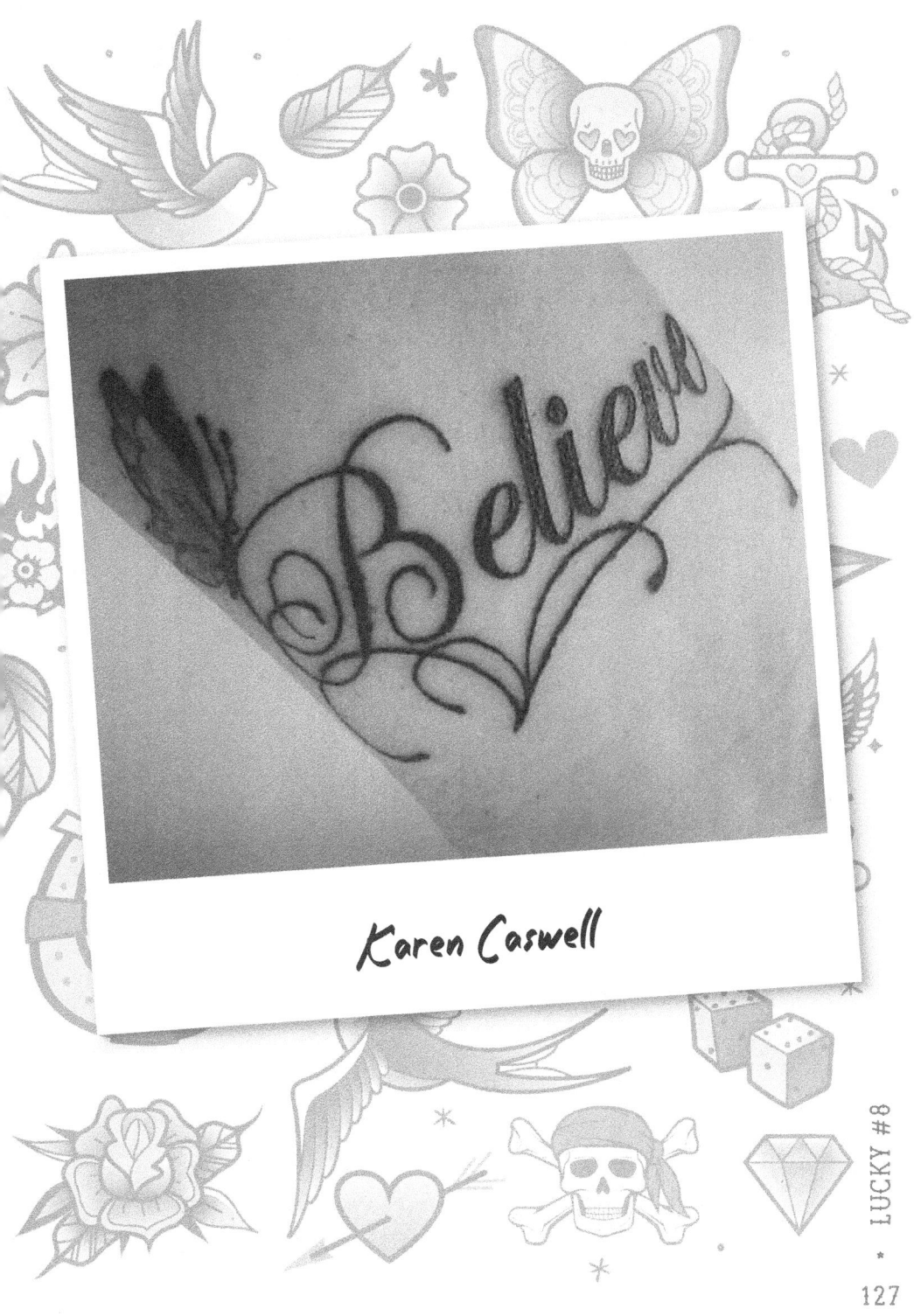

Mike Llerena

**Languages Teacher
South Korea**

Mike Llerena is a passionate teacher with over sixteen years of experience teaching languages. He speaks four languages himself, and his sixteen-year adventure as an educator has taken him on travels around the world.

> I've always felt that tattoos are an artistic and unique way for humans to express their life experiences. This tattoo is my own design, mixed with and inspired by a Viking vibe. To me, it shows life, death, and reincarnation. It also carries pieces of my family and my own strengths as a person.

Mike Llerena

Micro Motivator

Pain isn't something to be avoided, it is something to be prepared for. Stay open to things that might be painful. They often end up worth it, but only if you embrace the healing too.

Teaching is a tattoo because both are things that we do to feel a little more seen as a human being

I know when my dog is happy. Which is good, because I want him to be as happy as possible as often as possible. I love that dog. I tell him constantly that he's a good boy. In fact, I tell him multiple times a day that he is the best boy. He, in turn, does not understand much English and so has no concept of what "best" means. When dogs are happy, they have these uncontrollable responses. My own dog will run around with stuffed toys in his mouth when he has big feels. Or he'll lick my face, despite my objections. His most overt reaction to happiness is that his tail wags with reckless abandon. Sometimes he is so happy that his entire back end, straight from the hips down, will sway side to side like it's trying to separate itself from the front half of his body. All dogs have their tells for happiness. They didn't evolve mechanisms for hiding or downplaying or dismissing those positive emotions. Dogs cannot pretend to be

happy. Human beings are different in that way. Even something like a smile can be falsified or suppressed. Emotions aren't really a choice, but the overt reaction to them can be at times. That's one of the reasons why taking the time and having the care to recognize the lived emotional experiences of the people around us is so essential. If we don't care enough to see it, they might not feel like there's a place where they are cared enough about to show it.

There was a fascinating little photo essay, a theory and idea made into a beautiful visual, that showed the way ice crystals formed in water was directly affected by the positive and negative nature of the words spoken into that water during the freezing process. Words like *love* created these beautiful symmetrical patterns in the ice whereas words like *evil* created disconnected and disfigured shapes. The science is solid; words can have a physical and measurable effect. The intentions behind what we say, the act of speaking our thoughts and feelings aloud, physically affects the world around us. People have said some very positive things to me over the years, and I make a conscious effort to be openly appreciative in return. I've had people tell me that I have a kindness in my eyes when I speak. I have been called creative, caring, and empathetic. I have been told that I am a good dad. All those things, once verbalized, vibrated into the over 60 percent of me that is water, affecting how my fluids flow. Those positive words have physically become part of me, literally making me a better version of myself. We all have the option to keep our thoughts to ourselves, so that choice to turn thoughts into soundwaves and send them out into the world is a wildly impactful thing. We have almost infinite words, motivations, reasons, and moments to bring into physical existence. But within all that, the most powerful and meaningful thing we can say to another human being (as long as we mean it) is "I see you."

It is not something to say lightly. It's something to say with honesty and consideration. You're not giving them an update on how well your eyes work (unless you're at the optometrist). This is you telling another human being that you see who they are, that when

you look at them, you see more than muscle and bone. You are telling someone that you have taken the time and care to prioritize knowing who they actually are. You're saying that with your finite minutes in this life, you chose to use some of that time understanding them. As social animals, that matters big-time to us. Feeling seen hits almost every level of Maslow's hierarchy of needs. It lets us know that our existence has value. It helps us all feel safety and the interconnectivity of love and belonging. It helps us to self-actualize and feel purpose. That's why teaching is a tattoo—because if we're being really honest with ourselves, both are things that we choose to do to feel a little more seen as a human being. People don't get tattoos so that nobody ever sees them. At the very least, the artist holding the tattoo machine gets to know your story. The same is true for teaching.

People don't get into the business of teaching to hide in the corner. We get into teaching because we want to exist meaningfully and be part of something bigger than ourselves. We get into the business of human beings because we want to be part of what other human beings become. We see the value of legacy and human connection. We know the worth of being seen and helping others feel seen. The existence that we create, like all great tattoos, matters most when others can be part of the experience, when it means something, when it is really seen. We also help to create possibilities for students and colleagues by acknowledging that their stories deserve to be seen as much as our own.

Driving home one day, it occurred to me that every singer I sing along with on the radio knows they can sing because someone heard them sing and said, "That's good singing right there." So they recorded that singing and now play it back for others to hear. It floored me to realize that there are students in our classes that might have incredible voices and have absolutely no idea because they've never had a moment where they felt like they should sing out loud. They've been too quiet or shy or life has given them too many reasons to not let their voice sing out. This is part of the beauty of being educators; when we help others feel seen, we open up countless potential

paths for them, and in a way, that makes us seen too. Their choices, the songs and stories they create—that's in part us. Without us being who we are, there are undeniably some students who would never find their voice. What more beautiful way is there to be seen than to have a meaningful impact in the stories of who all these kiddos become? What more powerful way is there to be seen than to have the story of who you are woven inextricably into the stories others are writing of themselves?

Every few years my students and I do a deep-dive film study of an exceptional film called *Big Fish*. It is one of my all-time favorite movies. I think the only movie that I've rewatched more times in my life is *Jurassic Park*. My students and I call it "The Danny DeVito Booty Movie," as there is a scene in which you do indeed get to see Danny DeVito's booty in all its glory. Don't worry, I send a note home with students first so that everyone is on the same page with the backside that we're about to collectively experience. It is arguably one of the top three moments of Danny DeVito nudity in cinema history. I adore *Big Fish*. It's quirky and clever and plays the heartstrings so deftly. I don't want to spoil it for you; I'm genuinely hoping that you watch it yourself. But the premise is that there is a man trying to separate what is fact and what is fiction in the elaborate stories that his father told him about the life he has lived, trying to repair their relationship in his final days.

I believe that there are moments in movies and music and shows and books and pop culture that tattoo themselves onto who we are. That is very true of *Big Fish* for me. There is a stunning moment where a girl opens her window to see that a boy has brought her a literal entire field of daffodils, her favorite flower. The music swells and you understand what it means to love someone like a field full of their favorite thing. There is a second moment where one of the characters explains that, to this man in love, there has only ever been two women that have existed in the world: the woman he loves, and everyone else. That moment made itself a permanent part of how I understand love. A third moment, one that ties itself best to what

we're doing as educators, is when the young man comes to the understanding that you can't separate a person from their stories.

Each of us becomes our stories. That is why teaching is a tattoo. We do both to be a little more seen because we understand the power of not only living our own stories, but also of being a meaningful character in the stories of others. We become larger-than-life fish tales. We become memories and "remember whens." When we are seen for who we are as teachers, we become as close to being immortal as possible. We become part of what our students become, part of their memories and growth, because we're doing the very human work of helping them write their own stories. We're helping them become those stories. Even as background characters to their main character existence, we understand that just being seen in their story changes what it can become.

Both teaching and tattoos show that we understand and appreciate that the power of anyone's story lies in having others experience and interact with it. Both teaching and tattoos show that we understand the impact and value of being seen. We ask for the responsibility of it. We know what we're getting into when we sign on for both. When we teach or get tattoos, it's because there is an understanding that being seen means you're engaging in something worth seeing, a story worth hearing and living. There is an epic cycle there. The more we value being seen and heard, the more we show our students

the value of being seen and heard. The more they see who we are, the more they know that who they are deserves to be seen too. There is another brilliant little film called *Coco*. It shows off aspects of the beautiful, colorful, musical, and passionate Latinx culture. I am not Latinx, but one of my takeaways from this movie is that there is a cultural importance placed on remembering, celebrating, and talking about the lives and lessons of those that came before us.

Many cultures place great importance on the acknowledgment of ancestors, but the movie *Coco* is an experience that streamlines that message and highlights Latinx culture—plus the soundtrack is a banger. In the movie, if people are forgotten by the living, then they disappear forever in the land of the dead. Again, proof positive of the power of being seen. Of course we want to be seen as human beings. Not only does it remind us that our existence matters, but both *Big Fish* and *Coco* speak volumes to the importance of how our existence is remembered. The stories we become matter as deeply as the people who tell the stories of us long after we're gone.

And don't worry, there's nothing selfish in wanting to be seen. It is fundamentally human to want to feel like our existence matters, that our story will continue to be told through the lives of those that come after us. I want you to embrace the fact that there is a part of you that chooses the very human work of teaching because you want to feel a little more seen. That, like tattoos, just goes to show that you value the moments of your life enough to share them. Own your need to be seen, but know that there is responsibility in that. When you acknowledge that teaching and tattoos are things that we choose to do in part to be seen a little more as human beings, then you can commit to living stories that are inspiring to see. Embracing an audience makes for better stories. Teaching is a tattoo because both create opportunities to be seen. Own that. You're absolutely worth being seen. Own that too.

We're back for another opportunity to challenge you to own the things that you would proudly wear about who you are as an educator!

⭐ INK

Here's the tattoo design challenge this time around: I'd like you to draw yourself a tattoo that represents what you hope you look like when people see you. Like, really honestly see you. In an ideal reality, what do you hope people see? (Feel free to get as creative as you'd like with representations. That's what tattoos do!)

⭐ THINK

Now that you've owned what you hope people see in you, I want you to reflect for a few minutes on these guiding questions. Remember, always write your reflections down. Physically putting things down in ink is powerful practice. Own why teaching is your tattoo.

- ⭐ What parts of who you are do you hope people really see? Why do you hope those parts of you are seen?
- ⭐ What do you actively do to make those parts of yourself seen?
- ⭐ Do you think you're seen the way you want to be seen as an educator and a human being? Why or why not?
- ⭐ How do you think those parts of who you are show themselves in your work as a teacher?
- ⭐ How do you make sure the people around you know you really see them?

LUCKY #9

⭐ ASK-TIVITY: SEE YOUR TEAMMATES AS THEY SEE THEMSELVES

It's easy to see how great ready-made activities are! Let's work together to create space and opportunity for others to reflect in the same way that you've been given the chance to in the section above!

This is a fun and engaging visual activity that lets participants show others how they see themselves through team-building trading cards!

Step 1—Prep Your Cards: Each participant will be creating their own personal trading card, like an old-school baseball or hockey card, with an action picture on the front and important individual info on the back. I've included a simple template if that helps!

You'll also want to develop some info sections or questions to fill out on the back. This one is up to you because you know your participants best. It will look very different if your participants are early year students versus your colleagues, so make it an authentic reflection for your team. Here are some suggestions for things you might want to include on the back of the card:

- ✯ Name/nickname/what you like to be called
- ✯ Best things about you as a person
- ✯ Things you are good at (what you bring to our team)
- ✯ What family looks like for you
- ✯ Things that you are working on improving about yourself
- ✯ Unique skills/talents that you have
- ✯ Your favorite (foods, places, activities, etc.)
- ✯ Your theme song

Step 2—Create! Once the participants have their cards, have them draw themselves on the front of the card. I have actually given students mirrors for this part because we don't often take the time to look at ourselves (you'd be surprised how much this simple act makes students smile). I've also often asked them to draw themselves in action doing their favorite activity because it shows people what they like to do and makes it look more like a traditional trading card.

Step 3—Sharing Is Caring: This is always the most important part of the work, especially for helping everyone feel seen! There are some great ways to make space to share this work. You can actually photocopy or print each card and have participants trade them with one another, you can have them share in a circle or present them, or you can even make a wall display. A few times, as a really great starter to the year, I've had students or staff make their cards, then I scan them into little booklets and send those booklets home so that they can introduce their school teams to the people on their home teams.

Accessibility here looks like modifying the questions on the back of the card. If you have participants who aren't in a position to write

that effectively yet, you can simplify what you ask them, you can have them talk through their answers rather than write them down, or you can even make videos of each student or staff member responding and send a link out so that the community can meet the team! (I've done that last one myself, and it's great!)

This is an example (complete with stats!) made by Sawyer, a grade 4 student.

My name is Sawyer. I am creative. I am good at hockey. I am vary friendly. I like fantasy. I like to play. I also like to draw.

stats
creative: 10 friendly: 10
drawing: 8 playing: 8
sports: 9 gaming: 9

THE CANVAS WE ARE

Back in the tattooist's chair! This chapter we're spotlighting . . .

Lucy Sayer

Religious Education Teacher
Plymouth, England

Lucy Sayer is a religious education teacher from Plymouth, England, who dabbles in travel and photography.

> I have been a religious education teacher for almost twenty years. Not religious myself, I took a year out in '05 to visit many of the places and cultures that I teach about. When I came back, I was a little lost. The lotus flower on my left wrist is inspired by Buddhism; the idea being that beautiful flowers can emerge from swampy, pond-like water. This is why many images of the Buddha show him sitting on a lotus/lily. I had this one done soon after returning. On my right wrist is Ganesh. As the Hindu deity who helps us overcome obstacles in life, he's been pretty apt for the past few years.

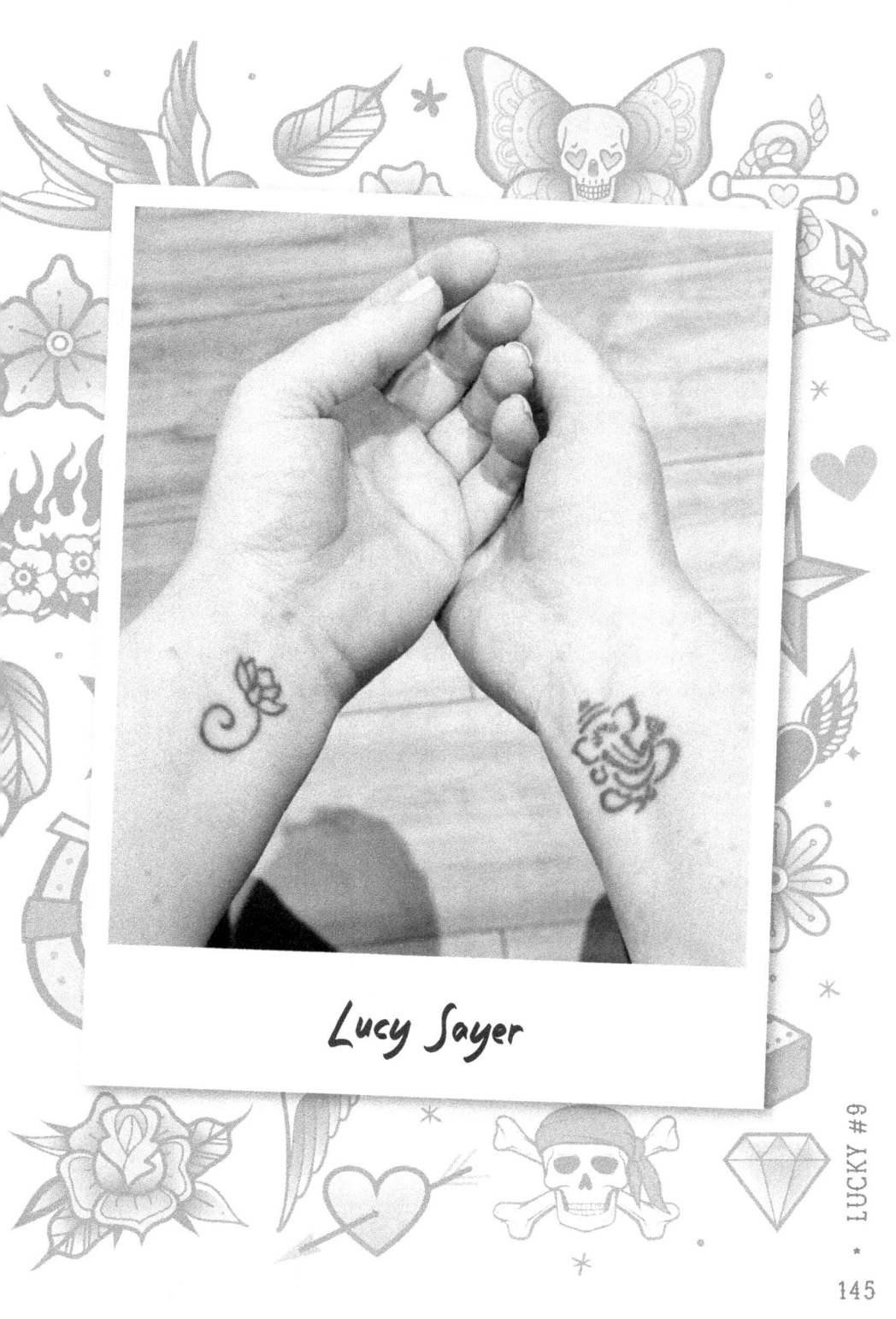

Sara Seigla

Instructional Technology Coach
Richmond, Virginia

Sara Seigla is an instructional technology coach. She has been in education since 2009 and has taught a variety of elementary and middle school grades. Her tattoos have always been a conversation starter and way to connect and bond with students and their families. She is an avid tattoo collector and loves to share her art at bit.ly/SeiglaInk.

> This is Wishbone! As a '90s kid who frequently shares nostalgic memories with students, this is one of my favorite tattoos. Wishbone was an important part of my childhood and one of the reasons I love reading so much, so I knew I had to get him as permanent art. I have made it my goal to add tattoos that make me smile, and this past year has been strictly '90s inspired. This was done by Abel Killian, who has done over thirty of my tattoos.

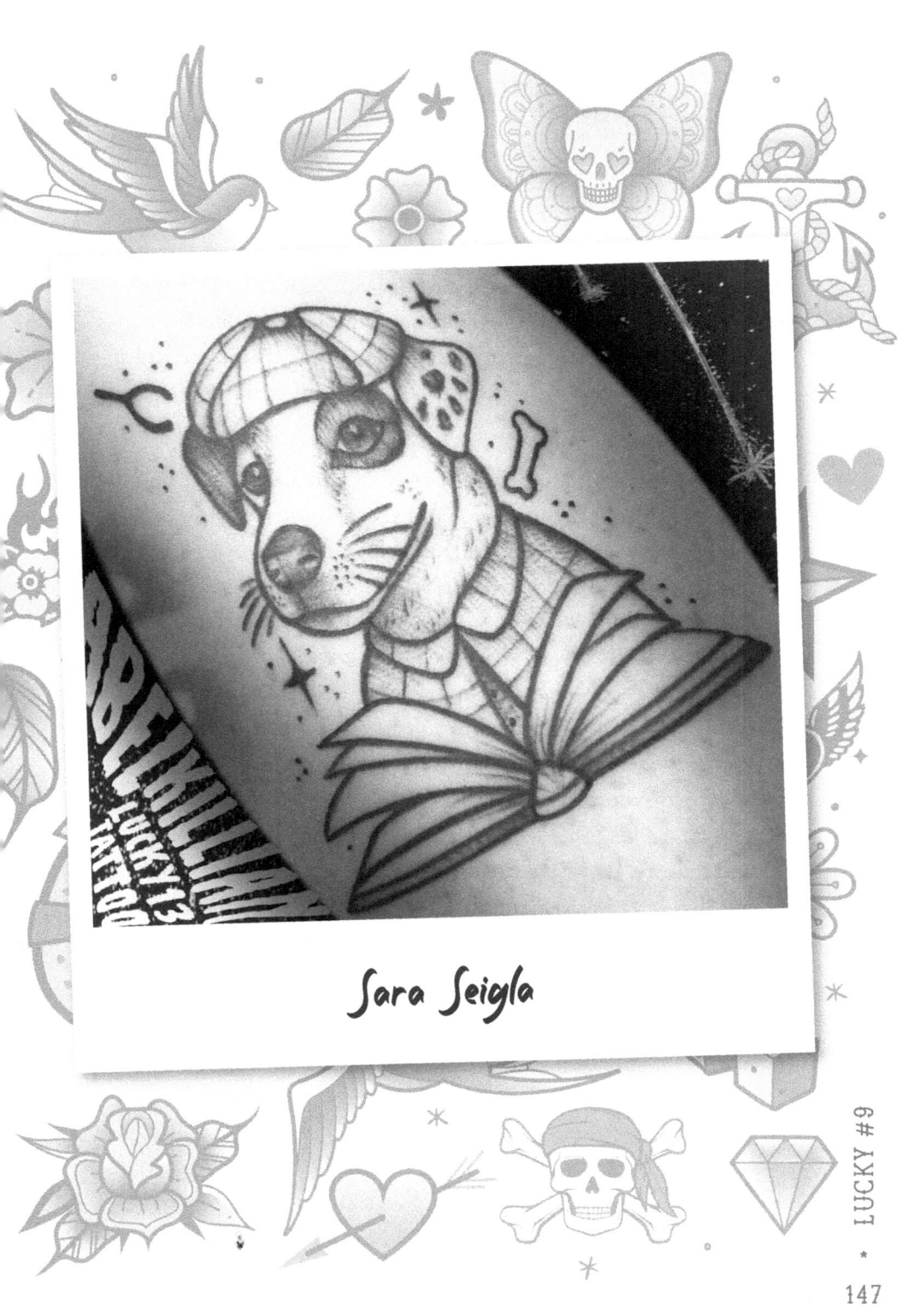

Sara Seigla

Damico and Tamika Bartley

Educators
Houston, Texas

Damico and Tamika Bartley are educators with a combined forty-plus years of experience in roles as varied as administration, literacy consultation and development, classroom teaching, success coaching and coordination, and charter school board membership.

> In 2015 a friend of our family was killed in a tragic vehicle accident. Her entire life, she traveled across the world meeting people from all walks of life, making the best of each day, and repetitively speaking, "I just say yes to God. Whatever he asks me to do, I say yes." So we—my husband, a principal, in education for twenty-two years and myself, an educator for twenty years—decided, in honor of her legacy, to choose to say yes too. We decided to not negotiate, rationalize, or hesitate when God asked anything of us. His requests are always for your good or the good of others, so we strive to give God a yes. These tattoos are symbolic of a life well lived and that we, too, have what it takes to say yes. Her yes took her all over the world, and she made an enormous impact, so the least we can do is say yes right here locally.

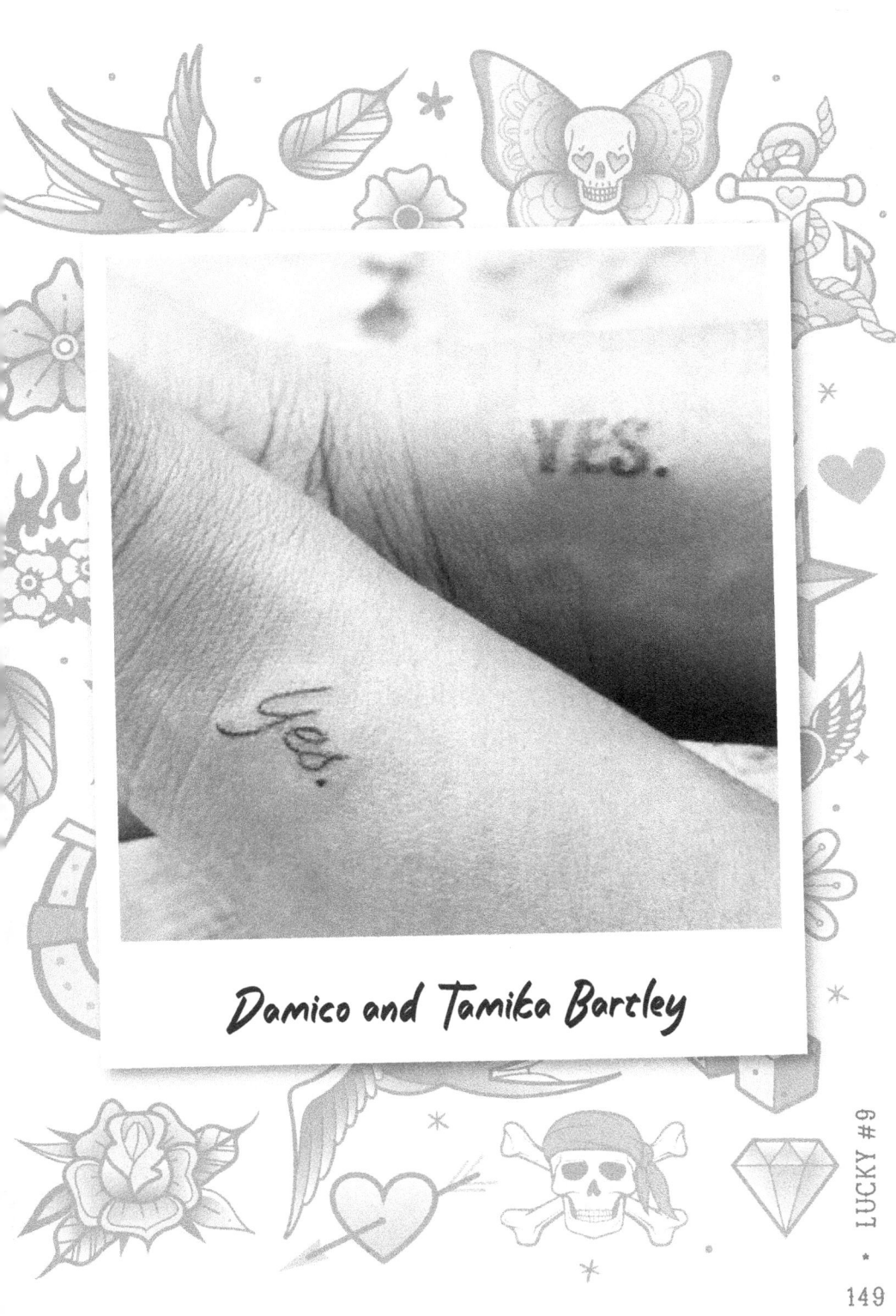

Damico and Tamika Bartley

Micro Motivator

You deserve to be seen the way you want to be seen, to have your story told the way you want it to be told. Embrace wanting to be seen, but remember that being seen is just the start; it's what you do once they see you that matters.

Teaching is a tattoo because sometimes it's black and gray, sometimes it's full color, but it's always meaningful art

Being a teacher is like being the mayor of a relatively small but very adorable city. Sometimes it feels like being the mayor of Munchkin City (in the county of the land of Oz), considering all the guilds and leagues and welcoming people most regally. Sometimes it feels like being the mayor of Gotham City or Metropolis, where you're trying to figure out a few jokers while also doing your best to make every kid feel super. There are even days where it feels like being the mayor of Radiator Springs, simultaneously a judge, doctor, coach, and general go-to source for every issue, hiccup, or mishap in the city, all while delivering gold nugget philosophical tidbits like "If you're going hard enough left, you'll find yourself turning right." The thing about mayors is that they live in this really neat little cross section of duties: They must figure out the logistics of keeping a city running every day while also considering how the collective population and individual

residents feel about living in that city. Mayors spend time in wildly uninteresting but undeniably important meetings and strategy sessions, day in and day out, to make decisions about everything from mass transit routes to sanitation services to infrastructure to bylaws about what animals qualify as acceptable city pets.

Sadly, I can't currently realize my dream of keeping backyard chickens within city limits, but my mayor is reviewing the feasibility of urban chickens on one of so many subcommittees, so fingers and feathers crossed on that one. Outside of the logistics, mayors also spend time building the heart of a city. They help to plan parades and events. They place bets with neighboring cities on social media about whose sports team will win the big shiny thing. They eat local, promote local businesses, and show their city and the people living there that they can trust the structure, the systems, the tap water. They give speeches and interviews and let themselves be seen by the people among the people. They also give citizens of the city reasons to fall in love with where they choose to live together. Everyone in the city expects a certain safety and standard on the daily. But not a single person in any city has ever expected a daily parade. That's why teaching is a tattoo: Sometimes it's simple black and gray, sometimes it's full color, but it's always art that matters.

Parades are spectacular. There are all kinds of cultural landmarks that help to build the personality of a place and its people. El Colacho, Spain, is put on the map by its yearly baby-jumping festival, which is exactly what it sounds like it is. Gloucestershire, England, wouldn't be what it is without the yearly downhill cheese-rolling competition. The annual Albuquerque International Balloon Fiesta is seen from miles around as it launches over 750 hot air balloons skyward. And yet, with all those cultural staples, not a single citizen would fault their mayor if they woke up the day after those events and there was no cheese wheel to chase down a hill, no balloons in the air, and no babies to jump over. Those moments are unique and give a city a vibe and a personality. The fact that the water flows and the garbage is picked up are the black-and-gray pieces that keep the city

functioning. It is undeniable that while colorful moments are essential to building a culture and a heartbeat in your school and your classroom, we have to focus on the black-and-gray nuts and bolts, the infrastructure of education.

Both black-and-gray and color tattoos matter profoundly. They make permanent and visible changes and carry a story worth telling. They do it differently, but they both move toward the same goal: changing a human being. Making a human being the library of their own stories. The same is true for being a teacher. You champion using different ways to move toward that very same goal of changing a human being. Making them into a walking testament to the things they have learned. Some days your teaching looks black and gray, some days it looks colorful, but each student, each lesson, is a work of art that matters. And that's brilliant. You wouldn't just tattoo the same spot over and over again the same way, and you wouldn't take the same approach to teaching every day. You need to embrace and celebrate moments spent grinding through worksheets and practice and nuts-and-bolts skill building as deeply as you do the experiential once-a-year moments that you spend weeks preparing for. I promise you both kinds of experiences can change a human being.

People talk about how teachers are magic. And we are, no question. But we must also acknowledge how much work goes into magic. Magic takes creativity, imagination, and a firm grasp of logistics. You have to fully understand what is possible before you try to make something that looks impossible happen. These unique, magical, memorable moments do take a ton of time and hustle to put together. They are undoubtedly worth it. I still remember building a full working trebuchet for a study of both physics and ancient warfare, and I also recall each item we launched from it. I will never forget a single lyric that I spit when we had an afternoon of costumed hip-hop performances themed around countries of the world. Or the day a real cow was brought to school so we could learn hands-on about adaptations. I could tell you about every second of those experiences. I couldn't tell you a single detail of any of the worksheets or

practice pieces or quizzes or drills or note-taking sessions or lectures that I worked through as a student, but I will testify that I know that without them, I wouldn't have had the bedrock of comprehension that those flashier experiential days relied on. Both the challenge and opportunity lie in acknowledging and embracing just how powerful a story you can tell both in black and gray and in color. Teaching is a tattoo because even though the daily grind and the magic moments involve different approaches, there is so much potential for meaningful art through both. They both change people and tell stories that matter. The most impactful you can be as a teacher is when you honestly embrace and champion both.

Especially in the age of social media, there seems to be pressure to make yourself a colorful teacher every day. There is undeniably a place for that. Like I said, Albuquerque wouldn't be the same without the Balloon Fiesta. A good teacher and a good mayor are capable of building a culture, a heartbeat, and a reason to love being there every day. But don't confuse parades with progress. Parades only look like they're going somewhere, but they mostly end up just a few blocks away in a parking lot. You go farther by putting one foot in front of the other and doing the work of walking. It isn't as fun or as flashy, and there aren't crowds of people cheering, but there is hard-earned step-by-step movement in the right direction. Don't conflate magic with meaning. Wow factor isn't the same as understanding. Show them the magic, but let them in on the secrets of how you did the trick so that they can make magic themselves. Magic is an illusion; teaching is just about the realest thing we can do. We are not in the business of entertainment—we're in the business of engagement. Entertaining earns attention, but it is essential to be mindful of what we do once we've earned that attention. I know, using both black and gray and full color is a lot to ask of a teacher. But that is the power in what we do. It is why teaching and tattoos matter so much: Both are actually physically changing people.

When we have life-changing full-color days where students and staff experience things that they will never forget, that changes who

they are. Physically, it adds neural connections in their brains that will stay with them for a lifetime. But the same is true for all of the black-and-gray worksheets and daily calendars and protocols and practice. Learners need nuts and bolts. That changes their brains too. See the beauty in the grind. The grind builds capacity and functionality. The black and gray gives them a deeper appreciation and understanding of colorful days. And this gives you permission to put the time and effort into big events without feeling like you have to plan a parade on the daily. It gives you perspective on the value of the grind moments. It reminds you that in black and gray or color, you are changing real human beings in real ways through your teaching. Whether your moments are fireworks or footsteps, magic or mechanics, both teaching and tattoos create permanent and meaningful changes that are absolute works of art.

We're back for another opportunity to challenge you to own the things that you would proudly wear about who you are as an educator!

★ INK

I'd like you to draw yourself a tattoo that represents how colorful you are versus how black and gray you are, specifically in terms of your teaching. Doodle in some patterns to show yourself off! (I've even added a template to color in if you'd like.)

★ THINK

Now that you've owned what you hope people see in you, I want you to reflect for a few minutes on these guiding questions. Remember, always write your reflections down. Physically putting things down in ink is powerful practice. Own why teaching is your tattoo.

- ★ Are you happy with your balance between black and gray and color as a teacher? Why or why not?

- ★ Do you feel like other people (students, colleagues) would see you in the same way? How would they describe you? What makes you say that?
- ★ What specifically do you consciously do to be colorful in your work? How about black and gray?

★ ASK-TIVITY: YOUR LIFE IS TASTY!

Nice work! Here's an easy and ready-to-use activity as a reward! Let's work together to create space and opportunity for others to reflect in the same way that you've been given the chance to in the section above!

This is a fun and engaging visual activity that lets participants take a look at the balance of the lives that they are living.

Step 1—Plates and Chats: Each participant will be creating a plate of food that represents the life they are living. There are a lot of different ways to approach this, but it all comes down to things they do that are black and gray versus things that are colorful. I like to use the language of "everyday foods" versus treats.

Give participants a blank page for them to draw their own plate or give them a blank plate template. (Plate. Tem*plate*. Love it.) Have participants think about all the things that they do in their lives (they can even make a list on a separate piece of paper). All the little have-tos and get-tos of their day from school to sports to chores to hobbies to spare time.

Step 2—Create! (Think carefully about size!) Once the participants have a solid idea of the things they do, they can draw items that represent those things on their plate! For example, if they play soccer, maybe they draw a soccer ball. If they spend time reading, maybe a book. The more time they usually spend doing a certain thing, the bigger the item will be (hence, the more space it will take up on their plate!). They can also get metaphorical with representations on this one!

Step 3—Sharing Is Caring: This is always the most important part of the work. Once participants have filled their plates, creating a visual of what their lives look and feel like, then they need to have a chance to show those pieces off and reflect on them. Have them share on the wall or in a sharing circle—anything that gives them a moment to be seen works. This offers a chance to get to know each other on a deeper level as human beings.

During the sharing portion, I think it is important to ask them a few questions. Have them write or share aloud once they've reflected on the following:

- ✯ How do you feel about the things that fill the plate of your life?
- ✯ How many things are there that are just straight-up treats for you? (Treats are important in life!)
- ✯ What kinds of things would you add to your plate?
- ✯ Are there pieces that you'd like to make smaller? Bigger? Why?
- ✯ Do you feel like your life is a well-balanced meal?

veggies are good most of the time.

vegetables
School
(classes, homework, studying)
I like veggies!

Chicken
Rest
(sleep, reading, roblox)
feuls me for everything

Pasta
Social
(Family, Friends, ect.)
I love this part!

Cake
Activities!
(water polo, musical theatre)
my favourite part

CUCUMBERS
Stuff I dislike
(vocal Jazz, math, Yearbook)
Not signing up for these next year!

Here's an example made by Sadie, a grade 10 student.

If you have participants who aren't in a position to write effectively yet, just focus on the drawing and talking about feelings! Give even the youngest participants a chance to reflect on and share what they give their time to in their daily lives.

THE CANVAS WE ARE

Back in the tattooist's chair! This chapter we're spotlighting . . .

Elijah Carbajal

District MLSS (MTSS) Coach
Albuquerque, New Mexico

Elijah Carbajal has been teaching in New Mexico since 2014 and is currently working as a district MLSS (MTSS) coach for Albuquerque Public Schools. He is the author of *A Place They Love* and the host of *The Shut Up and Teach Podcast*.

> This is my tattoo. It is a reminder to always hold fast to and never let go of hope, to always be willing to lend a helping hand.

Elijah Carbajal

Emily Geile

Elementary Teacher
Tacoma, Washington

Emily Geile has taught for twenty years in Tacoma. She has taught all elementary grade levels and has loved every minute of it. She loves to see young people grow and learn to be exactly who they are.

> I started when my seventeen-year-old went into a treatment program for depression. I felt lost and my husband suggested that I do something powerful. The bee is an addition. My kid has overcome a huge depression cycle and things are looking better. We got matching bee tattoos because we both love growing things and both know the importance of bees.

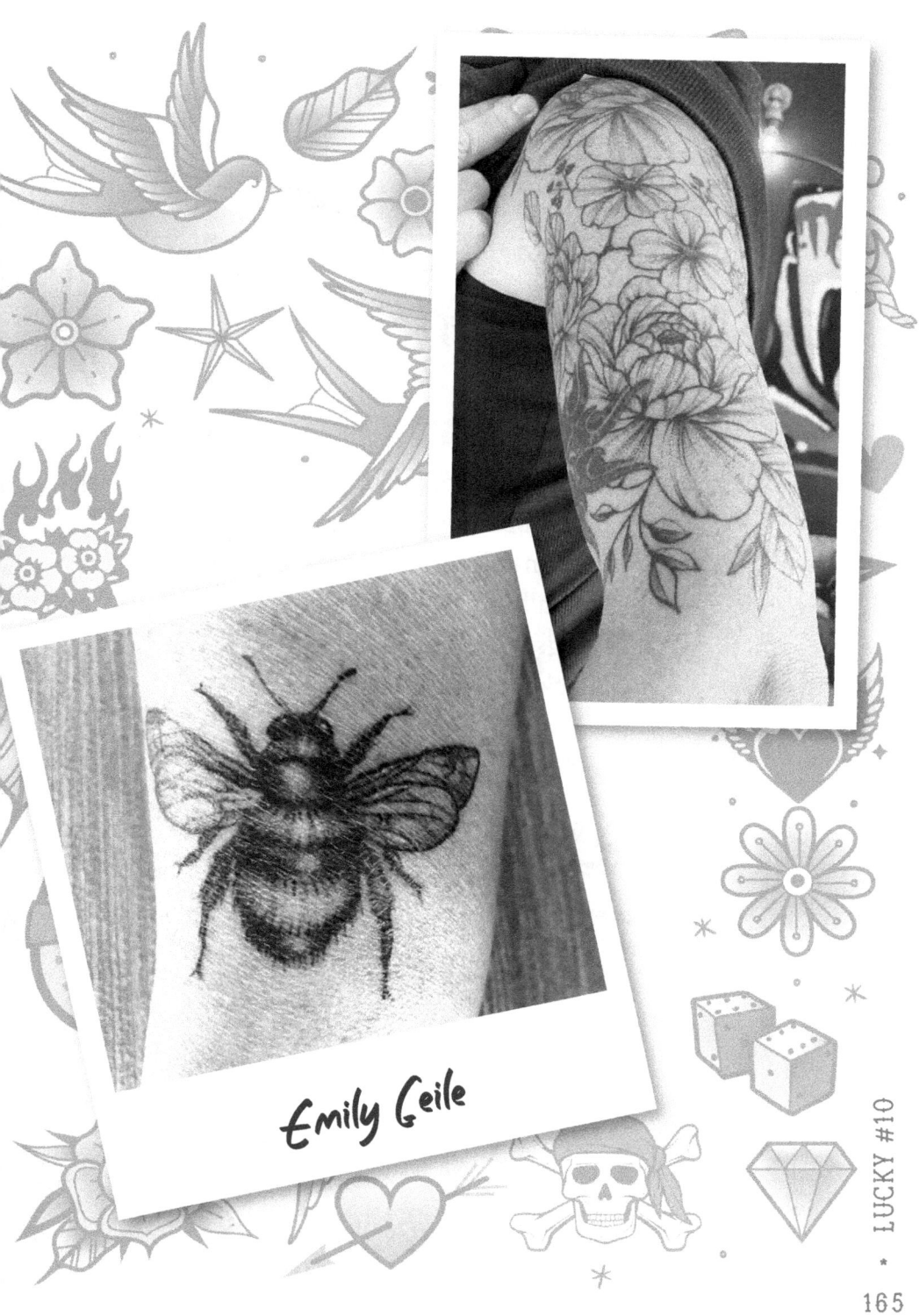

Micro Motivator

You are physically changing human beings when you teach in full color. You are physically changing human beings when you teach in black and gray. You are both magic and mechanics. Celebrate and value both.

Teaching is a tattoo because people too easily make assumptions about the human beings who choose either (or both)

In so many ways, the only constant is change. Things that don't evolve, culturally speaking, tend to disappear or at least become disconnected as the rest of the world moves on. Take Netflix. It started out as a business that snail mailed actual physical DVDs right to your mailbox, and now, since both DVDs and snail mail are facing extinction, Netflix has evolved the become a provider of streaming content that we fall asleep in front of before waking to that very judgmental question on the screen: "Are you still watching?" And we are watching. That's what we do. It's part of being the social animals that we are. We watch for signals and hints and social cues. We watch trends and friends, mentors and colleagues. We look for clues that help us to make decisions about how to best live our own lives within ever-evolving social realities. After all, the only constant is change, and we don't want to be left behind.

Though it looks different for everyone, we all just want to be a meaningful part of Team Human Being. Learning from the other human beings around us is a useful skill set to master in that endeavor. Unfortunately, we sometimes get ourselves into a place where we create these tropes and effigies, these pictures of people based on that limited social information. It means that sometimes complex, dynamic, interesting human beings get too easily reduced to stereotypes. That's why teaching is a tattoo: because it is far too easy for people to make assumptions about the human beings who choose either (or both). That being said, those assumptions are well worth pushing back on.

A concise and pertinent donkey-related expression is that when you assume, you make an ass of you and me. I would argue that assumptions aren't even donkey worthy. Donkeys are hardworking. Assumptions are too easy. Maybe a more apt animal expression is when you assume, you make a jellyfish of yourself because jellyfish don't have a central nervous system capable of complex thought, so they just go with the flow around them rather than creating their own understanding. Admittedly less concise, but I think there's a lot more metaphorical honesty there.

Making assumptions about teachers or tattoos sidetracks the beautiful work of getting to know the person rather than the stereotype. Think about how many times you've felt like a single word, *teacher* or *tattoo*, was all that people saw when they looked at you. The irony is that teaching and tattoos are things we choose because of the power they carry to

amplify individual stories, not pin us down with stereotypes. Both teaching and tattoos are worth more than assumptions. Each teacher's unique personal experiences help forge their skill set and perspectives on pedagogy and relationship building as they change others. Tattoos represent something that someone cared enough about to change themselves to wear. The beauty of both is that, like Transformers, they're absolutely more than meets the eye. The culture around both is evolving through that only constant: change.

Before my first minute of actual teaching, I went into the divisional office to sign my first ever actual teaching contract. An older male in a suit and tie handed me the paperwork with a smile and said, "Welcome to the team." As he took my hand and shook it, he added, "Of course, you'll cover up those tattoos before you hit the classroom." Then he winked. It wasn't a question, it was a statement. It was years ago now, and the culture around tattoos at the time was a little on the fringe side. I was used to being told that covering them up was the expectation. Of course, I've never been a huge fan of living by the expectations of others, so I had short sleeves on in class before the winter break.

In the new year, when I returned to school rested and ready, my admin asked me to chat for a minute. A parent had called to complain that my tattoos were inappropriate. For the record, I do not have any inappropriate tattoos. They share stories and moments that mean everything to me, but I'm also aware that I teach kids, so I have nothing tattooed on me that could even be misinterpreted as inappropriate. What the parent thought was inappropriate was that I was tattooed and still allowed to teach. That administrator told me that who I was and how I was teaching was more important and I had his full support. To this day, I credit my comfort bringing who I am into the classroom to this interaction. These days, I proudly wear my tattoos as I teach, and I get asked about the stories behind them with equal kindness and curiosity by kindergartners and bigwig administrators and everyone in between. Before, there was no conversation about the stories behind my ink; now they're a constant

conversation starter and point of connection. That's proof positive that we are evolving our definitions of the educators who take on this work. Assumptions are still undoubtedly reality and always will be, but we are floating down that river of constant change. We are living in a moment where who we are as human beings is becoming a much more important part of the picture of who we are as teachers. We're giving students, colleagues, and caregivers in our communities reason to be curious, not judgmental.

"Be curious, not judgmental" is one of my all-time favorite series of words ever strung together. It was brought into my life by a little TV show called *Ted Lasso*. Easily one of my favorite shows of all time, it's a darn near perfect piece of storytelling. In the show, the titular character explains that when people judge others, it's because they're just not curious enough to ask questions about them. That resonated so deeply with who I am. Teaching is a tattoo because we're well aware that people make assumptions about both, but we know that's because they're just not curious enough about who we are as people under those assumptions. I also know that both teaching and tattoos come with this unbelievable opportunity to be more than what people assume about us. If we're willing to bring who we are as human beings openly and proudly into our pedagogy and practice, then we'll create moments where people can't help but be curious rather than judgmental. Arguably, our job is to spark curiosity in learning about everything from science to sewing to sports. We want to inspire our students to get curious and stay curious about how their world works. I believe we need to put in just as much work to spark their curiosity about who the human beings are that they share that world with.

I'm not trying to say that we're at war with assumptions. Assumptions have their place when time or social contact is limited. But we have plenty of both over the course of a school year. We have months to build community that begins with individual personal relationships and that extends far beyond the walls that we teach in. We have time and social contact and opportunity to create

a culture of being curious about each other rather than judgmental. All that starts with us being willing to make our stories something we proudly wear out loud. Sparking curiosity about who you actually are as a human being sets that as the standard for the relationships you create. Each brick builds a better and clearer human understanding. People will know you value really seeing them too.

Teaching is a tattoo because the culture of assumption around both is an opportunity. It is an opportunity to invite people to be curious, not judgmental. If we wear both teaching and tattoos authentically, assumptions make way for curiosity. You're inviting others to value your humanity and perspective. It's a joy to discover there are things you never knew you never knew, especially about the people you live your life beside.

We're back for another opportunity to challenge you to own the things that you would proudly wear about who you are as an educator!

★ INK

I'd like you to draw yourself a tattoo that represents you as a teacher, but as an anthropomorphic animal! We've all seen anthropomorphic animal/people in animated movies, so you know the vibe. Why anthropomorphic animals? Because if you drew yourself or a generic teacher figure, people would say, "Yeah, that makes sense." But there's thought behind choosing an animal and morphing it into a version of yourself teaching. That's going to make people curious about why and give you a deeper story to tell!

★ THINK

Now that you've drawn that tattoo, I want you to reflect on these guiding questions. Remember, always write your reflections down. Physically putting things down in ink is powerful practice. Own why teaching is your tattoo.

- ★ What are some assumptions that you yourself make about teachers, people with tattoos, or teachers with tattoos? What motivates those assumptions?
- ★ How do you inspire students to be curious, not judgmental toward each other? How do you get people intrigued about knowing the stories of other humans around them?
- ★ What kind of assumptions do you think people make about you as an educator? What do you base that on? Do you feel like they're close to being accurate?

★ ASK-TIVITY: SEEN/UNSEEN SELF-PORTRAIT

Time for you to be curious . . . about what this chapter's activity is! Let's work together to create space and opportunity for others to reflect in the same way that you did in the section above!

This is a fun and engaging visual activity that lets participants reflect on what people see about them and what they think people *don't* see about them.

Step 1—The Paper and the Outline: Each participant will be creating a self-portrait, so they'll need blank paper. On that blank paper, have the participants draw a basic outline of a head and shoulders. This way they can create something that they feel looks like them.

Step 2—Brainstorm Both Sides: Have participants take a separate piece of paper to brainstorm! Explain that on one side, they will do their best to draw a self-portrait. In the background, they are going to put items that represent things they feel people know about them. For example, they can put things like equipment for a sport that

people know they play. It's all about them saying, "This is what I think people see when they look at me."

On the other side, please have them brainstorm things that they feel people don't see about them. Feelings, thoughts, ideas, little bits of information saying, "When people look at me, these are the things that they don't know about me."

Step 3—Create! Give participants time to create! Give them time to get colorful and unique and make the best piece of art that they can. Remind them that one side is all about what people see when they look at them, the other is all about what they feel people don't see.

Step 4—Sharing Is Caring: This is always the most important part of the work. It is empowering for participants to either speak about or display publicly (or both) what they believe people don't see when they look at them. It really sparks curiosity from their peers too.

This piece is very visual, so modification would just look like changing the language level to suit the discussion. I usually go with "What are some things that everyone knows about you?" and "What are some things that you think not a lot of people know about you?" or "What do you think people would be surprised to learn about you?" We then incorporate that into the activity.

These are some grade 7/8 examples.

THE CANVAS WE ARE

Back in the tattooist's chair! This chapter we're spotlighting . . .

Tyler German Arnold

High School Principal
Milford, Ohio

Tyler German Arnold is an education professional with a rich thirteen-year tenure in the field. After commencing his career as a one-to-one aide, he navigated through diverse roles within different high school settings. Currently, he is privileged to be in his third year as the building principal at Milford High School in Ohio.

> Tattoos, to me, serve as a powerful medium through which I can intricately weave personal narratives and commemorate profound moments in my life. The design I carefully selected is a poignant homage to my late mother, whose sudden departure left an indelible mark on my heart. In this tattoo, she is rendered as a young girl, accompanied by her beloved canine companion she often reminisced about. The imagery of birds, particularly the majestic dove, symbolizes her eternal journey to the heavens, where I believe she now watches over me from above.

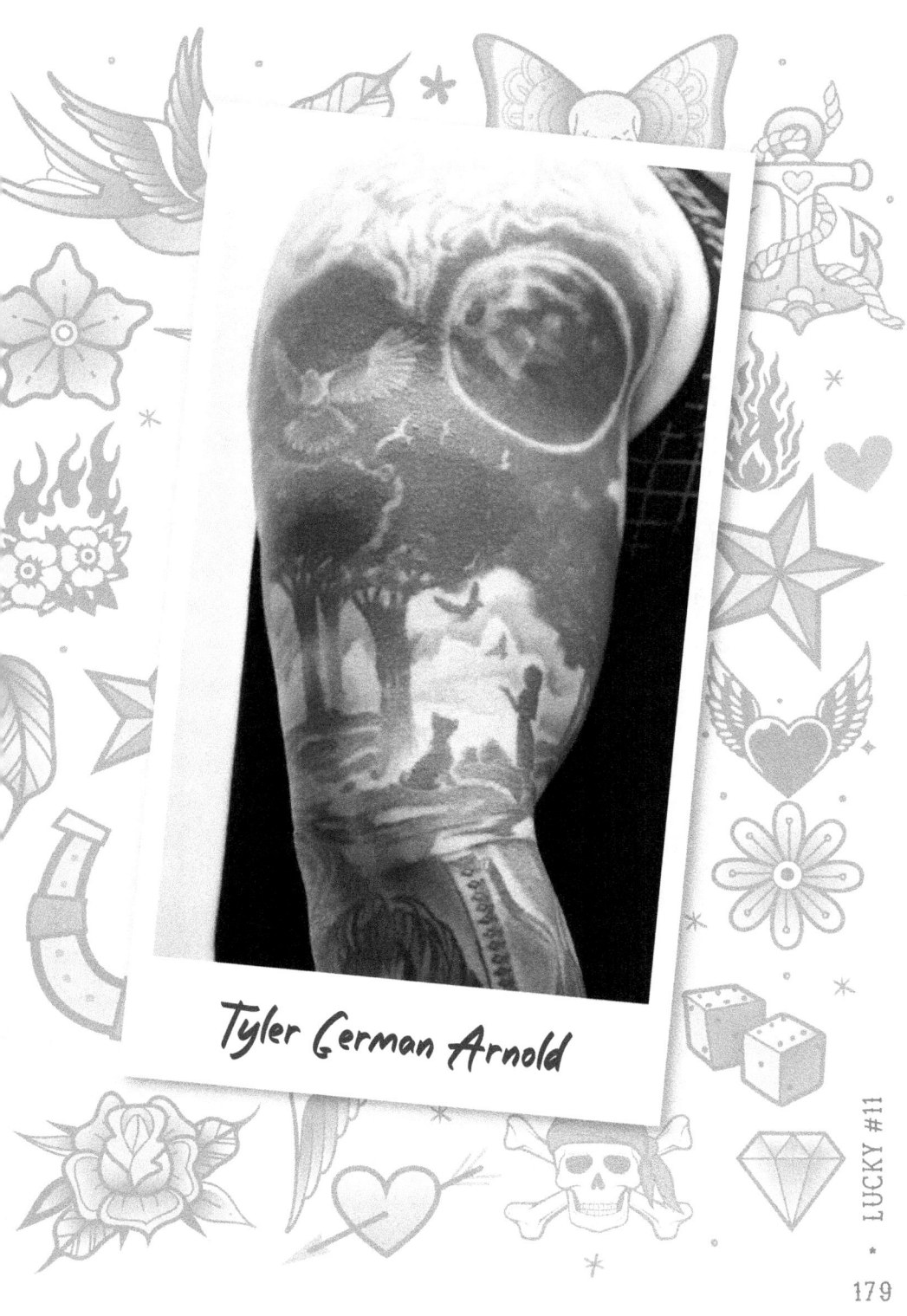

Tyler German Arnold

Chantal Remo

Grades 4 and 5 Teacher
Ottawa, Ontario, Canada

Chantal Remo teaches grades 4 and 5 with the Ottawa Catholic School Board. She is the Indigenous education rep in her school and loves being able to share her culture with her students and colleagues through that role.

> My tattoo is a Scorpio zodiac sign on my inner ankle. I got this tattoo with my stepdad the summer before I went to university as an empowering "I'm leaving the house and the city I grew up in" statement.

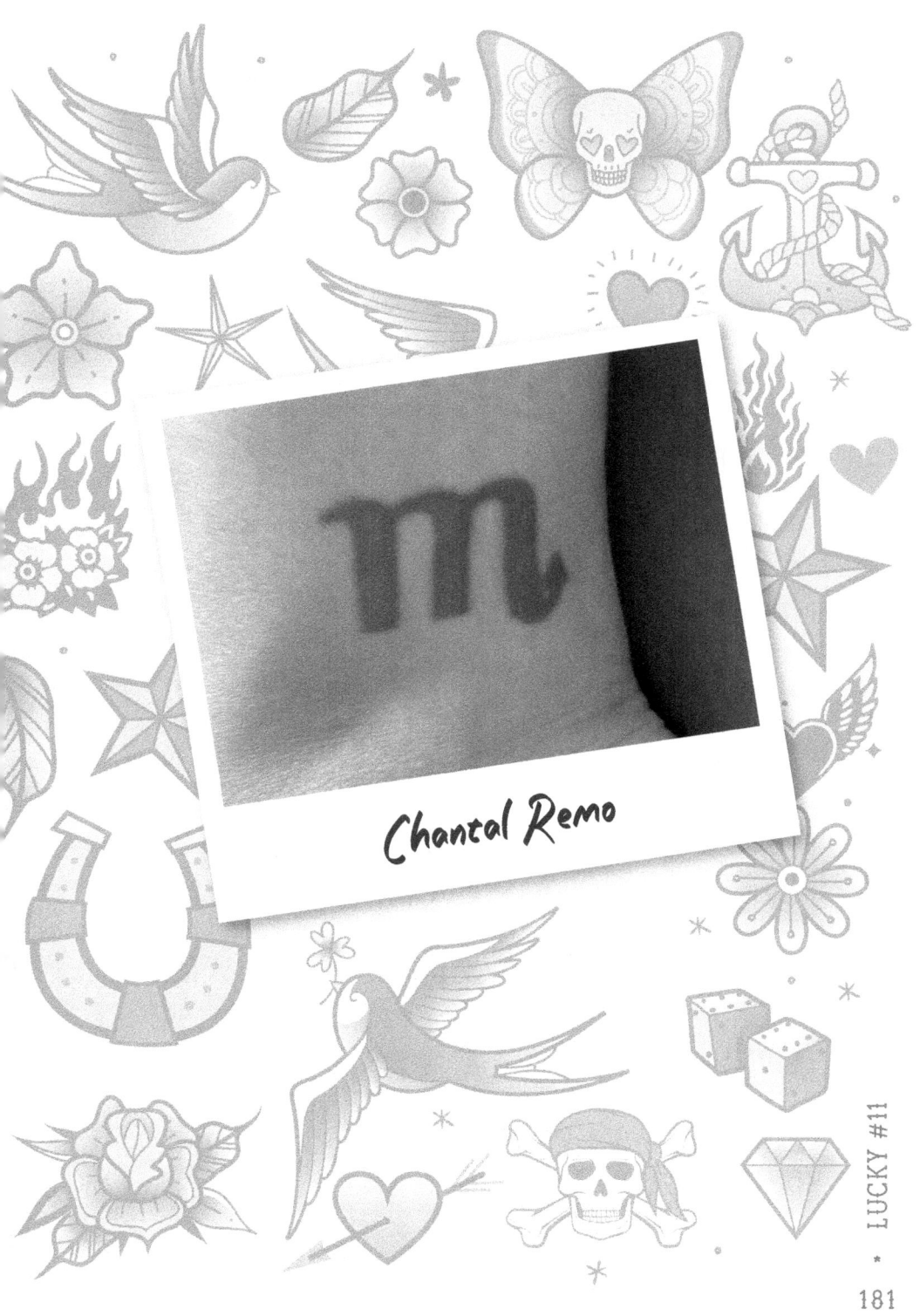

Ryan Tapsell

Principal
Manutuke School, New Zealand

Ryan Tapsell leads as principal at Manutuke School in Gisborne, NZ, boasting twenty years of educational expertise. His journey spans from preschool through composite-school years 1–13 (ages 5–18), extending to tertiary levels, with a strong emphasis on Maori language immersion and cultural integration. Passionate about Maori rugby, sports, and performing arts, he advocates for holistic education. Ryan's leadership not only fosters cultural pride and academic excellence but also prioritizes students' physical well-being. He's got a profound commitment to the Maori language, working to ensure its preservation and vitality and to enrich the school community with linguistic diversity and cultural understanding.

> My tattoo is my carrying of the Māori word and concept of whakapapa. Genealogy is so important to us as Māori, and *whakapapa* is a word we use for discussing, describing, and reciting genealogy. My tattoo is my genealogy—my whakapapa—that I carry. On my shoulder, the highest spot on the tattoo begins with our deities. As it flows down, so do the generations. Koru shapes incorporate the stories of significant ancestors and connections to my own story and the story of the land. Guardians are woven in with the story of who I am through all of that geneology, through the land and through my own experiences carried at the opposite edge of my tattoo.

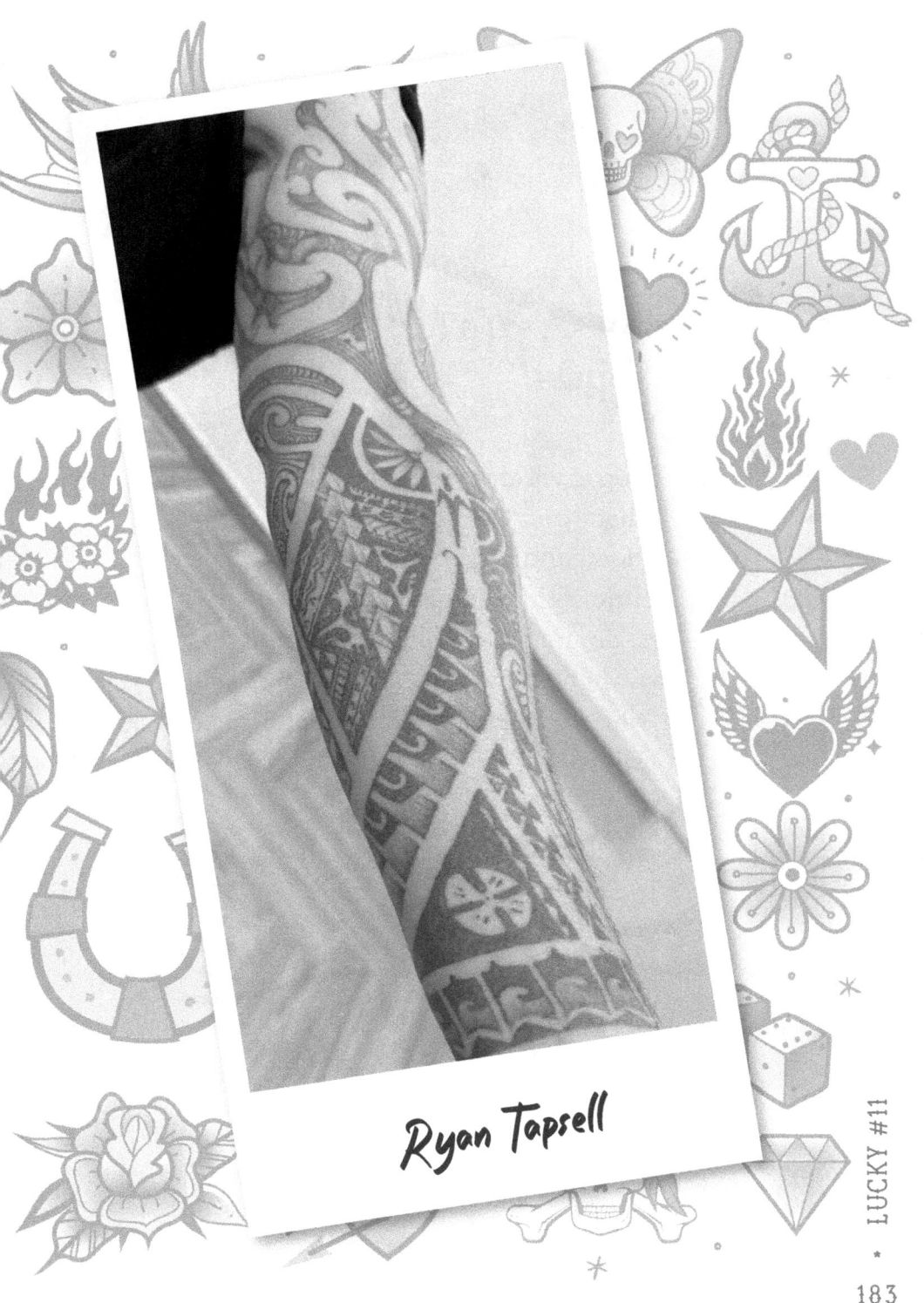

Ryan Tapsell

Micro Motivator

People will always assume things about you. Live your stories out loud until they become more curious than judgmental. Be the first domino that will inspire people to want to know more about others, which will inspire more people, which will . . . you get the idea.

Teaching is a tattoo because at some point, you have to have enough faith to give control to the artists to create

I believe that teachers only really do one thing: We try everything we can to empower other human beings to be able to do absolutely anything they want to do with their lives. Without question, that one thing we do is a big thing. It encapsulates so many other things of every size. It actually physically changes both the world itself and the humans sharing it. But at the end of the day, it boils down to this: We build capacity in others so they can build themselves. We have to simultaneously muster enough faith in our own ability to meet that goal, and we must allow students space to use that capacity we've helped them build. That's why teaching is a tattoo: At some point, you have to have enough faith to give control to the artists to create.

Teaching and tattoos both create a unique relationship between the artist and the work. We start with a vision, an idea of what we

imagine the final product will look like. We have reasons for what we're asking for, we know the story behind it all, the purpose, the why. We have parameters and expectations and criteria. Then, we steady ourselves and prepare for pain and discomfort as our artists or students create something permanent and beautiful.

Regardless of potential pain and discomfort, being that close to what students create is a complete and utter privilege. Whether they are writing, researching, asking big questions, deepening their understanding of their own existence and impact, or engineering structures and solving equations, they are using the context and skill sets we helped them build—and they are making art. It is the art of newly sculpted and permanently written pathways in their brains. It is the art of confidence painted on their faces as they achieve their mastery through independence. It is the art of their relationship with you, a snapshot of the physical manifestation of what they're learning together with you and who they feel they can become through it. None of that is possible without you having enough faith in them and in yourself to let them make that art. And nobody gets to be closer to that art than you do, because it becomes part of you. Just like a tattoo, your input informs their work, and what they create becomes a permanent part of who you are as an educator, personally and pedagogically, moving forward.

Each work of art, regardless of what it looks like in practice—big or small, personal or practical, social or scientific—is a footprint showing you where students are going. You learn from students' successes and failures. It can be a powerful thing to forgo control, have faith, and learn from what is created. This is the same magic for all kinds of educators. Regardless of your role, we're all simply creating opportunities for others to create. We're all lying there exposed, sometimes gritting our teeth through discomfort and pain, trusting the steadiness of the artist's hand and the strength of our shared vision. There's a collaborative story written in there, and that collaborative storytelling is what can turn the work that we're doing from food to a meal. It is the difference between boiling up store-bought noodles to

keep a belly full and the experience of choosing to hand make pasta with tomatoes you might have grown yourself, fancy cheese, and something green on top to show that you care enough to elevate it.

We have days as educators that are just food, and that is important. But giving students the recipe, the ingredients, the skill set, the time, the space, and the inspiration to make a meal—that's the goal. Sitting down beside them and sharing that meal, letting it nourish and energize us, giving them feedback—then we're turning that meal into a feast together. We all benefit from a feast, but we have to let students cook. I still have the wonderful handwritten recipe cards my grandmother made me. But I don't have her support, her deft hand, her experience, or her company in the kitchen anymore now that she's passed on. Those recipe cards are an echo of the stories I lived with her, the stories she taught me in. Now the hands are mine, the measurements and substitutes are mine. There will always be a moment where the hands that were taught things become the hands doing things.

That all sounds great, as visions are, but we must acknowledge that sometimes things don't go as planned. For example, tattoos can end up bad. Any educator will tell you that you can plan and prepare and explain and support and have all the best intentions, but the very real business of human beings is often messy and unpredictable. For some of us, that is one of the charms of the work. Teaching is a tattoo because the art can look very different from the vision. Bad tattoos happen. Often. But very rarely do people intend to make something genuinely bad a permanent part of themselves. The same goes for teaching: We never go into it with the intention of achieving bad results. But as diverse as we are, one of the universals of being a teacher is that we've all had days we carefully planned that turned out very differently than envisioned.

Some days and some tattoos end up being hard to look at. Luckily for us, in both teaching and tattoos, success isn't the only measuring stick for beauty and value. The story that a thing carries is what makes it valuable to anyone. My grandfather used to remind

everyone that his replacement hip had Phillips screws in it. Often. His working life was filled with jobs involving all different kinds of screws. His successes were built working with tools that he knew. When he went through the ugliness of a full hip replacement, knowing that he understood and owned the screws and stories under the scars took a painful moment. But once understood, he owned it and wore these stories literally in the bones of who he was. Bad moments, like bad tattoos, can still hold great stories.

I challenge you to empower yourself in the same way as an educator. Be my grandfather. Know the names of the screws holding you together under your scars. If you look for the story in everything, especially in the bad days, then ugliness becomes learning. It becomes ownership. It becomes an anecdote. It becomes part of you in a positive way. The secret is that even bad tattoos can be good stories. It is about perspective and the choice to wear them proudly. To tell the story beyond the bad. I know it's hard, but I believe there's more value in the story behind a bad tattoo than there is behind a beautiful tattoo that you have no real connection to, that there's no real personal meaning behind. My grandfather's false hip wasn't beautiful. It was standard plastic and metal and painful, but it was his. He gave up control completely to his doctors, trusting that they would make that permanent new part of himself into something worth wearing. The discussions and vision and decisions were made together by him and his doctors. The faith was mutual. He had faith in what they could create, and they had faith in themselves and cared enough to do their best possible work. The tools were theirs. The hands were theirs. The perspective was his. That made the hip his. It was his because the story was his. The ownership was his. He found his way to love that part of himself.

One of the best and most heartbreaking things about teaching is that if we're doing it right, we're helping students to evolve past needing us. Success looks like having them be ready, willing, and able to navigate their lives as independently as possible, creating meaningful art in ways that make them feel capable of making anything they

want out of themselves. Like I said, we educators only really do one singular thing: We try to build capacity in students to create without limits in their own lives. This capacity is laced with our trust and faith that they'll grow into being independent creators. Ms. Frizzle took the Magic School Bus kids on some incredible adventures, but she would undeniably feel less successful as an educator if she planned to show up at Arnold's house in his middle age, the anthropomorphic bus rolling its eyes as they teach him about how his washer and dryer work. Master Yoda's wise words "Do or not do, there is no try" would lose their impact if he added, "Unless you need me to do for you." In both teaching and tattoos, we work to help build the vision; we have faith in the artists to create with it. It all becomes art that we wear out loud, part of us moving forward. Never forget what a privilege it is that beautiful or bad, we empower others to create.

INK-THINK-ASK

We're back for another opportunity to challenge you to own the things that you would proudly wear about who you are as an educator!

★ INK

I'd like you to draw yourself a tattoo that represents how you think you get your students' futures ready, how you view your job of preparing them to not need you anymore. Here's the added fun bonus! Make it *bad*. Intentionally, a bad tattoo. That way you can practice the grace needed to create something less than ideal and allow yourself to see the beauty and potential in it.

★ THINK

Now that you've drawn that tattoo (and it's bad!), I want you to reflect for a few minutes on these guiding questions. Remember, always write your reflections down. Physically putting things down in ink is powerful practice. Own why teaching is your tattoo.

- ★ How do you show your students and colleagues that you have faith in what they can create?
- ★ How do you recognize moments that turn out different from what you envisioned? What do you look for?
- ★ How much faith would you say that you have in students and colleagues to independently create? Do you need to up the level of trust you have in those around you to create something beautiful independently?
- ★ How do you create space to learn from your own less-than-successful days? How do you help your students and colleagues do the same?

ASK-TIVITY: REASONS TO BELIEVE IN ME

Let's work together to create space and opportunity for others to reflect in the same way that you've been given the chance to in the section above!

This is a fun and engaging visual activity that lets participants reflect on and own the things inside them that make them able to create beautiful things. It's also a great way for you, as the leader of the activity, to be reminded why you should have faith in them.

Step 1—Rock, Paper, T-Shirts: Each participant will be creating a visual representation of the things that make them great, capable, creative human beings. I like to choose materials that are more on the permanent side. I've used rocks, canvases, and even T-shirts (the absolute best choice because participants can wear them like tattoos). But whatever the material, the goal is for participants to show why they're capable creators and why people can believe in them!

Step 2—Brainstorm: Have the participants brainstorm a list of the reasons they're great on a piece of paper. Are they creative? Are they hardworking? Nice? A good friend? Have them put down everything that they believe is good about who they are. And get in there and help! Help them see all the greatness inside of them.

Step 3—Create! Give participants time to create! Whatever material they're using, have them put down the words and, of course, decorate! They can also use visual representations instead of words.

Step 4—Sharing Is Caring: This is always the most important part of the work. Either as a discussion, a fashion show, or a sharing circle, it is essential to let participants verbalize and own these words and ideas that show people all the reasons to believe in who they are and what they can do.

This piece is very visual, so keep the language simple. Single words are fine, visual representations are amazing (just like tattoos)—any way to get participants to own those things that make them worthy of having faith in!

THE CANVAS WE ARE

Back in the tattooist's chair! This chapter we're spotlighting . . .

Lynette White

District and Community Relations
Coordinator and Author
Southern California

Lynette White's career in education spans fourteen years. She is currently the district and community relations coordinator for Banning Unified School District. Lynette has presented nationwide on the importance of telling your story utilizing social media to brand yourself and your organization as well as the importance of developing a professional learning network (PLN). Lynette holds her BA in communications from Southern New Hampshire University and is completing her MA in communications with an emphasis on education from Grand Canyon University. She was recently recognized as a 2023 CalSPRA Rising Star and also received the 2023 MOSAIC Inclusivity Excellence Award. Lynette is also coauthor of *The Ed Branding Book: How to Build Educational Leadership with Social Influence* and the co-host of the wildly successful *Ed Branding Podcast*.

> My most recent tattoo is the words *let them*. This tattoo has been a year-plus in the making. As my career has progressed, so has the doubt from others, which at times caused me to doubt myself. My motto throughout the book-writing process and starting my consulting business has been "let them." The meaning to me is to remember my own self-worth, independence, and self-expression without allowing the judgment of others to affect me. So I just let them, as I continue to be the best version of myself I can be.

Becky Schnekser

**Teacher and Science Education Author
Norfolk, Virginia**

Becky Schnekser is a passionate educator explorer with nineteen years (and counting) of experience in classroom and museum contexts. Becky believes in the power of connection and that to truly connect with learning, experiences—not lesson plans—yield the best results. As an educator explorer, Becky works alongside scientists in the field to replicate real-world expeditions with learners. Becky is the author of *Expedition Science: Empowering Learners Through Exploration*, which is filled with inspiration and lived experiences creating epic learning opportunities.

> Tinker Bell has always been a fascination of mine, and I've often been told I emulate the positive parts of her persona. She's sassy, fun, magical, opinionated, and loyal to her friends. She was a character I fixated on when I was young, and I continued to into my adult years. I've always loved being outdoors, and the thought that magical beings, fairies, might be among the flora and fauna also fascinated me. There was also a movie, *FernGully*, that was a favorite of mine, reinforcing environmental stewardship and, you guessed it—fairies! Late in college, I decided to get a tattoo. My first one was a simple silhouette of a fairy, on my right hip. A couple years later, I chose a Tinker Bell photo for a second tattoo that would be on my left side. I leaned into the sassy Tinker Bell persona and chose a pose of her looking over her shoulder. This connection to my childhood and nature through my tattoos reminds me of what I've always loved and helps me refocus when it seems like the world around me is spinning out of control. Shortly after I got my first tattoo, I was stretching my arms above my head and it

was visible to my father, who was against tattoos at the time. He yelled, "What the hell is that?" To which I replied, "It's a henna tattoo, it'll be gone in a week!" He never found out the truth, or at least he never told me he did. Fast-forward ten years later, he chose to get a few tattoos on his forearms and became a champion for tattoos.

Micro Motivator

You're in the business of helping human beings evolve past needing you. That business requires faith. Have faith in yourself to get them there. Have faith in them to create. Even when it turns out ugly, wear what they create for the beautiful learning it is.

Teaching is a tattoo because both can be changed, but that demands work

In both teaching and tattoos, the work can be an opportunity to get to know each other better while collaborating on creation. Once, sitting for a relatively lengthy session with a tattoo artist, I asked her if she had any cardinal rules, any tattoo commandments that she tried to follow when collaborating on a tattoo with her clients. She had a few non-negotiables, of course, as we all do, but she said that it mostly came down to her talking it through with the person getting the tattoo to make sure that both the canvas and the artist were embarking on something that they could mutually be proud of for as long as that tattoo stands—generally a lifetime. That sounded to me like exactly what we try to do as educators. She went on to say that there were a few things that often came up as red flags in the design process that she tried to gently guide her collaborators away from in favor of choices that her experience had shown her were maybe smarter in the long run. Again, teacher work all day.

She shared that people who come in to get inked always have a reason and a vision, otherwise they would have just stayed home. She talked about how it's important to understand that every human being has a unique life, a unique perspective on what is meaningful and worthy of carrying with them, so knowing and valuing their story is essential. The work, she said, was about seeing them, creating with them, and helping them understand that this is all now part of who they're going to be moving forward. I mean, do the similarities between tattoo artists and educators never end? It was nice to hear her take on the work she was doing and feel like it was so familiar. She added that she did always advise that people avoid getting tattoos in languages they don't understand for obvious translation reasons. It sucks to believe you're walking around showing the world that you espouse "Love, Courage, and Strength" when your arm really just says "BBQ Watermelon Noodle."

Growth and change are powerful. One of the most impactful moments of my life happened on a summer road trip in coastal California, driving through the Avenue of the Giants. It's miles of ancient coastal redwoods, and I'm at a loss to explain their magnitude. Of all the hikes I had the privilege of taking among these giants, there was a moment that struck me in the absolute silence of the Founders' Grove in Humboldt Redwoods State Park. Together, as human beings, we are not unlike these massive redwoods. We too started from the smallest of seeds, of origins. We earned our inches and used every opportunity for water and sunlight, for learning and experience, to become something so much grander because of what we live through. Both people and redwoods use what they get from the environment around them to grow. The biggest difference is that redwoods become the tallest living things on the planet while us

humble humans have only ever reached a recorded maximum of eight feet, eleven inches. The biggest similarity is that both redwoods and human beings, especially educators, become a collective of eons of slow, earned growth.

As much as the learning that we do as educators becomes a permanent part of us, woven into our neural pathways, how we incorporate that learning allows us to change moving forward. We can choose to be different once we know different. But we don't just snap our fingers and change. Change has to be earned. That's why teaching is a tattoo: Both can be changed, but that change demands work. Always. A redwood takes ages to grow. So do we. It takes work. I want to be clear, though: The word *work* shouldn't carry a negative connotation. Too often people get exasperated at the mention of work, like hard work is a burden. Work is something earned. Work is progress and growth and potential given a chance to be made tangible. Work is so often the catalyst of change, which makes work powerful in the virtually limitless possibilities that it unlocks. Both tattoos and teaching age with us. Sometimes what we do in teaching and tattoos don't age well.

Sometimes, as we age, we end up feeling differently about the things that we used to wear proudly. While it can be easy (if we let it be) to try new strategies, new ideas, new programs and tools, it takes work to really change the aspects of who we are as educators that have gotten under our skin and into the bones of us. Luckily, to paraphrase Snow White, you're never too old to (choose to) be young. Changing the way the electricity travels through our brains takes work. In my experience, in both teaching and tattoos, choosing and earning a change in how we think and feel and do the work has three pathways: remove, cover, or integrate.

Removing tattoos completely is a little like winning a battle in the Star Wars universe: It usually comes down to lasers. And aim. Sometimes the only way forward is out with the old, in with the new. Lasers will actually engage a tattoo below the skin, breaking it down into smaller and smaller pieces until your own immune system

does the work of getting rid of it. I love this as a metaphor for when we as educators have to change how we approach the work. There is typically some kind of external catalyst, something laser focused toward what we do and how we do it, that helps to break apart old ideas and understandings, old stories we used to wear. But then it is up to us to actually work to make that change happen.

The catalyst can be something you see or experience or read, something from a colleague or a conference or a moment that lights you up enough to look inward and break down old ways until your "immune system" just clears them out. It can be systemic changes—new policies and procedures, official systems and strategies, government or divisional or district shifts—that make us ask ourselves if we're doing the work the way that we're being contracted to. Of course this is still something we bring our beautiful individuality to, but changes in the systemic nuts and bolts of expectations, tools, or programs can catalyze the breakdown of old understandings, again forcing our educator immune system to sweep out the pieces of the old.

Cultural shifts can also kickstart this process. Think of how the words *teacher* and *student* are perceived. In the past, teachers were essentially expected to live in one-room schoolhouses; nowadays we see teachers and their lives are as varied as their genetics. Which is brilliant, because the more students see themselves in their teachers, the more they learn and the more they see the personal value of that learning. As I've already mentioned, I used to keep my tattoos and the fact that I am Indigenous covered up while teaching. As cultural expectations changed, I needed to break down my own understanding of who I was as a teacher into small pieces, then let my educator immune system carry those pieces off and make blank spaces for something new and relevant to the story I carry. If you're willing to work for it, embracing the external factors that spark change can keep us from becoming outdated or even extinct. The invention of the car forced us to rethink travel. Those who proclaimed, "Horse-drawn covered wagons until I die!" very likely died without seeing that

much more of the world. Listen and learn from the catalysts and culture around you. Embrace these changes and evolve with them. No matter how hard it is to break down something you used to wear, don't worry: Your immune system is built to rid you of things that don't work for you anymore.

Reflection is a beautiful thing. As an adult, I look back on things like the cartoons I used to watch and often understand them very differently. A byproduct of aging, for sure. Take *Jem*, for example. I used to be dazzled by that cartoon. A strong female record executive, Jerrica, uses a holographic computer by the name of Synergy to secretly turn her into Jem, titular pop rock superstar of Jem and the Holograms. Synergy was gifted to Jerrica by her deceased father, who designed it to be "the ultimate audio-visual entertainment synthesizer," and Jerrica activates it through her earrings, always to the dismay of rival band the Misfits. Every episode features several absolute banger songs. It was an absolute late-'80s cartoon masterpiece. Only upon adult reflection did I realize that the entirety of Jem's power was just being exactly who she was, but projecting a slightly more exciting and dynamic facade over it. This can be done with tattoos and with teaching: You don't always have to obliterate something with laser-powered reflective work. Sometimes, we can cover something old with a new layer of understanding. While I would argue that some systems, strategies, and understandings do have to be broken down with high-powered lasers and high-powered reflective work before we can move into something new, there are also moments when just moving on with a new understanding is a fine way to change.

Finally, when it comes to the work of growth and change, there is the option to keep the old and just add new things around it,

creating a tapestry of everything you've learned and proudly carry with you. There will be times when you feel like you can't break down and dissolve old ideas or even cover over them with new ones. Those times might call for just adding to the art and making it part of something bigger. Integrating the old into the new, if possible, is a powerful way to celebrate the things you used to value enough to wear while simultaneously embracing the new things you choose to wear. There is a lot of value in old ideas, as long as we put the work into making sure they're both worth keeping and viable to build on. That is where the most work lies. Regardless of what paths we choose in teaching and tattoos, change is work. Change is choice. Change isn't something inevitable that washes over us; it is something that we have to decide on and adapt to. Teaching is a tattoo because both can be changed, but both demand work to change. And changing either puts us in a tremendous position of power. We get to decide what we look like and what we wear moving forward.

INK-THINK-ASK

We're back for another opportunity to challenge you to own the things that you would proudly wear about who you are as an educator!

⭐ INK

I'd like you to draw yourself a tattoo that represents a time when you changed meaningfully and purposefully as an educator, a moment when you chose to put in the work to look different. As an extra challenge, you could try to do three tattoos this time: one that represents a time when you had to completely remove old ideas, one that shows how you covered over an old idea with a new one, and one that shows how you integrated old ideas into new visions.

⭐ THINK

Now that you've drawn your tattoo (or tattoos!), I want you to reflect for a few minutes on these guiding questions. Remember, always write your reflections down. Physically putting things down in ink is powerful practice. Own why teaching is your tattoo.

- ⭐ If you're being honest with yourself, what do you think your relationship with change is? Are you happy with where you're at in that relationship?
- ⭐ What is something that inspires change in you as an educator? Be as specific as possible!
- ⭐ How do you feel you react and/or act when presented with new educational ideas? Do you think that has served you well?

★ What is something that you are currently aware of wanting to change about how you educate? How do you plan to work to make that change?

★ ASK-TIVITY: NEW TO YOU

Here's one thing that never changes: I will always offer you an activity that you can easily and immediately take into your classroom or to your staff! Let's work together to create space and opportunity for others to reflect in the same way that you've been given the chance to in the section above!

This is a fun and engaging visual activity that lets participants reflect on how new and different contexts and ideas change how things look for them. There are a few different approaches, but they're all fun!

Step 1—Blank Paper, the Infinite Canvas: Each participant will be creating a visual representation of themselves. I always feel like a blank page is the way to go here. It makes the possibilities endless! Hand out a blank page to each participant and make sure they have the pencils and colors to create!

Step 2—Create! Have the participants draw themselves now, in this moment in their lives. The emphasis should be on making this as straightforward and run-of-the-mill as possible. Draw yourself. Period.

Step 3—Flex the Context and Change: Now is the time to practice using context to change. For this one, I often toss out several fun and interesting scenarios and ask participants to change themselves based on them, modifying their drawings of themselves accordingly. After the activity, each participant can look at their drawing and reflect on how much change they are capable of. Here are some sample scenarios:

★ Change yourself to be able to live underwater.
★ Change yourself into the you of the future.

- ★ Change yourself into an animal person.
- ★ Change yourself into a superhero.
- ★ Change yourself into the best version of yourself.
- ★ Change yourself into someone going on an adventure.
- ★ Change yourself into yourself doing your dream job.
- ★ Change yourself to be able to use your five senses extremely well.

Fun things like that! It's also always great to ask participants for ways that we can adapt ourselves visually. Students in particular always have more creative suggestions than we do. Dive into that.

Step 4—Sharing Is Caring: This is always the most important part of the work. Hold a discussion, fashion show, or sharing circle and ask participants why they made the changes they did. This allows them to see themselves as capable of change, and it gives you a better understanding of how they see themselves and their capacity to evolve. The why and the how are essential parts that make this activity meaningful.

This piece is very visual and very simple. The biggest modification here is the language you use to approach the instructions. Make sure participants feel supported in their creativity.

THE CANVAS WE ARE

Back one last time to spotlight . . .

Kristin Daley Conti

Grade 7 Science Teacher
Massachusetts

Kristin Daley Conti is a seventh-grade science teacher in Massachusetts. This is her twenty-sixth year of teaching. She loves teaching middle school students because their minds are open, they like to be silly, they ask great questions, and they have amazing energy. In the classroom, she is passionate about providing hands-on learning, she loves going outside with kids, and she uses ed-tech to not only positively impact learning, but to incorporate real-life (future-ready) technology skills.

> I drew this tattoo myself. A symbol for each family member is nestled inside an infinity symbol. The heart is for my husband, the paw print is for my dogs, the butterfly represents my ever-evolving, independent daughter, who has a passion for seeing the world, and the star represents my son, who is a musician and a performer. He shines both on stage and off.

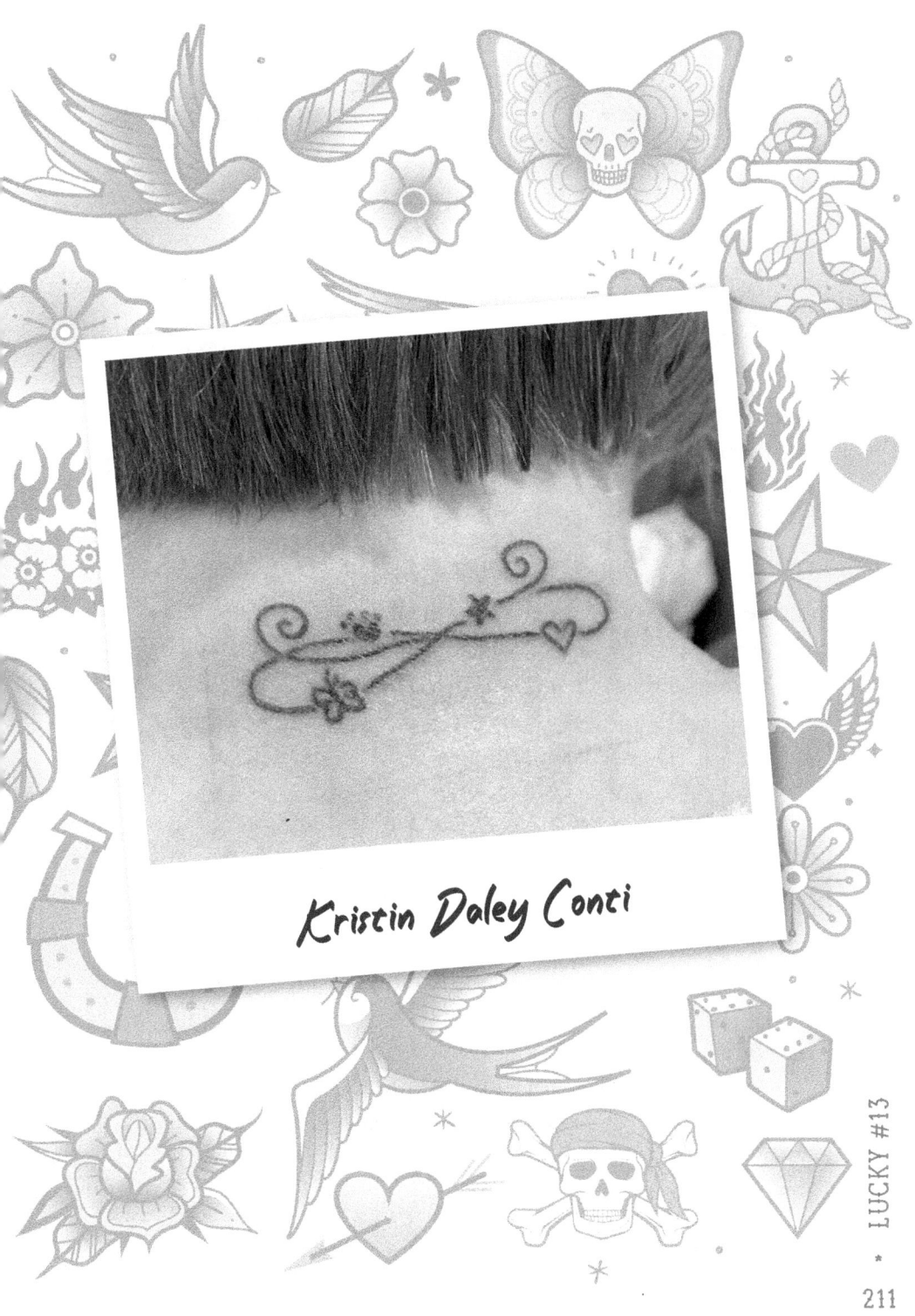

Jade Murphy

Head of Art
Liverpool, England

Jade Murphy is the head of art at Co-op Academy Belle Vue, and she has over thirteen years of teaching experience. Throughout her career, she has been dedicated to fostering creativity and artistic expression as well as developing technical skills and passion for the arts in students. She is the art department lead, inspiring and supporting the next generation of artists.

> My first tattoo, a lion on my chest, came after a period of personal growth. I went through a tough six-month period and, afterward, discovered a strength in myself that I hadn't realized I had. I decided to get the lion tattoo as a reminder that I am strong and capable of facing adversity. That's why I placed it on my chest; it is a symbol of having a "lion heart." The name Sharu above the lion was actually supposed to be Saroo. The name comes from a movie about a young boy named Saroo who becomes estranged from his family, faces incredible difficulties, and is eventually adopted. His journey echoed mine, so I chose to have the name Saroo written above the lion because the word actually means *lion* in Hindi.
>
> However, when I arrived at the tattoo studio, my phone had died, so I asked my friend to double-check the word on her phone. She mistakenly found Sharu. At first, I was devastated to have the wrong word tattooed on me, but I later found out that Sharu carries its own deep meaning, which made me feel at peace, as it had its own connections to me.

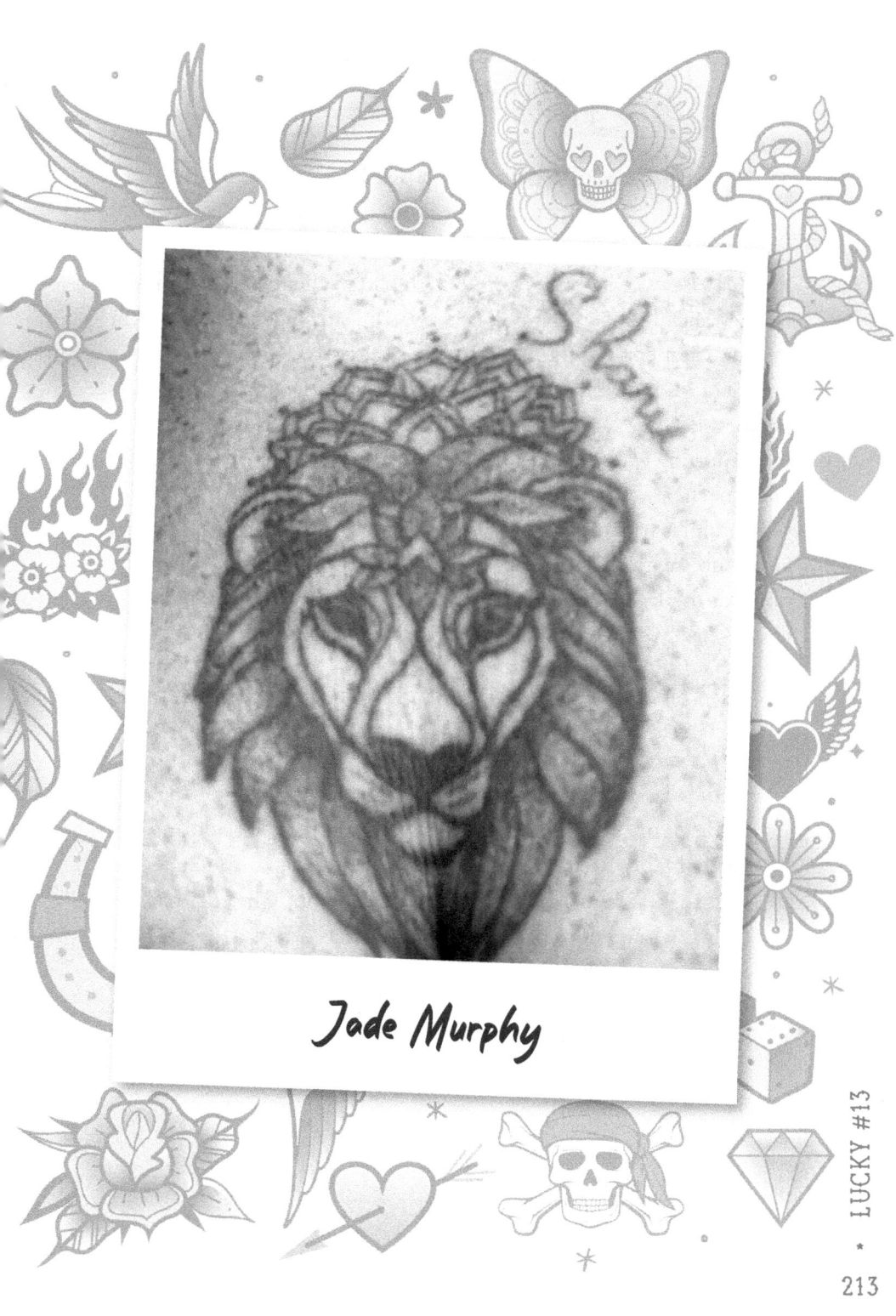

Phil Januszewski

High School Educator, Speaker, and Coach
Chicagoland Area, Illinois

Phil Januszewski has been a proud high school chemistry and physics teacher since 2005. He holds a degree in chemistry, a master's in teaching leadership, and a positive education certification. Phil is experienced with a microphone and has had a love of entertaining people since high school. Fast-forward through years of announcing local sporting events and DJing weddings, and Phil is now a speaker and coach for educators looking to flourish and avoid burnout. When Phil is not teaching, speaking, or coaching, he enjoys everyday adventures with his wife and two children or pursuing his personal passions of physical fitness, cooking/baking new recipes, and reading about self-improvement and positive psychology.

> I decided to finally tattoo my hands as an educator after we came back from the pandemic lockdown. I had been heavily tattooed for years, wearing long sleeves daily to cover up in the classroom. After the pandemic and realizing all that we have in this life and all that we could have lost during COVID-19, I felt an overwhelming sense of gratitude and love to be alive. The "grateful" tattoo reminds me of that daily . . . grateful to have a job that impacts others . . . grateful to have my health . . . grateful to have my family. After COVID was the very first time I ever showed my tattoos in the education setting. It felt good to be my authentic self.

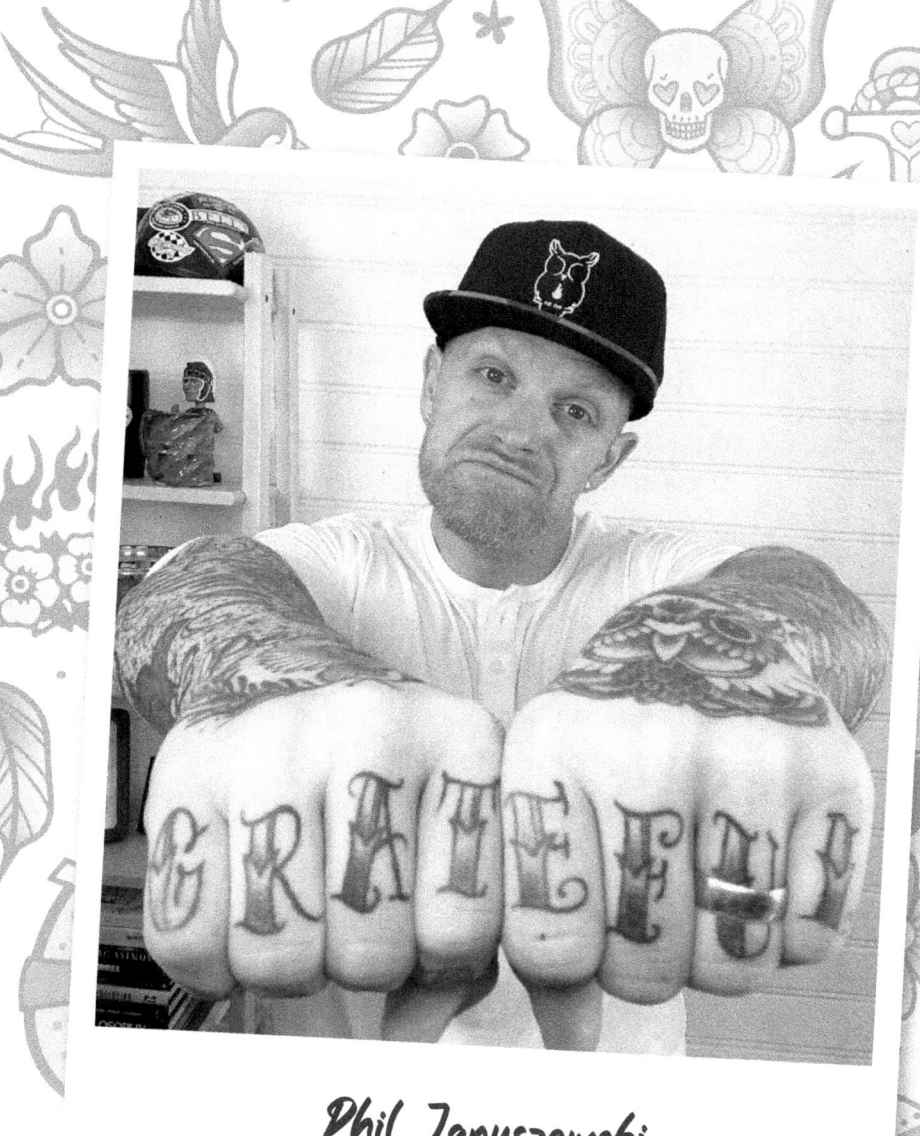

Phil Januszewski

Micro Motivator

As an educator, you create change. You change capacities. You change neural pathways. You change potential futures. When you embrace change in yourself, it is essential that you treat the work that comes along with it as the privilege it is. Earned inches are the most meaningful.

Sometimes constellations reveal themselves one star at a time

There are as many human stories as there are stars in the sky. Some of them are brighter, closer, more visible. Some of them are part of a larger story, a constellation. The beauty of constellations, aside from their actual visual beauty, is that each star exists on its own, but we've collectively taken the time to look up long enough and with enough consideration to know the stories written there. There is an entire celestial existence worth seeing in each star. There is a story worth seeing when we weave them into constellations. There are stories in satellites and shooting stars and moons and meteors and planets and planes flying overhead. It is impossible to love the night sky without at least being curious about all the little stories that quilt it together. Teaching and tattoos are the same. Both are complex in terms of what they are and how people see them. Neither can really be understood without curiosity about the stories that shape them. The little things that make us feel so deeply for teaching and tattoos and the night sky reveal less about them and more about who we are at heart. That heart matters more now than it ever has.

My love for constellations and star stories runs so deep that I wear a constellation whose story means the world to me: the Pleiades. It's hidden in plain sight among some of my other tattoos. It has an added layer of importance for me as an Indigenous person. For many Indigenous people, star stories hold a depth of knowledge and understanding. This constellation is known to some Indigenous people as the Hole in the Sky. To many of us, it is seen as a connection, a doorway to the spirit world or star world.

The heart of us matters because the word *teacher* is far less of a monolith than ever before. It is becoming more and more dynamic and fluid, more individual and holistic. While we always carry that banner of *teacher*, we're allowing ourselves this freedom to bring more and more of who we are into that word. We're questioning what the word means, and asking questions is a good thing. It's phenomenally important to ask questions about what we do, why we do it, who we become through it, and how much of ourselves we bring to it, especially in this business of human beings that we're lucky to be in. The biggest question that we should be asking, the driving question behind all the work that we've just done together, remains this: What do you love about who you are as an educator enough to wear it out loud?

We've done a lot of work together here over these pages. Valuable, meaningful work. But the thing that matters most is the way you're going to wear who you uniquely are as an educator out loud, how you're going to show that teaching is your tattoo. You've even gone ahead and drawn some tattoos as reflective practice. If you choose to physically get one of those tattoos as a reminder to wear who you are proudly in your work, please send me a picture.

It all comes down to making the work your own by bringing your most authentic self to it. You have to make the story of the work part of the story of you, and vice versa. You are a human being who is doing the work of educating other human beings, and the more we embrace the stories and struggles and strengths, the personality and purpose, the more we humanize that work. Which makes it infinitely more valuable and connects it more deeply to the students and staff who are engaging in that work with us. Both in teaching and tattoos, the more we ask about the stories behind what we see, the less we assume and the more we engage with the art and the artists, the more we can beautifully blur the lines between learning and living. Isn't that the goal? I'd argue that both teaching and tattoos boil down to creating opportunities to see and be seen, speak our own stories and

value others', all in an attempt to figure out how billions of unique humans can effectively create tomorrows together.

The humanness of the work we do is what makes it magic. As an Indigenous educator, I was taught by my elders that traditional Indigenous education embraces the idea that learning is lifelong and natural. Our experiences while learning are valuable and important to share. Teachers are also always learners, especially alongside their students and colleagues. We're learning about each other and learning from each other, through each other. That's why teaching is a tattoo: Both require reciprocal relationships. Teaching and tattoos invite a holistic look at who a human being is, who their stories have made them, and what we can learn about them and ourselves if we value their experiences. It makes both students and teachers partners in learning. It makes both students and teachers responsible for seeing each other for the human beings that they are. Both teaching and tattoos are opportunities to see all human beings as knowledge keepers of their own experiences and as opportunities to know more. Becoming a good teacher requires an understanding of the subject areas, but becoming a great teacher requires understanding the people you're teaching as human beings. Teaching has evolved from a rote memory delivery system to the holistic and dynamic work that we continue to grow into.

Our work is big. Our work is monumentally, wonderfully, impossibly big. It's why sometimes we inflate the word *teacher* into this umbrella concept, this caricature. I'm here to remind you to allow yourself to fall in love with some pieces of the work of educating enough to wear them like tattoos. Trying to wear the word *teacher* with all its varied definitions is like trying to tattoo yourself with your entire life story. You can't wear all the aspects of who you are simultaneously, so you pick and choose how and when you highlight what's unique and amazing about you. Showing off how much you love to cook is perfect at a BBQ but feels weird if you bring it up too often at the zoo. Our moments and methods of bringing who we are into what we do are important and empowering. Both teaching and

tattoos are made more meaningful when you know why you choose the pieces you do. When you embrace your why in both teaching and tattoos, you deepen your connection to it. You value the stories. You start to understand that teaching and tattoos permanently change people and that this must be considered and respected.

We're at a really neat moment where worthy traditions and innovative modern approaches are coalescing and who we are as educators and human beings is forging the connective tissue. Both teaching and tattoos are a deeply personal and openly public experience, which is what puts us at the forefront of the redefinition of *teacher*. But that also puts us in the driver's seat of what we become. We have a say in what the word *teacher* means, how it is seen, and how much of it we wear. We bring our perfectly imperfect selves to the table for the work of evolving the word. Growing pains and all, we are the ones who will decide, regardless of policy and protocol, what the story of being a teacher is and how we will wear it. That is why teaching is a tattoo: It carries the weight of great power and great responsibility. Teaching and tattoos are opportunities to create our own art and tell our own stories while also helping to inspire the creations of artists and storytellers around us. Teaching is a tattoo because both are limitless in their potential value to human beings. Both invite us all to learn about each other together, to build our understanding and appreciation for who we are as individuals. The more we care about our own stories and how we choose to wear them as human beings, the more we start to seek and care about the stories that those around us wear. That care and humanity inevitably and invariably makes us better teachers.

I want to leave you here at the end with a lyric from one of the greatest Canadian bands of all time: the Tragically Hip. It's appropriate for a lot of reasons, but there's a beautiful symmetry with the first lines of this book ("so dangerous you'll have to sign a waiver"), which were lyrics written by another Canadian band, Barenaked Ladies. Yes, that is their real name and yes, they are brilliant. But the Tragically Hip were fronted by Gord Downie, who was arguably the

most exceptional poet Canada ever produced. Before his untimely death from brain cancer at the age of fifty-three, he penned lyrics about how life, unlike theatre, doesn't come with the grace and safety of a dress rehearsal. He also lived out loud as a brilliant example of how to use every minute we're each gifted. Life doesn't afford us the opportunity to try experiences on for size, to walk around in them and see how they fit. The moments of our lives make us who we are, they become us. That's why teaching is a tattoo and why I believe so deeply in the value of figuring out what about teaching is your tattoo; because we carry the stories of who we are in the spaces between our cells, and there is nothing more meaningful or powerful than how we choose to own and wear them. Especially because we are in the business of helping other human beings fill the empty spaces between their atoms with lived stories of their own.

We've asked a lot of questions over these pages. Of ourselves, about ourselves, about this noble and meaningful work and what parts of ourselves we bring to it. This is a rallying cry to see yourself and be yourself while making that space for other worn stories. It is my fondest hope that every question we've asked about who you are has inspired you to turn and ask the same questions of someone else. I hope you always value seeing and hearing others as much as you value being seen and heard. I want you to see yourself as both a canvas and a microphone. I want you to be a constellation while also prioritizing time to stargaze. Let me ask you just one more question, and it's the one I'd invite you to not only think about the most honestly, but also to commit to the most fervently once your answers bubble to the surface. How is teaching your tattoo? Whatever your answer is, whatever pieces and stories you love about who you are as a human being who chooses to teach, put it proudly into the skin and bones of how you educate, and wear it out loud. Make something meaningful and beautiful and permanent. Remember, everything is a blank canvas, until it isn't.

Flash Art Tattoo Activities

If you've ever walked into a tattoo parlor, you'll likely have seen walls full of flash art tattoo inspiration. (If you haven't visited a tattoo parlor, you absolutely should—there's nothing like it.) Turns out, sometimes people are inspired to get a tattoo, but they haven't figured out what visual best tells their story. To that end, many tattoo parlors have walls full of little tattoo ideas, things that might fire up a story worth telling on your own skin. That's what I'm offering you here! (Metaphorically!)

Below are potential visual flash art tattoo activities that you might want to use yourself or with your community of teachers and learners. Take these ideas and run with them! Make them your own!

VISUALIZE ONE OF MY FAVORITE MOMENTS

Invite participants to re-create a moment, a story in their lives, that means a lot to them in a visual way. Then have them present it with their best storytelling. I've done this with quick clay sculptures, poster boards, tableaux, all kinds of things. It allows participants to think about how to re-create that moment visually while also giving listeners a chance to learn about others' big moments. In the end, everyone better understands the experiences we all carry with us.

FIVE BIG FEELINGS

We want to focus on the power of visual representation. Give participants some blank paper—either five blank pages or a page with enough space for five items. Either way, you'll also need art supplies! One by one, introduce participants to one big feeling: happy, angry, scared, sad, surprised, or whatever you'd like! Allow them to create a visual that shows when they feel that emotion, what makes them feel that big feeling. Don't forget to share the stories behind those big feels.

TATTOO THE BUILDING

Permanence adds additional meaning to tattoos, and I've often used activities that involve making a physical change to participants' shared space. I've had students design ceiling panels, recover and paint over furniture from garage sales, paint designs on walls, create vinyl sticker patterns on floors—anything that gives them a chance to create a visual legacy that will be a proud part of the physical space they share. It's like a tattoo for the building.

TATTOO TIME CAPSULE

Each year of teaching is its own experience. Every year the students change, the staff changes, the space changes. Even if only in small ways, change happens. I like to create a tattoo time capsule at the beginning of each year. I take a photo of each student (or staff member), print that photo out, then allow participants to decorate it any way they want. Then I seal it away for the rest of the year! We open it at the end of the year and take time to review and reflect, seeing just how we've changed or stayed the same as human beings over those months together.

TATTOO TUESDAYS/TATTOO WEEK

I've had lots of fun and discovered insights by committing to a day a week (or a week a year) where all our responses have to be thought out and submitted completely in visual form. Honestly, it's surprising what happens when you can't use numbers or writing to express understanding and ideas!

DAILY DRAW TATTOO CHECK-IN

I love a good morning check-in. Often, I'll set a timer and ask participants to draw a picture of how they're feeling or what's on their mind. Then we share, and it's a nice way to really reflect on and own our perspective coming into the day. (I also sometimes just do it for myself because it's a fun way to focus and acknowledge the things that will help frame my day.)

ACKNOWLEDGMENTS

Acknowledgments are always difficult, because it is my honest personal belief that everyone we have the privilege of interacting with brings something valuable into our own experience. To that end, I would like to acknowledge and thank everyone who gave moments of themselves that helped make me who I am. Without that, I wouldn't have anything to say and this book would have been very, very short. I would like to acknowledge the educators who were brave enough to share their personal individual tattoo stories in these pages. We're still in a time and place where being a tattooed teacher takes courage. We're working on it, though, and stories shared like this are a big part of that. I want to acknowledge my whole team at Dave Burgess, Inc. for having faith in me to create this book and do justice to important stories. I want to acknowledge Sal, who is the epitome of proof that collaboration makes projects better. I want to acknowledge every tattooed teacher whose stories aren't in these pages. Wear them proudly.

More than anything, I want to acknowledge my family. Without their constant support, I wouldn't have had the chance to write this. More importantly, without the adventures of our life, my skin would have no stories to tell.

ABOUT MIKE JOHNSTON

Like you, Mike Johnston wears a lifetime of stories.

Many of which he wears as tattoos. Mike is an award-winning public school teacher with over eighteen years of classroom experience as a middle years educator, Indigenous education teacher, land-based learning specialist, and poetry educator, among other roles. He chose his first tattoo at the age of eighteen and has added many more since then, each carrying a moment, story, or lesson learned worth wearing. He is committed to living his life in ways that offer consistent new experiences that inspire new tattoos.

Mike is a proud Indigenous man, Red River Métis citizen, champion slam poet, *National Geographic* Grosvenor Teacher Fellow, and author of international best seller *You Are Poetry: How to See—and Grow—the Poet in Your Students and Yourself*.

More from Dave Burgess Consulting, Inc.

Since 2012, DBCI has published books that inspire and equip educators to be their best. For more information on our titles or to purchase bulk orders for your school, district, or book study, visit DaveBurgessConsulting.com/DBCIbooks.

★ THE *LIKE A PIRATE*™ SERIES

Teach Like a PIRATE by Dave Burgess
eXPlore Like a PIRATE by Michael Matera
Learn Like a PIRATE by Paul Solarz
Plan Like a PIRATE by Dawn M. Harris
Play Like a PIRATE by Quinn Rollins
Run Like a PIRATE by Adam Welcome
Tech Like a PIRATE by Matt Miller

★ THE *LEAD LIKE A PIRATE*™ SERIES

Lead Like a PIRATE by Shelley Burgess and Beth Houf
Balance Like a PIRATE by Jessica Cabeen, Jessica Johnson, and Sarah Johnson
Lead beyond Your Title by Nili Bartley
Lead with Appreciation by Amber Teamann and Melinda Miller
Lead with Collaboration by Allyson Apsey and Jessica Gomez
Lead with Culture by Jay Billy
Lead with Instructional Rounds by Vicki Wilson
Lead with Literacy by Mandy Ellis
She Leads by Dr. Rachael George and Majalise W. Tolan

★ THE *EDUPROTOCOL FIELD GUIDE* SERIES

Deploying EduProtocols by Kim Voge, with Jon Corippo and Marlena Hebern

The EduProtocol Field Guide by Marlena Hebern and Jon Corippo
The EduProtocol Field Guide Book 2 by Marlena Hebern and Jon Corippo
The EduProtocol Field Guide ELA Edition by Jacob Carr
The EduProtocol Field Guide Math Edition by Lisa Nowakowski and Jeremiah Ruesch
The EduProtocol Field Guide Primary Edition by Benjamin Cogswell and Jennifer Dean
The EduProtocol Field Guide Social Studies Edition by Dr. Scott M. Petri and Adam Moler

★ LEADERSHIP & SCHOOL CULTURE

Be 1% Better by Ron Clark
Be THAT Teacher by Dwayne Reed
Beyond the Surface of Restorative Practices by Marisol Rerucha
Change the Narrative by Henry J. Turner and Kathy Lopes
Choosing to See by Pamela Seda and Kyndall Brown
Culturize by Jimmy Casas
Discipline Win by Andy Jacks
Educate Me! by Dr. Shree Walker with Micheal D. Ison
Escaping the School Leader's Dunk Tank by Rebecca Coda and Rick Jetter
Fight Song by Kim Bearden
From Teacher to Leader by Starr Sackstein
If the Dance Floor Is Empty, Change the Song by Joe Clark
The Innovator's Mindset by George Couros
It's OK to Say "They" by Christy Whittlesey
Kids Deserve It! by Todd Nesloney and Adam Welcome
Leading the Whole Teacher by Allyson Apsey
Let Them Speak by Rebecca Coda and Rick Jetter
The Limitless School by Abe Hege and Adam Dovico
Live Your Excellence by Jimmy Casas
Next-Level Teaching by Jonathan Alsheimer
The Pepper Effect by Sean Gaillard
Principaled by Kate Barker, Kourtney Ferrua, and Rachael George
The Principled Principal by Jeffrey Zoul and Anthony McConnell
Relentless by Hamish Brewer

The Secret Solution by Todd Whitaker, Sam Miller, and Ryan Donlan
Start. Right. Now. by Todd Whitaker, Jeffrey Zoul, and Jimmy Casas
Stop. Right. Now. by Jimmy Casas and Jeffrey Zoul
Teach Your Class Off by CJ Reynolds
Teachers Deserve It by Rae Hughart and Adam Welcome
They Call Me "Mr. De" by Frank DeAngelis
Thrive through the Five by Jill M. Siler
Unmapped Potential by Julie Hasson and Missy Lennard
When Kids Lead by Todd Nesloney and Adam Dovico
Word Shift by Joy Kirr
Your School Rocks by Ryan McLane and Eric Lowe

TECHNOLOGY & TOOLS

50 Things to Go Further with Google Classroom by Alice Keeler and Libbi Miller
50 Things You Can Do with Google Classroom by Alice Keeler and Libbi Miller
50 Ways to Engage Students with Google Apps by Alice Keeler and Heather Lyon
140 Twitter Tips for Educators by Brad Currie, Billy Krakower, and Scott Rocco
Block Breaker by Brian Aspinall
Building Blocks for Tiny Techies by Jamila "Mia" Leonard
Code Breaker by Brian Aspinall
The Complete EdTech Coach by Katherine Goyette and Adam Juarez
Control Alt Achieve by Eric Curts
The Esports Education Playbook by Chris Aviles, Steve Isaacs, Christine Lion-Bailey, and Jesse Lubinsky
Google Apps for Littles by Christine Pinto and Alice Keeler
Master the Media by Julie Smith
Raising Digital Leaders by Jennifer Casa-Todd
Reality Bytes by Christine Lion-Bailey, Jesse Lubinsky, and Micah Shippee, PhD
Sail the 7 Cs with Microsoft Education by Becky Keene and Kathi Kersznowski
Shake Up Learning by Kasey Bell
Social LEADia by Jennifer Casa-Todd

Stepping Up to Google Classroom by Alice Keeler and Kimberly Mattina
Teaching Math with Google Apps by Alice Keeler and Diana Herrington
Teaching with Google Jamboard by Alice Keeler and Kimberly Mattina
Teachingland by Amanda Fox and Mary Ellen Weeks

 TEACHING METHODS & MATERIALS

All 4s and 5s by Andrew Sharos
Boredom Busters by Katie Powell
Building Strong Writers by Christina Schneider
The Classroom Chef by John Stevens and Matt Vaudrey
The Collaborative Classroom by Trevor Muir
Copyrighteous by Diana Gill
CREATE by Bethany J. Petty
Ditch That Homework by Matt Miller and Alice Keeler
Ditch That Textbook by Matt Miller
Don't Ditch That Tech by Matt Miller, Nate Ridgway, and Angelia Ridgway
EDrenaline Rush by John Meehan
Educated by Design by Michael Cohen, The Tech Rabbi
Empowered to Choose: A Practical Guide to Personalized Learning by Andrew Easton
Expedition Science by Becky Schnekser
Frustration Busters by Katie Powell
Fully Engaged by Michael Matera and John Meehan
Game On? Brain On! by Lindsay Portnoy, PhD
Guided Math AMPED by Reagan Tunstall
Happy & Resilient by Roni Habib
Innovating Play by Jessica LaBar-Twomy and Christine Pinto
Instant Relevance by Denis Sheeran
Instructional Coaching Connection by Nathan Lang-Raad
Keeping the Wonder by Jenna Copper, Ashley Bible, Abby Gross, and Staci Lamb
LAUNCH by John Spencer and A.J. Juliani
Learning in the Zone by Dr. Sonny Magana
Lights, Cameras, TEACH! by Kevin J. Butler

Make Learning MAGICAL by Tisha Richmond
Pass the Baton by Kathryn Finch and Theresa Hoover
Project-Based Learning Anywhere by Lori Elliott
Pure Genius by Don Wettrick
The Revolution by Darren Ellwein and Derek McCoy
The Science Box by Kim Adsit and Adam Peterson
Shift This! by Joy Kirr
Skyrocket Your Teacher Coaching by Michael Cary Sonbert
Spark Learning by Ramsey Musallam
Sparks in the Dark by Travis Crowder and Todd Nesloney
Table Talk Math by John Stevens
Teachables by Cheryl Abla and Lisa Maxfield
Unpack Your Impact by Naomi O'Brien and LaNesha Tabb
The Wild Card by Hope and Wade King
Writefully Empowered by Jacob Chastain
The Writing on the Classroom Wall by Steve Wyborney
You Are Poetry by Mike Johnston
You'll Never Guess What I'm Saying by Naomi O'Brien
You'll Never Guess What I'm Thinking About by Naomi O'Brien

★ INSPIRATION, PROFESSIONAL GROWTH & PERSONAL DEVELOPMENT

Be REAL by Tara Martin
Be the One for Kids by Ryan Sheehy
The Coach ADVenture by Amy Illingworth
Creatively Productive by Lisa Johnson
The Ed Branding Book by Dr. Renae Bryant and Lynette White
Educational Eye Exam by Alicia Ray
The EduNinja Mindset by Jennifer Burdis
Empower Our Girls by Lynmara Colón and Adam Welcome
Finding Lifelines by Andrew Grieve and Andrew Sharos
The Four O'Clock Faculty by Rich Czyz
How Much Water Do We Have? by Pete and Kris Nunweiler
P Is for Pirate by Dave and Shelley Burgess
A Passion for Kindness by Tamara Letter
The Path to Serendipity by Allyson Apsey
PheMOMenal Teacher by Annick Rauch

Recipes for Resilience by Robert A. Martinez
Rogue Leader by Rich Czyz
Sanctuaries by Dan Tricarico
Saving Sycamore by Molly B. Hudgens
The Secret Sauce by Rich Czyz
Shattering the Perfect Teacher Myth by Aaron Hogan
Stories from Webb by Todd Nesloney
Talk to Me by Kim Bearden
Teach Better by Chad Ostrowski, Tiffany Ott, Rae Hughart, and Jeff Gargas
Teach Me, Teacher by Jacob Chastain
Teach, Play, Learn! by Adam Peterson
The Teachers of Oz by Herbie Raad and Nathan Lang-Raad
Teaching the Ms. Abbott Way by Joyce Stephens Abbott
TeamMakers by Laura Robb and Evan Robb
Through the Lens of Serendipity by Allyson Apsey
Write Here and Now by Dan Tricarico
The Zen Teacher by Dan Tricarico

⭐ CHILDREN'S BOOKS

The Adventures of Little Mickey by Mickey Smith Jr.
Alpert by LaNesha Tabb
Alpert & Friends by LaNesha Tabb
Beyond Us by Aaron Polansky
Cannonball In by Tara Martin
Dolphins in Trees by Aaron Polansky
Dragon Smart by Tisha and Tommy Richmond
I Can Achieve Anything by MoNique Waters
I Want to Be a Lot by Ashley Savage
The Magic of Wonder by Jenna Copper, Ashley Bible, Abby Gross, and Staci Lamb
Micah's Big Question by Naomi O'Brien
The Princes of Serendip by Allyson Apsey
Ride with Emilio by Richard Nares
A Teacher's Top Secret Confidential by LaNesha Tabb
A Teacher's Top Secret: Mission Accomplished by LaNesha Tabb
The Wild Card Kids by Hope and Wade King
Zom-Be a Design Thinker by Amanda Fox

www.ingramcontent.com/pod-product-compliance
Lightning Source LLC
Chambersburg PA
CBHW050522170426
43201CB00013B/2053